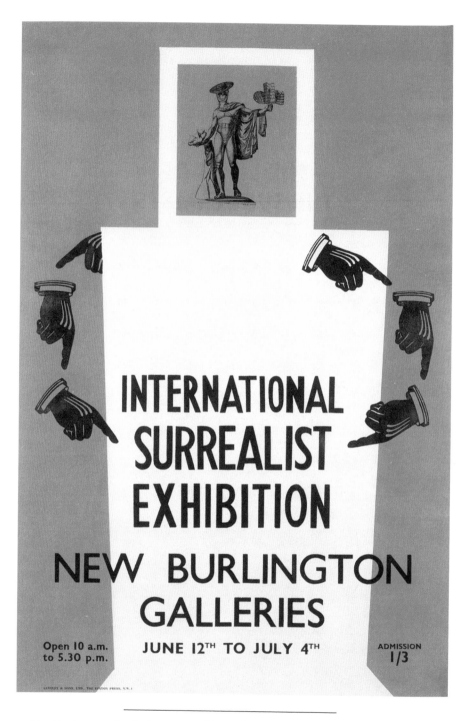

Max Ernst, poster for the International Surrealist Exhibition, New Burlington Galleries, London, 1936.

THE LIVES OF
THE SURREALISTS

DESMOND MORRIS

Thames & Hudson

CONTENTS

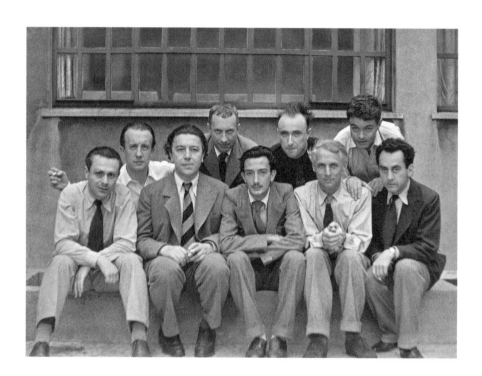

Surrealist artists in Paris (from left: Tristan Tzara, Paul Eluard, André Breton, Jean Arp, Salvador Dalí, Yves Tanguy, Max Ernst, René Crevel, Man Ray), 1933. Photo by Anna Riwkin.

PREFACE

This book is a personal view of the surrealists, focusing on their lives rather than their work. I have restricted myself to the visual artists and have chosen the thirty-two individuals that I find most interesting. The artists are each presented in the form of a short biography, summing up their life story and discussing their personality.

The surrealist movement began in Paris in the 1920s and continued vigorously throughout the 1930s. When World War II broke out in 1939 the surrealist artists scattered, many of them ending up as refugees in New York. There, they continued to work, but when the war ended in 1945 and they returned to Paris, they found it difficult to re-activate the movement and, as an organized body, it went into a rapid decline. Most of the major artists abandoned city life at this point and went off to work elsewhere. They did not stop creating important surrealist works of art, but did so now as separate, independent individuals.

I have illustrated each of the thirty-two surrealists with a portrait photograph to show their appearance and with a typical example of their work. The portrait photos have been selected to show them as they were during the heyday of the movement and, wherever possible, I have avoided the more familiar photographs of them as mature artists. In choosing the thirty-two works of art my primary focus was on works done before the end of World War II – in other words, on paintings and sculptures made during the height of the movement.

A number of authors have divided surrealist works of art into two main categories, variously called figurative and abstract, illusionistic and automatist, oneiric and free-form, or veristic and absolute. I feel that these dichotomies are too sweeping and that there are, in fact, five basic types of surrealism:

1. Paradoxical surrealism. The artist presents compositions in which the individual elements are realistically portrayed, but are irrationally juxtaposed. Example: René Magritte

2. Atmospheric surrealism. The artist presents a realistic composition, but with such a strange intensity that the scenes portrayed take on a dreamlike quality. Example: Paul Delvaux

3. Metamorphic surrealism. The artist portrays recognizable images but their shapes, colours and other details are distorted. The figures depicted are metamorphosing but it is still possible to recognize their original source. In their most extreme form they become little more than surrealist hieroglyphs. Example: Joan Miró

4. Biomorphic surrealism. The artist invents new figures that cannot be traced to specific, original sources, but which have an organic authenticity of their own. Example: Yves Tanguy

5. Abstract surrealism. The artist employs organic abstract shapes, but with sufficient differentiation to make them more than simply a visual pattern. Example: Arshile Gorky

Two important points need to be made about these five categories. First, many surrealists employed more than one of these approaches during their careers. Max Ernst was probably the most versatile, having used all of them at one time or another. Others, like Magritte, remained faithful to a single category. Second, the use of one of these categories is no guarantee of a successful artwork. Many people have adopted these surrealist procedures without achieving interesting results. The great mystery of surrealism and, indeed, of all art, is what makes one example of a particular genre more rewarding than another.

There has been a great deal of argument about who is a true surrealist and who is not. The purist will say that only a member of André Breton's inner circle can be called one. Others will say that any painting that is strange can be called 'surreal'. I reject both extreme views. My compromise accepts the following categories:

1. Official surrealist artists

Artists who not only produced exclusively surrealist works of art but also participated in surrealist group meetings and followed the rules laid down by Breton in the surrealist manifestos. These artists agreed to operate as part of a collective, acting subversively to undermine the establishment and traditional values. They each had a vote when formally admitting or expelling someone from the group.

2. Temporary surrealists

Artists who worked in other genres but who, when they came into contact with the surrealists, entered into a surrealist phase in their work.

3. Independent surrealists

Artists who knew about the surrealists and their theories, but were individualists and not interested in any form of group activity. They were not opposed to the group, or the official aims of the movement, but as loners simply wanted no part of it.

4. Antagonistic surrealists

Artists who produced surrealist works but who disliked Breton and his followers and what they stood for. One of them, for example, said that he 'fervently admired' the art of the surrealists but disapproved of their theories.

5. Expelled surrealists

Artists who were expelled by the official group but who continued to make surrealist work, despite the fact that they were no longer considered to be surrealists.

6. Departed surrealists

Artists who belonged to the official group but then decided they no longer wanted to be associated with it, and left the group.

7. Rejected surrealists

Artists who considered themselves surrealists and who wished to belong to the official group, but were not allowed to join because their work was considered unacceptable.

8. Natural surrealists

Artists who produced truly surrealist work but who operated in isolation, knowing little or nothing about the movement itself.

Finally, I am omitting two types of surrealists from this book. They are:

Official surrealist non-artists

Surrealists who produced no visual works of art but who were the theorists, writers, poets, activists and organizers of the movement. They were important in the early days, setting out the aims and intentions of the group, but their significance soon faded into history, whereas the work of the visual artists grew steadily in its global impact.

Surrealist photographers and film-makers

Some of these were extremely important and this category has been omitted with regret, simply because of the size of the task.

INTRODUCTION

There is no other art movement in history that contains two artists as different as Magritte and Miró. This is because surrealism was not in origin an art movement but a philosophical concept. It was a whole way of life – a rebellion against the establishment that had given the world the hideous slaughter of World War I. If conventional human society could lead to something as disgusting as that, then surely it must itself be disgusting. The Dadaists decided that the only solution was to laugh in its face. Their acts of ribald ridicule were so outrageous that André Breton, sitting in a street café in Paris, pondering the future, decided that something more serious was needed to combat traditional, orthodox society. In 1924 he presented his idea in the form of a manifesto that for the first time described the new movement called surrealism. He even provided a dictionary-style definition:

SURREALISM, n. Psychic automatism in its pure state, by which one proposes to express – verbally, by means of the written word, or in any other manner – the actual functioning of thought, in the absence of any control exercised by reason, exempt from any aesthetic or moral concern.

As debates swirled around this new philosophy, Breton identified nineteen people who had performed acts of pure surrealism. They were poets, essayists, authors and thinkers and their names are now all largely forgotten. Only specialist scholars would recognize names such as Boiffard, Carrive, Delteil, Noll or Vitrac. Outside the specialist sphere, their writings have sunk without trace. And that is how it would probably have stayed if one of them, Pierre Naville, had had his way. For it was he who wrote: 'Masters, master-crooks, smear your canvases. Everyone knows there is no surrealist painting.' For him, the visual arts had no place in the surrealist scheme of things. If his view had prevailed, surrealism would have enjoyed a few years of obscure literary philosophizing in Paris and then have faded away.

Fortunately for Breton, Naville had overlooked one thing. The Dada movement out of which surrealism had grown contained several brilliant visual talents in the shape of artists such as Max Ernst, Marcel Duchamp, Francis Picabia, Man Ray and Jean Arp. They were now attracted to the more promising surrealist movement and brought with them visual images that could not be ignored. Naville was ousted and Breton took sole charge. In 1928 he set the record straight by publishing a book called *Surrealism and Painting*. The artists were there to stay.

These artists gave Breton two huge advantages. They could stage big exhibitions that turned into major surrealist events; and they could be understood in any language. The visual arts of surrealism were spectacular and they were international. As time passed, the tail started wagging the dog. In the public mind, surrealism became purely an art movement and its literary beginnings were largely forgotten. Its star performers became famous around the globe.

This explains how it is possible for artists as different as Magritte and Miró to be lumped together under the surrealist banner. They were not obeying a fixed visual code, like the impressionists or the cubists. Instead, they were obeying the basic rule of surrealist philosophy – work from the unconscious, do not analyse, do not plan, do not apply reason, do not strive for balance or beauty. Instead, let your darkest, most irrational thoughts well up from your unconscious mind and inhabit your canvases. Let your pictures paint themselves as you watch. In this way, it was argued, surrealist works would be more valid than any of the old-fashioned art forms, where images were either copied slavishly from the external world or carefully worked out as logically organized, fictional scenes. By tapping the deeper recesses of the mind, the surrealist works should speak directly to the viewer with a much stronger voice because, of course, at those depths we all share the same hopes and fears, the same hatreds, loves and longings.

How each of the surrealist artists approached this technique varied considerably, hence the wide range of visual styles we see. Magritte had a wild, irrational idea and then settled down to transmit this idea to canvas using a highly traditional technique. His ideas were pure surrealism but his technique in rendering them visible was deliberately, boringly conventional. It is this contrast between the imaginative lunacy of his imagery and the almost pedestrian application of the paint that makes his paintings so

An oddity of this book is that it makes little attempt to analyse or discuss in detail the actual paintings or sculptures made by the surrealists. I will leave that to the critics and art historians. I held my first solo exhibition of surrealist paintings in 1948 and ever since then I have been fending off questions about what my paintings mean. I doubt if there has ever been a surrealist who enjoyed answering such a question. Some respond rudely, some waffle vaguely and others make up answers they think will please their questioners. It should be obvious that, if a surrealist artist is painting images dredged up directly from the unconscious, he or she cannot possibly know, in rational, explanatory, or analytical terms, what is going on. If they do, then their work is not surrealist; it is fantasy art, telling an exotic story that has been carefully scripted beforehand. Superficially, the work of some fantasy artists does look rather similar to the work of true surrealists, but in truth they are as close to surrealism as Disney is to Hieronymus Bosch. In this book I have concentrated on the surrealists as people – as remarkable individuals. What were their personalities, their predilections, their character strengths and character weaknesses? Did they enjoy a social life or were they loners? Were they bold eccentrics or timid recluses? Were they sexually normal or erotically perverse? Were they self-taught or professionally trained?

One of the problems that André Breton faced when trying to organize his little band of rebels was that they so often resisted his call for collective action. It is in the nature of rebels to be eccentric and individualistic. As artists they do not want their paintings to look like those of others in their group, for fear of being considered derivative. So poor Breton had an impossible task and it is no wonder that most of the important surrealist artists either eventually rejected him, or were themselves expelled by him. This has led some people to think of Breton as a foolish tinpot dictator trying to control a bunch of misfits. But this grossly underestimates his importance. He was the driving force of the movement and was badly needed to give it a shape and a history.

In one sense, surrealism has failed. It did not change the world. In another, it has succeeded beyond its wildest dreams, because its works of art are now being enjoyed by millions, all over the world. Ignoring those who want them explained and analysed, there are many more who stand in front of them and allow the images to pass directly from the unconscious minds of the artists into their own minds. In permitting this intuitive, instinctive

process to take place, the viewers of these works are honouring the deeply held convictions of those who created them.

One of the early surrealists, the Spanish film-maker Luis Buñuel, summed it up well in his memoirs when he said, of his time with the surrealists in Paris: 'we were nothing, just a small group of insolent intellectuals who argued interminably in cafés and published a journal; a handful of idealists easily divided where action was concerned. And yet my three-year sojourn in the exalted – and yes, chaotic – ranks of the movement changed my life.' This was true of everyone who was involved with the surrealist movement. No matter how brief their involvement, it left a mark on them. It was the same for me, even though I only caught the tail-end of the movement in the 1940s. Despite all the pompous rules and regulations, so extreme that they were impossible to obey even by those who formulated them, the impact of the surrealist philosophy left a lasting impression on all of us who fell under its spell.

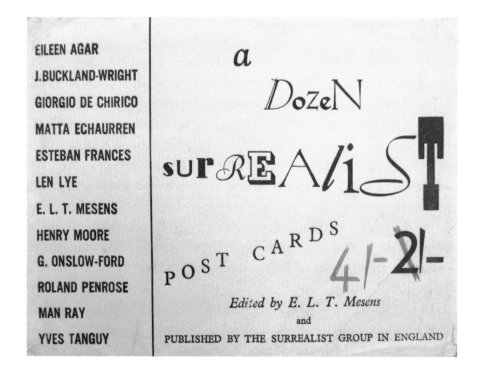

Front cover of *A Dozen Surrealist Postcards*, 1940.

THE LONDON GALLERIES
23 BROOK STREET LONDON, W.1

E.L.T. MESENS PRESENTS

ROOM A

JOAN

MIRÓ

BOOKSHOP GALLERY

DESMOND

MORRIS

FIRST ONE-MAN EXHIBITION

ROOM C

CYRIL

HAMERSMA

FIRST ONE-MAN EXHIBITION

2 FEBRUARY — 28 FEBRUARY 1950

ADMISSION FREE

DAILY 10 a.m.—6 p.m. SATURDAYS 10 a.m.—1 p.m.

Poster for Joan Miró, Desmond Morris and Cyril Hamersma exhibition at E. L. T. Mesens'
London Gallery, February 1950.

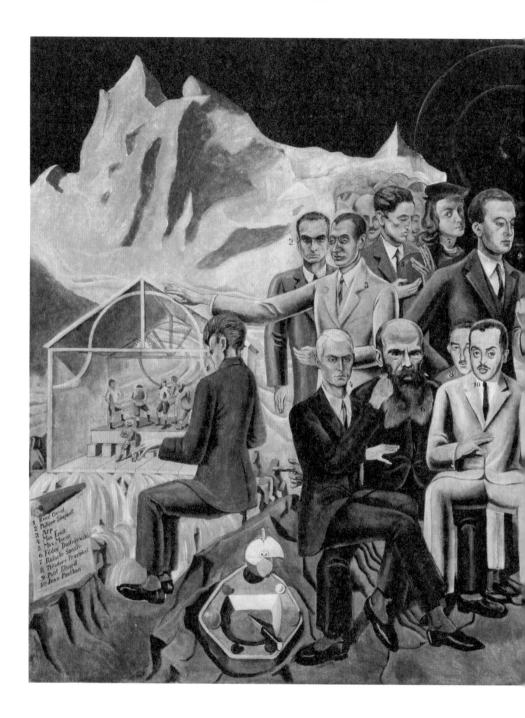

Max Ernst, *Rendezvous of Friends*, 1922–23.

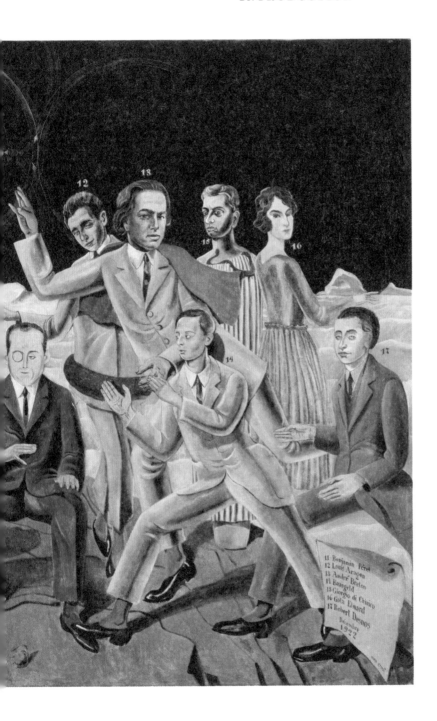

11 Benjamin Péret
12 Louis Aragon
13 André Breton
14 Boangeld
15 Giorgio di Chirico
16 Gala Eluard
17 Robert Desnos
Décembre
1922

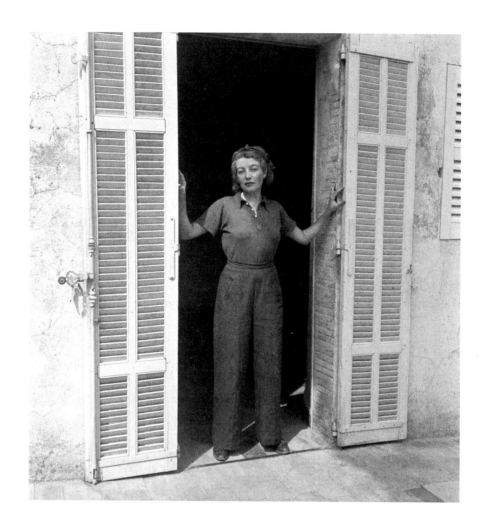

Eileen Agar at the Hotel Vaste Horizon, Mougins, September 1937. Photographer unknown.

EILEEN AGAR

ENGLISH • Joined the surrealist group in 1933

BORN: 1 December 1899 in Buenos Aires, as Eileen Forrester Agar

PARENTS: Father Scottish businessman (windmills); mother American/English

LIVED: Buenos Aires 1899; London 1911; Paris 1927; London 1930

PARTNERS: Married fellow art student ROBIN BARTLETT 1925–29

• Hungarian author JOSEPH BARD 1926 • PAUL NASH 1935–44

• PAUL ELUARD 1937 • Married JOSEPH BARD 1940–75

DIED: 17 November 1991 in London

I FIRST MET EILEEN AGAR when she was ninety years old and even then she retained the beauty and the charm that must have enchanted the surrealists she had known when she was young. Her figure was still slim, her posture upright and her face mischievous. She gave off an aura of imaginative playfulness that is rare in the very old. She would probably have put this down to the fact that she never wanted any children and never had any. As a teenager she had read about a possible human population explosion and remembers the huge relief she felt at having found a justification for not wanting to breed.

Although there was nothing especially erotic about her paintings, in life she seems to have been more sexually adventurous than most women of her generation. According to her husband she was always 'trying to do something in a way that cannot be done, such as making love standing up in a hammock'. And she was not averse, it seems, to being involved with three separate lovers at the same time. She was a hedonist, but in a cheerfully childlike way. She once remarked gleefully that she slept in Picasso's bed, but not when he was in it – setting up a wicked thought only to demolish it. A wicked innocence is a contradictory idea, but it somehow fits Agar's appealing personality and also her work as an artist.

She was born in Argentina of an Anglo-American mother and a Scottish father who was selling windmills to the local population. The family was wealthy and sociable, so that their children usually only saw their parents

briefly, once a day, to say goodnight. The rest of the time they spent with devoted servants. When Eileen was nine, her parents decided to go off on a nine-month-long trip around the world, leaving their children behind. She admitted to having a temper and to rule-breaking that, on one occasion, led to her being struck with a hairbrush by her mother – a punishment that made her very angry and which she still remembered vividly eight decades later. A young rebel was being formed. She was happiest when playing out of doors, reacting strongly to the colours and shapes of the Argentine landscape. Even as an old lady she could still see, in her mind's eye, such details as the glinting bridles of the black horses that drew her green carriage.

When she was ten the family left Argentina and her father retired to England. On the journey, they were accompanied by a cow and an orchestra to provide them with fresh milk and music. In London they lived in a large mansion in Belgrave Square, complete with a ballroom; a house that has since become a foreign embassy. Her mother became a society hostess with lavish parties, a butler, housemaids, footmen and a chauffeur-driven Rolls Royce. The family spent the autumns at their country retreat in Scotland.

The relaxed splendour of Agar's childhood, during which time she had, when at boarding school, become passionate about drawing, came to a sudden, jarring halt with the outbreak of World War I. The Rolls was given to the Red Cross and Eileen's eccentric mother sent a telegram to her boarding school forbidding them to teach her German. After the war the Agar family resumed their lavish lifestyle at a new house in Mayfair, where Eileen recalled playing musical chairs with ex-Prime Minister Herbert Asquith – she was told she had to let him win. When a fashionable London magazine wanted to feature her, her mother refused on the grounds that the footmen might use her photographs as pin-ups. Her home life was full of formalities; even when there were no guests, she had to appear in evening dress for dinner.

The next problem was to find an acceptable suitor for Eileen, who was expected to marry well and raise children. She rebelled, saying that she did not want to rear a brood that would be slaughtered in the next war, but her objection failed to stop her mother's match-making. One suitor was an English lord and another was the Russian prince who had executed Rasputin. A third was a Belgian prince, who was refused by Eileen on the grounds that she disliked Brussels sprouts. Then there was a daring pilot officer who took her up in his plane and allowed her to take the controls so that she could loop the

loop herself. However, all offers of a husband were rejected. Art had become increasingly important to Agar and she now saw it as her future way of life. Her mother, instead, saw it as an elegant pastime and enlisted the help of a friend of Auguste Rodin's (1840–1917) to teach her watercolour painting. When an acquaintance of Pierre-Auguste Renoir's (1841–1919) said that Eileen should take art more seriously and attend art school, her mother was outraged but lost the struggle and, in 1920, Eileen started attending art classes in London. That autumn, her mother managed to disrupt this by whisking the family away to Argentina, where she organized a lavish all-night ball for 600 people in Buenos Aires to celebrate Eileen's twenty-first birthday. When the family returned to London she was, at last, allowed to attend the Slade School of Fine Art, but only if she was ferried there and back each day in the family Rolls. To avoid embarrassment, she arranged with the chauffeur to drop her off and collect her around the corner.

While she was studying at the Slade, she determinedly lost her virginity in a bed of leaves in a glade on the Isle of Wight. Shortly after this, during a family row, her mother hit her and, at the age of twenty-one, Eileen had packed her bags and left home for good. She found a small studio in Chelsea and began painting seriously. She married her young lover Robin Bartlett in 1925 and they moved to a small mud-floored cottage in rural France. She soon tired of him, however, and left him for the man who would become the love of her life, a handsome Hungarian writer called Joseph Bard. She and Bard moved to Italy and later to Paris where, in the late 1920s, she met the avant-garde artists and poets and revelled in her rebellious freedom. She visited Constantin Brancusi's (1876–1957) studio and encountered André Breton at the very peak of the surrealist revolution. Her father had died and left her a generous annual allowance, so that she never had to face the prospect of working for a living. This meant that she could satisfy every intellectual whim and spend time with many of the major figures of the day, including Evelyn Waugh, Ezra Pound, Cecil Beaton, Aldous Huxley, W. B. Yeats, Osbert Sitwell, Ernest Hemingway and F. Scott Fitzgerald.

Back in London she received encouragement as an artist from Henry Moore and they became close friends, though he never forgot that she beat him at tennis. He introduced her to Jacob Epstein (1880–1959) and the American Alexander Calder. The poets Dylan Thomas and David Gascoyne also entered the scene at this time, in the early 1930s. In 1935, while passing

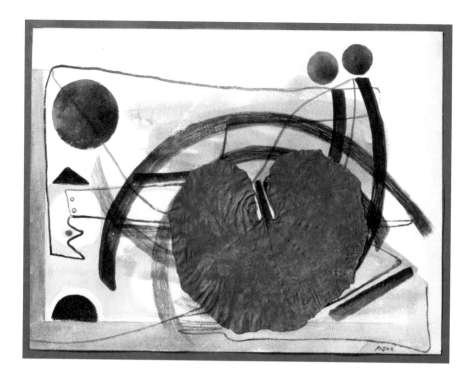

the summer on the south coast of England, Eileen met the artist Paul Nash (1889–1946) and his wife Margaret Odeh. Nash excited her and encouraged her to search for strange objects on the beach and elsewhere that could be modified to make surrealist objects. Eileen and Nash fell in love and after a while became lovers, causing much heartache for their still actively involved partners. Eventually Eileen decided to end the relationship, but neither she nor Nash could bear to lose the excitement they felt when they were together and they took to arranging secret meetings to avoid causing more distress. Having two lovers at the same time was something that Eileen could not resist, although she admitted it involved considerable pain.

Early in 1936 Roland Penrose and David Gascoyne decided to arrange a major exhibition in London to introduce surrealism to the British public. Paul Nash was on the organizing committee, along with Henry Moore and others. Both Nash and Moore knew about the strangely powerful paintings that Agar had been producing since her time in Paris and she was visited in

Eileen Agar, *The Reaper*, 1938. Gouache and leaf on paper.

her studio by Penrose and Herbert Read, who selected three of her oils and five of her surrealist objects for the show. At first she was startled to find that she was now an official member of the surrealist movement. She had always fought to be a free spirit working on her own, but now she found herself co-opted into a fervently rebellious group. After she had experienced the intense excitement of the opening night of the exhibition, she commented 'I was proud to be among them'. A thousand visitors a day poured into the exhibition and Agar's work was more widely studied than ever before. She was fascinated by her new surrealist friends. She found Max Ernst bird-like, Paul Eluard romantically classic-looking, André Breton leonine, Yves Tanguy bizarre, nervous and excitable, Salvador Dalí conspicuous and with an explosive temper, and Joan Miró childlike and poetic. She made the interesting point that the surrealist women were all elegantly, quietly dressed in complete contrast with the female bohemian artists, who showed off in deliberately scruffy, paint-splattered clothes.

The following year Agar found her love-life becoming even more compli-cated. She and other surrealists were staying with Roland Penrose in Cornwall. Roland, as she put it, was always 'ready to turn the slightest encounter into an orgy'. The atmosphere was sexually loaded and she quickly succumbed to the charms of the French surrealist poet Paul Eluard. She described him as a living Eros and was soon in his arms and in his bed, despite the presence of his second wife Nusch, an ex-circus performer. Eileen's other lovers, Joseph Bard and Paul Nash, were also on hand. Nash became insanely jealous of Eluard, but Bard minded less because it so happened he was having a fling with Eluard's wife Nusch. Around this time there were other troubles because Lee Miller, now coupled with Roland Penrose, was told by mischief-maker Edouard Mesens that Eileen had sexual designs on Roland. Lee's forthright reaction was to throw a glass of water over Eileen, before she discovered that the story was untrue. These were the complexities and intricacies of the relations within the surrealist group that Eileen Agar had now joined and, far from being upset by it all, she took to it with a twinkle in her eye and a joyous sense of release from the formal restrictions of her earlier family existence. Surrealism gave her a rich emotional life as well as one full of intellectual argument and debate.

The house party in Cornwall developed a step further when most of the participants moved on to the south of France to join up with Man Ray, Pablo

Picasso and Dora Maar. It is rumoured that, during this gathering, Eileen and Picasso had a brief sexual encounter, but she herself never admitted to this. Despite the social pleasures of the late 1930s, war was on the horizon. In an oddly prophetic gesture at table one day, Picasso pulled the cork out of a bottle, handed it to Eileen and told her to put it between her teeth to stop them chattering when the bombs started falling. And fall they did. The war had begun in earnest when, in London, following a night of heavy bombing, Eileen and her greatest love, Joseph Bard, were surprised to find themselves still alive. Eileen decided that, under these terrible new circumstances, they should get married and they did so without delay. Henry Moore, still a friend, was one of the guests at a party to celebrate their marriage in 1940.

Agar found it hard to concentrate on painting while the war was raging around her. Instead she poured herself into war-work. When the conflict was over she returned to painting, 'as if I were renewing a belief in life itself'. For the next thirty years she lived happily with Joseph Bard and her wild days were over. She worked hard on her paintings and her surrealist constructions, exhibited frequently and successfully, and travelled abroad with the man she described as 'the warmth of my life'. When he died in 1975, she faced the last sixteen years of her long life alone with her memories and, in 1988, nearing her ninetieth year, she recorded them for posterity in her autobiography *A Look at my Life*. And she never stopped working in her studio.

Eileen Agar described her work as a blend of abstraction and surrealism, rather than pure surrealism, but the words she used to sum up her life suggest that she was more of a surrealist than she liked to admit: 'I have spent my life in revolt against convention, trying to bring colour and light and a sense of the mysterious to daily existence.'

JEAN (HANS) ARP

GERMAN/FRENCH • A pioneer figure in the surrealist movement

BORN: 16 September 1886 in Strasbourg

PARENTS: Father German; mother French

LIVED: Strasbourg 1886; Paris 1904; Weimar 1905; Paris 1908; Berlin 1913; Switzerland 1915; Cologne 1919; Paris 1920; Grasse 1940; Zürich 1942; Paris 1946

NATIONALITY: Became a French National in 1926

PARTNERS: Baroness Hilla von Rebay 1915 • Married Sophie Taeuber-Arp 1922–43 • Married Marguerite Hagenbach 1959–66

DIED: 7 June 1966 in Basel, Switzerland

Arp was one of the key figures in the early days of the surrealist movement. His nationality was complicated. He was born in Strasbourg, Alsace, on the border between Germany and France, a city whose complex history saw it switching back and forth between German, French and Alsatian. As a child he had two names and spoke three languages. His German name was Hans Peter Wilhelm Arp and his French name was Jean-Pierre Guillaume Arp. He spoke French with his mother, German with his father and Alsatian in daily life. His father ran a cigar factory, his mother was musical, and the family was wealthy, with a country house in the nearby mountains.

When he was six, the young Arp fell ill and during his convalescence passed the time making drawings. At eight he was sketching in the local forests and at school was more interested in drawing than in his lessons, to such an extent that he was physically punished by his teachers. His father was forced to employ a private tutor for him, but Arp was only interested in literature, poetry, drawing and painting and was a poor scholar at everything else. As a teenager he spent most of his time in the studios of local artists and at the age of eighteen made his first trip to Paris and fell in love with the city. With his German bias, his father refused to let him move there and he was enrolled instead as an art student in Germany at the Academy of Arts

Jean (Hans) Arp in project headquarters of the Aubette, Strasbourg, 1926.

in Weimar. It was there that he first encountered modern art in the form of the post-impressionists.

In 1907, when Arp was twenty-one, his family moved to Switzerland. He made trips to Paris, where he discovered the cubists and abstract art. At his new home he started experimenting in his work and, in 1911, was pivotal in organizing an exhibition in Lucerne that included works by himself, Pablo Picasso, Paul Klee, Henri Matisse and Paul Gauguin, among others. It was not well received and one visitor to the show spat tobacco juice at one of Arp's drawings. The following year he was a driving force behind another exhibition, this time in Zürich, where Wassily Kandinsky, Franz Marc and Robert Delaunay were added to the list of artists. Although still in his twenties, Arp was fast becoming a pioneer of modern art. In 1913 the family moved to Zürich and Arp himself went to Berlin to organize more exhibitions. He met Max Ernst at a show in Cologne. When war broke out he managed to get a seat on one of the last trains to run from Germany to Paris. The French thought he was a German spy and he had to flee again, this time to Switzerland. To avoid being drafted, Arp pretended to be mad.

In Zürich, in 1915, Arp met his future wife, the abstract artist Sophie Taeuber (1889–1943). He also enjoyed a love affair with the Baroness Hilla von Rebay, who would later become the first director of the Guggenheim Museum in New York. In 1916 Arp provided the decorations for the Cabaret Voltaire that would soon become the centre for the birth of the Dada movement – a cry of ribald rage against the European establishment, an establishment that seemed to be so keen on mass slaughter and destruction. It was at this point that Arp introduced the idea of employing elements of chance in his work through the use of collage and, later, by having some of it done by others. In this he was anticipating elements of the doctrine put forward by André Breton in his First Surrealist Manifesto in 1924. The first Dada exhibition took place in Zürich in 1917 and Arp was actively involved. In his work he was now replacing his earlier, rather abstract compositions with what he called 'fluid ovals' – biomorphic shapes often presented as reliefs. Always ahead of his time, he had become a full-blown surrealist artist seven years before the surrealist movement officially began.

When the war ended Arp contacted Kurt Schwitters (1887–1948) and the Berlin Dada group, and was himself at the heart of the Cologne group, together with Max Ernst. With the freedoms of peacetime, however, the Dadaists were

beginning to disperse and the movement was starting to lose its impetus. In 1922, the end of Dada was in sight and in September that year Tristan Tzara formally delivered its funeral oration. The following month Arp and Sophie Taeuber were married and a new phase was about to begin.

Having moved to Paris, Arp would join up with the surviving members of the now defunct Dada group, including André Breton. In 1924, Breton and his circle replaced the negativity and deliberate absurdity of the Dada movement with a new concept based on the exploration of irrationality and the unconscious – surrealism. They welcomed Arp's work, but he himself still felt that he was a Dadaist at heart and did not take kindly to the political posturing of the early surrealists. In 1926 Arp became a French citizen and settled outside Paris. He continued to exhibit with the surrealists, but kept his distance from their declarations and their theorizing. He was still allowing chance to play a role in his relief compositions, but a visit to Constantin Brancusi's studio in 1929 converted him to working in the round and he began sculptural work that would later develop into his major contribution. His shapes were always strongly biomorphic and often based on the human torso, but in a highly abstracted form.

At the beginning of the 1930s Arp became a founding member of a new art movement called Abstraction-Création. Curiously, this was set up in opposition to the surrealist movement. Its intention was to bring together abstract artists and organize exhibitions that would rival the activities of Breton's surrealists. Arp's decision to join this group was at loggerheads with the fact that he was still actively involved with the surrealists in Paris. His own work, best described as abstract biomorphism, fitted well into either group, and he did indeed exhibit with both groups at the same time. Why did he take on this double life? Perhaps he was slightly piqued by the fact that the Dadaist movement he had pioneered from 1917 onwards had been taken over by the domineering figure of a Johnny-come-lately, namely the autocratic André Breton. Or perhaps he was ill-at-ease with the socio-political outpourings of the surrealists. Perhaps both. Whatever the reason, he soon tired of the infighting within the Abstract-Création group and officially left it in 1934.

In 1939, when war broke out again, as a protest, Arp stopped signing his work Hans Arp and switched to Jean Arp. He and Sophie moved to the South of France, in the unoccupied zone where they could continue to work in their studio. In 1942 they travelled to Switzerland in the hope of gaining

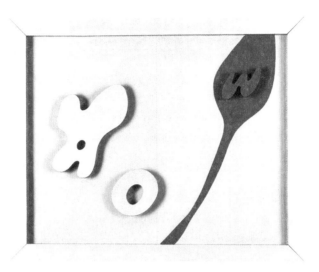

visas to the United States, but tragedy struck the following year when Arp found his wife dead one morning, asphyxiated by the fumes from a gas stove. His bereavement brought his sculptural work to a halt for four years and he became obsessed with Sophie's memory. He spent some time in a state of solitude in a Dominican monastery and also consulted the psychiatrist Carl Jung about his grief. His moods became darker, his health frail, and he began to take an interest in mysticism.

In 1949 he visited New York for the first time and met up with many old friends there. Two years later he started suffering from heart problems but, despite this, was working hard in his studio, his creativity undiminished. 1954 was a good year for Arp, when he, Max Ernst and Joan Miró – who, as young artists had all been friends and close neighbours in Montmartre – were all awarded prizes at the Venice Biennale. In 1959 he married Marguerite Hagenbach, who had been his constant companion for some years.

Arp's work was now in such demand that he had to employ assistants in his studio to increase his output. Honours were heaped upon him and his final years were full, busy and rewarding. He died of a heart attack in Basel in 1966. Max Ernst said of him that he taught us to understand the language of the universe.

Jean (Hans) Arp, *Torso, Navel, Mustache-Flower*, 1930. Oil on wood relief.

FRANCIS BACON

ENGLISH · Considered himself a surrealist and wished to
join the London group but was rejected by them in 1935–36
BORN: 28 October 1909 in Dublin
PARENTS: Father an English racehorse trainer; mother a socialite and heiress
LIVED: Dublin 1909; rented homes in England (childhood); Ireland 1918; Gloucester 1924;
Ireland 1926; London 1926; Berlin & Paris 1927; London 1928; Monte Carlo 1946; London 1948
PARTNERS: ERIC HALL 1929–50 · GEORGE DYER 1964–71 (died of an overdose)
· JOHN EDWARDS 1974–92
DIED: 28 April 1992 in Madrid, of a heart attack

I ONCE MADE FRANCIS BACON LAUGH when I told him that he was the only artist whose work had made me physically sick. I hastened to explain that it was not the content of his paintings that disturbed me, but their weight. One night, at a drunken party, my host, who had bought a number of Bacon's screaming Popes, asked me to re-arrange them, in order of increasing disintegration. In some, the Pope was more realistically depicted; in others, the pontiff was unravelling, as if his scream was tearing him physically to pieces. It was my job to shift the pictures around so that the disintegration process increased from left to right. The pictures were massive – taller than me – and had been encased in heavy gold frames and covered in glass to protect their unvarnished surfaces. This made them immensely heavy – almost unmovable – but my drunken, youthful bravado spurred me on and I was soon heaving and shoving them this way and that until, at last, they were displayed in the desired sequence. That was the moment when I realised that my exertions had brought on a state of acute nausea and I had to make a frantic dash for the nearest bathroom.

That was in the 1940s, when Bacon was virtually unknown, and my friend was the only person who collected him on a large scale. When I got to know Francis in the 1960s, he was now famous but, to my surprise, was very modest about his work. He wanted my assurance that the figure of a

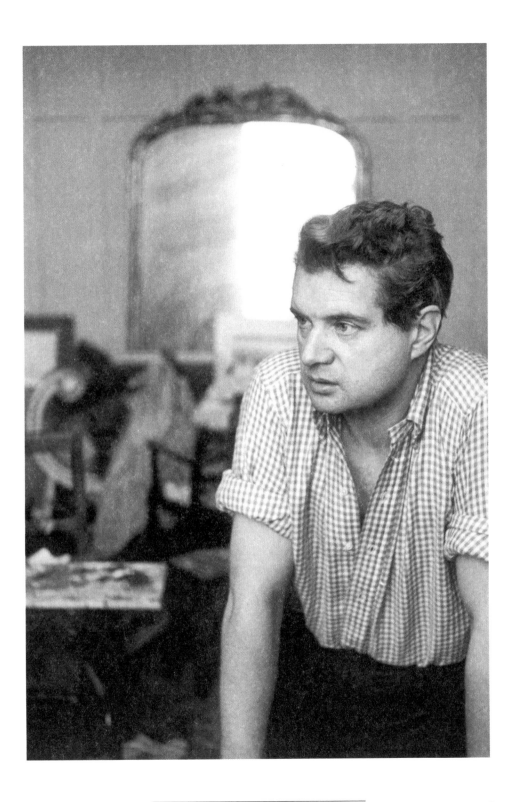

Francis Bacon, 1952. Photo by Henri Cartier-Bresson.

screaming baboon that he had painted was convincing. I assured him that it was, but this was a white lie. I had been told that Francis often copied photographs rather than studying the real thing and, in this instance, I knew the particular photograph from which he had taken the baboon image. It was not of a screaming baboon but of one that was yawning widely. I did not dare tell him this because he was notorious for taking a Stanley knife to any canvas that dissatisfied him, and his baboon may well have suffered this fate if I had told him the truth. He is known to have slashed to pieces over one hundred of his paintings and I did not wish to be responsible for yet another one suffering this fate. Instead, I changed the subject to other facial expressions and he amused me by saying, 'I think I've got the scream, but I am having terrible trouble with the smile'.

It may seem strange to include Francis Bacon in a volume on the surrealists, but I have done so for the simple reason that he considered himself to be a surrealist and wanted to be a member of the British Surrealist Group and be included in their great 1936 exhibition. Herbert Read and Roland Penrose visited his studio in London to decide whether to include him or not, but when they saw his work they were dismayed by what they thought were religious elements in it. On this ground they rejected him, to his great disappointment. His rejection was based on a misunderstanding; there was nothing faintly religious about his art. His interest in crucifixions was based not on Christian iconography, but on his own, private sexual fantasies. For Francis was deeply involved in sado-masochistic practices and the crucified figures were in reality self-portraits. His early life helps to explain this.

Francis's father was a racehorse trainer at the Curragh in County Kildare in Ireland and Francis was a great disappointment to him. Living in an intensely masculine world, Bacon senior was horrified to discover that his son was less than manly. His reaction to this discovery rebounded on him in a spectacular fashion. His first mistake was to have the young Francis whipped by his stable grooms for being effeminate. To his dismay, Francis loved this and even had sex with his tormentors. His second mistake was to send Francis away to boarding school. There, Francis had an affair with another boy and was promptly expelled. His father's third mistake was to throw Francis out of the house for trying on his mother's underwear. Francis immediately departed for the homosexual underworld of London. When he discovered what his son was up to, his father made his fourth mistake,

sending him packing again, this time to Berlin, little knowing that this was the sexual capital of pre-war Europe, where anything went. Francis was in his element. His father had lost every round in their family feud and the young man was now at last free to do as he wished.

From Berlin he moved to Paris, where he enjoyed the company of artists and started to paint. His first major influence was Pablo Picasso, whose work he saw in 1928. After a while he returned to London, where he continued to paint, and earned his keep by acting as a homosexual male prostitute, advertising his services discreetly in the columns of the august *Times* newspaper as a 'gentleman's companion'. During the London blitz, he volunteered to help in the grisly task of pulling mangled bodies from bombed buildings as the bombing took an increasingly heavy toll. This experience gave him unforgettable visual images of tormented flesh that he would later incorporate into his paintings. When the war ended, his serious work as an artist was soon to begin, although it never eclipsed his sexual excesses.

Francis's sexual preferences were always dangerous. He was exclusively homosexual at a time when it was totally illegal. And he was a devoted masochist who constantly risked serious injury. Unlike the modern gay community, he took no pride in it, saying bluntly 'being homosexual is a defect ... like having a limp'. Instead of bewailing the fact that the law was driving homosexuality underground, he relished the fact. He strongly opposed the idea of making it legal because it would take away some of the spice of engaging in it. When it was finally legalized in 1967, he voiced his disapproval, insisting that it was 'so much more interesting when it was illegal'. Bacon enjoyed being beaten and was said to have had an astonishing ability to withstand physical pain. He told the American poet Allen Ginsberg that he once obtained gambling money by allowing himself to be whipped, with a bonus for every stroke that drew blood. Deliberately selecting brutal partners, he was often injured, but this never weakened his lifelong quest for erotic extremes. Even as an elderly man in his eighties he was successfully seeking new young lovers.

With this background knowledge of Bacon's private life, it is easier to understand the tortured images in his paintings. But it does not explain their greatness. It is easy to imagine a homosexual masochist producing embarrassingly lurid images with no artistic merit whatever. With Bacon it is the restraint and the ambiguity of his images that makes them so powerful and

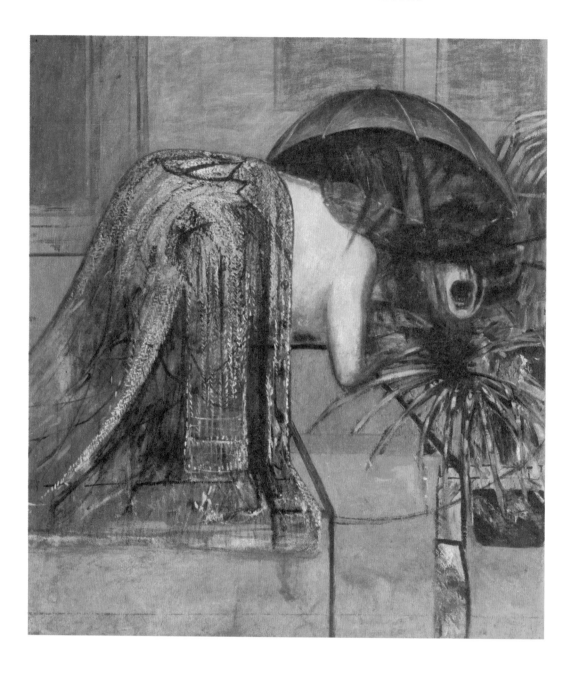

Francis Bacon, *Figure Study II*, 1945–46.

so haunting. One of his favourite motifs is of a solitary figure, apparently unable to move, and trapped inside a kind of box-like structure. The origin of this obsession can be found in an acute trauma from his own childhood. As he told the story, when his hated parents were away, he was left in the care of an Irish servant who enjoyed sexual visits from her boyfriend. Francis was jealous of this male visitor and repeatedly interrupted the couple's love-making. The woman's solution was to lock the little boy in a dark cupboard at the top of the stairs, where he would scream and scream until the love-making was over and he would be let out again.

Only six of Bacon's oil paintings survived from his pre-war days. It has been claimed that he destroyed around 700 early works, forever dissatisfied with his achievements. All his life he was savagely dismissive of his work, despite the praise it was receiving worldwide. When asked about his magnificent Pope paintings he replied, 'I regret them because they are very silly'. When he spent two months in Rome he refused to visit the great portrait of Pope Innocent X by Diego Velázquez (1599–1660) that was on permanent exhibition there, because viewing it would only start him 'thinking of the stupid things one had done to it'. It is tempting to regard these comments as an affectation, designed to provoke a strong contradiction, but although he did not always tell the truth about his work (sometimes producing a thoughtful answer to satisfy an intelligent interviewer), in this case his remarks seem genuine enough. He was never satisfied with what he had painted and sometimes a brilliant image was overworked and overworked until it was completely ruined and then discarded. His London gallery adopted the emergency strategy of arriving unexpectedly at his studio, grabbing any paintings that looked finished and removing them for safe keeping, before he could ruin them. So the biggest surprise, in talking to Francis, was to discover how gentle his manner was. It simply didn't match the powerful, brutal imagery of his paintings. It was as though all his agony and his intense emotional turmoil went onto his canvases, so that after the act of painting he was left drained and effete.

How does this knowledge of Bacon's private life help us to understand his paintings? One thought that comes immediately to mind is that a great deal of what has been written about his work has missed the point. Critics have spoken grandly of Bacon's depiction of the spiritual isolation of modern man and described his paintings as 'profound reflections on the century's trauma', but the truth is that they are almost totally personal and sexual in meaning.

The 'boxes' in which he depicts many of his human figures are not symbols of either 'spiritual isolation' or 'cultural trauma' – they are symbols of the confinements of sexual slavery and bondage. The twisted, blood-spattered male bodies that populate his huge canvases in silent, frozen torment are not symbolic of modern man's social dilemma, but fantasies of himself (or his sexual companions) in erotic anticipation or sexual extremis.

Outside his studio, Bacon's other obsessions, his boozing, gossiping and gambling, played little or no part in his art. The only possible connection is that he took great risks in his gambling and great risks in his imagery. Nor is his sharp sense of humour to be found in his typically tense and sombre canvases. None of his painted figures share the twinkle in the eye, the ready smile or the joyous laughter for which he was renowned in his social circle. In his art he 'made heavy' of everything. In life, by contrast, he made light of everything. When, in his later years, as an elderly, world-famous artist, he was offered various honours, including a knighthood, he even laughed at those, refusing them 'because they're so ageing!' It is doubtful if anyone other than Francis would have come up with such a delightful reason for declining such accolades.

To sum up, Francis Bacon was a creative genius who also, at times, was a thief, a homosexual prostitute, a compulsive gambler, a drunkard and a liar. He repeatedly broke the law by organizing illegal gambling sessions. He was mischievous, sarcastic, vain, abusive, arrogant, disloyal and unreliable. Even his published statements, on his own admission, are unreliable – 'I often say anything, you know, to pass the time'. And if he disliked something, he pretended it simply didn't exist. He polished his teeth with Vim, coloured his hair with brown boot polish, had beady eyes and a slack mouth, and lived in cramped squalor even when he became rich. When people gave him flowers on his birthday, he pointed out that he was not 'the sort of person who has vases'. He loathed nature, the countryside, and all forms of convention and authority. He despised all forms of religion, and when someone mentioned the soul to him, he replied 'Ah! Soul!' Then, as if having contemplated the subject deeply, repeated his comment with a slightly different emphasis: 'Arsehole!' As for death, he said: 'When I'm dead, put me in a plastic bag and throw me in the gutter.' He was an asthmatic with an especially strong allergy to horses and dogs. He exploited this fact when he received his call-up papers to serve in World War II by hiring an Alsatian dog from Harrods and

sleeping next to it all night. The close proximity of the dog gave him such a violent asthma attack that, when he reported for his medical the next day, he was immediately excused military duty.

He was often vicious in his criticism of other artists, once comparing Picasso with Walt Disney, and saying that Jackson Pollock's (1912–1956) paintings looked like 'old lace' and were, to him, completely meaningless. He railed against the decorative vacuity of abstract art and the 'inanities of academic art'. Although there were many flaws in Bacon's character, he was also, it must be said, a great conversationalist, with a caustic wit and a wanton generosity towards those he liked. He radiated charisma when he entered a room and was endowed with great charm whenever he wished to exercise it. As with many shy people, when he did manage to shake off his natural timidity, he over-compensated wildly and became an expansively entertaining social companion, with an exuberant, vivacious sense of fun.

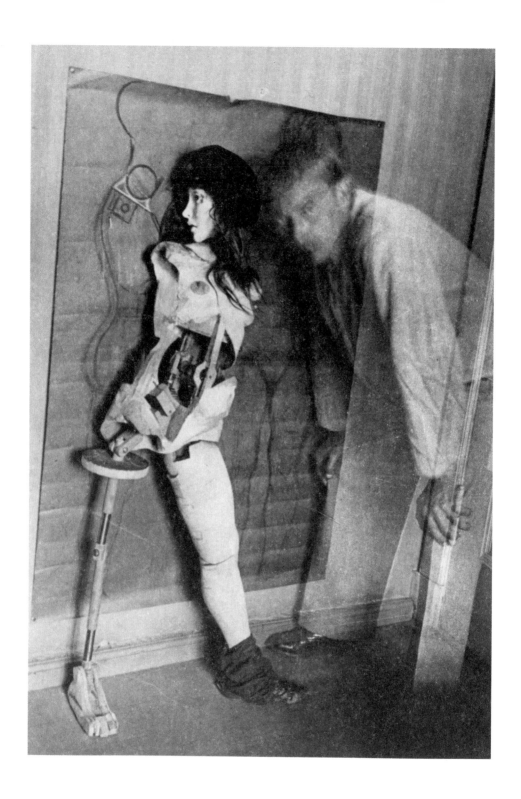

Hans Bellmer, *Untitled (Self-Portrait with Doll)*, 1934.

HANS BELLMER

GERMAN/POLISH · Welcomed by the Paris surrealists in the 1930s

BORN: 13 March 1902 in (German) Kattowitz, now (Polish) Katowice

PARENTS: Hated bourgeois Nazi father who was severe and humourless

LIVED: Kattowitz 1902; Berlin 1923; Paris 1938; prison camp 1939–40;

Southern France 1941; Paris 1949

PARTNERS: Married MARGARETE SCHNELL 1928–38 (died) · ELISE CADREANO 1938 ·

JOYCE REEVES 1939 · Married MARCELLE SUTTER 1942–47 (divorced); two children ·

NORA MITRANI 1946–49 · UNICA ZÜRN 1954–70

DIED: 23 February 1975, of bladder cancer

THE CONTROVERSIAL ARTIST HANS BELLMER holds the record for creating some of the most disturbing images in the history of the surrealist movement. In his work, he seems to have been obsessed with violating the female body in as many ways as possible, using the excuse that he was trying 'to help people lose their complexes, to come to terms with their instincts'. The assumption he is making here is that people, in general, must harbour a deep-seated need to mutilate and sexually abuse the human female. This may indeed be the need of a few isolated psychopaths, but for him to attempt to extend this concept to cover the whole human population, is laughable.

Surprisingly, several authors and critics have swallowed his excuse and have tried to twist the meaning of his work so that, by some cunning leap of the imagination, his brutalized female victims are supposedly there to remind us of the true beauty of the female form. It is true that, technically speaking, he was a master of design and many of his worst sexual excesses are immaculately depicted. It is only his skilful draughtsmanship and his imaginative transformations and distortions that prevent his work from becoming cheap pornography.

There is a phrase in the First Surrealist Manifesto that defines surrealism as: 'Thought dictated in the absence of all ... moral preoccupations'. Clearly, this meant that the surrealists were in no position to criticize or attempt to

censor Bellmer, whether his sadistic images appealed to them or not. He was welcomed into the surrealist fold and participated in all the major surrealist exhibitions from 1935 onwards.

Bellmer was born in an East German town that is now part of Poland. As a teenager he worked in a steel mill and a coal mine and became a labour activist. At the age of twenty he held his first exhibition, for which he was arrested by the police, accused of undermining morality. He escaped by bribing an official and, the following year, his father took him off to Berlin to start studying for a degree in engineering. He hated his tyrannical, moralizing father and did his best to embarrass him. When their train arrived in Berlin, to his father's horror he emerged from his compartment wearing lipstick and powder and carrying a Dadaist pamphlet. His ownership of the pamphlet revealed that, at the age of twenty-one, Bellmer was already well aware of the rebellion taking place in the world of art.

In Berlin he met the artists George Grosz (1893–1959) and Otto Dix (1891–1969) and further outraged his father by abandoning his engineering studies. As a result of this, his father cut off all financial support and Bellmer was forced to earn a living as a commercial artist, producing illustrations for books and magazines. On a trip to Paris he encountered Giorgio de Chirico. By 1926 he was able to open his own design agency in Berlin, and two years later married a fragile young woman called Margarete Schnell who was soon found to be suffering from tuberculosis. In 1933, in an act of rebellion against the state, Bellmer closed his agency and started making surrealist dolls, combining parts of real dolls to create strangely erotic monsters. Photographs of these were sent to André Breton in Paris where they were published in *Minotaure*.

In 1935 Bellmer visited Paris and met Breton for the first time and became part of the surrealist collective, exhibiting with them in a major group show. After this he became a regular surrealist exhibitor – in London in 1936, Japan in 1937 and Paris again in 1938. Although never rejected by them, not all the surrealists were happy with his relentlessly erotic imagery. According to Jacques Hérold, 'many of the surrealists found his libidinous obsessions rather unhealthy'.

Early in 1938 his wife died and he left Berlin to live in Paris where he met Marcel Duchamp, Max Ernst, Yves Tanguy and Man Ray. He had an affair with a Parisian dancer called Elise Cadreano, and another with an

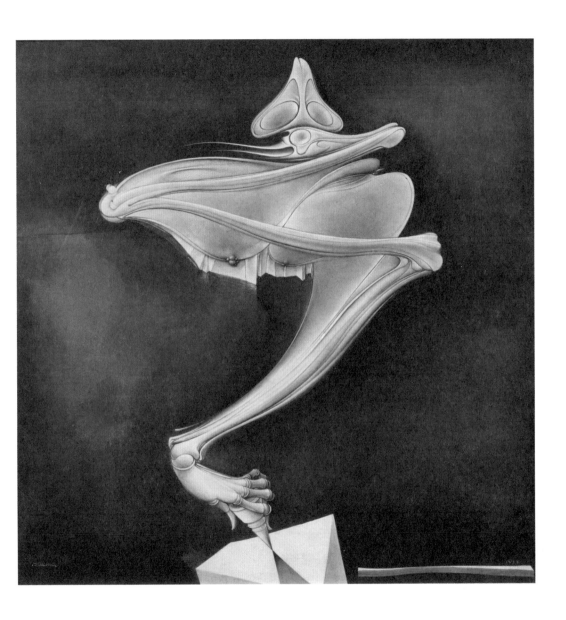

Hans Bellmer, *Peg-Top*, 1937.

English writer, Joyce Reeves, who was deeply embarrassed when Bellmer took her to brothels to watch pornographic films. When war broke out in 1939, he and Joyce Reeves were forced to part when he was detained as a German national in France. In 1939 he and Max Ernst found themselves in an internment camp in the south of France, infested with fleas and lice, along with 1,850 other inmates. Later, they managed to join up with the other surrealists in Marseilles, awaiting passage to the United States to escape the war, but Bellmer did not make the journey. He remained in Vichy France and, in 1942, in order to make to his life there easier, decided to marry a French citizen. His bride was a young woman from Alsace, called Marcelle Céline Sutter. After the marriage it turned out that her 'uncle' was in fact her lover and she expected Bellmer to engage in a ménage à trois with him. Worse was to come, when she falsely denounced him as a Jew. It was only when he obtained a certificate proving that he was a Protestant Aryan, and not a Jew, that he avoided being turned over to the Gestapo by the Vichy authorities.

As the war rumbled on, he remained in the unoccupied region of France and, amazingly, considering their strained relationship, Céline bore him twin girls. He jokingly said that one was his and the other was 'the uncle's'. He continued to exhibit his art locally and in secret worked as a forger, preparing false identity papers for refugees. As the war came to an end, he and his wife separated and in 1947 they were divorced. In 1946 he had begun an affair with a Jewish poet from Bulgaria, Nora Mitrani, that would last until 1949 when he moved to Paris.

In the 1950s Bellmer was busy as an illustrator and continued to exhibit with the surrealists. On a visit to Berlin to see his mother in 1953, he met the German writer Unica Zürn and in the following year moved back to Paris with her. She shared his cramped, dirty apartment where the dust piled up because they both refused to do any housework. Cooking on a tiny stove, they were described as a couple who 'enjoyed their misery together'. With Zürn, Bellmer had found someone with whom he could act out some of his strange sexual fantasies and there are some extraordinary photographs he took of her, naked and tied up tightly with string. The string cuts into her flesh, creating startling distortions of her body shape. It was as though he was transforming her into one of his erotic doll figures. It was during this period that Bellmer made a series of portrait drawings of his surrealist friends and other personalities. Escaping for a while from the oppression of

his erotomania, these were extraordinarily skilful sketches of which an old master would have been proud.

The 1960s were troubled days for Bellmer and his partner, Zürn. They both spent time in hospitals and clinics, she with schizophrenia and he with alcohol poisoning. His lifetime of heavy drinking and his habit of smoking eighty cigarettes a day were beginning to take their toll. At the end of the decade he suffered a stroke but, despite having his left side paralysed, he still managed to produce new illustrations. Although his work was being widely exhibited during this period, it was still capable of causing controversy, even at the height of the liberated, swinging sixties. The Robert Fraser Gallery in London was about to hold an exhibition of his etchings in 1966, but at the last minute cancelled the show on the grounds that it might offend the authorities and the gallery might be shut down.

In 1970 Bellmer had ceased to be productive and his life with Zürn had become impossible. They still had a deep love for one another, but he was confined to bed, unable to help her, and she was too mentally disturbed to help him. In their small apartment, the windows smashed by Zürn during a violent outburst, they never spoke to one another. The situation had become so hopeless that Zürn was eventually taken away to a psychiatric clinic. Bellmer was now so miserable that he said he wanted to die. He could not live with Zürn, but equally he could not live without her. In her clinic, Zürn's condition started to improve and she was allowed out for five days and visited Bellmer. They spent a pleasant evening chatting about their problems and concluded that their life together was now truly over. The following morning Zürn took a chair out onto the terrace of the top-floor apartment, climbed up on to it and leapt to her death.

Bellmer was distraught and his condition deteriorated rapidly. His final years were spent in pain and misery and he hardly ever left his apartment. One moment of relief came in 1971 when he was taken to a retrospective of his work in Paris. He was so moved to find himself honoured in this way that he broke down and wept in the gallery. He would probably have been happy to die after the joy of seeing that exhibition, but lingered on wretchedly until 1975, when he finally succumbed to cancer of the bladder.

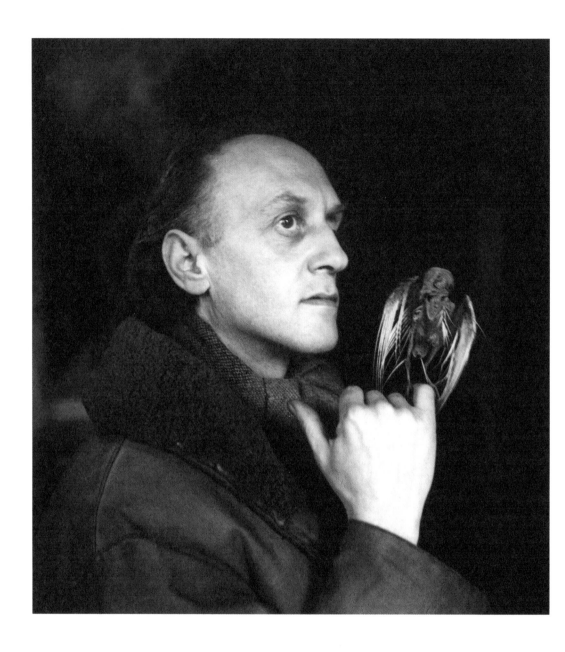

Victor Brauner holding the skeleton of a bird, c. 1950. Photographer unknown.

VICTOR BRAUNER

ROMANIAN · Joined surrealists in Paris in 1933; expelled by André Breton in 1948;
reinstated by Breton in 1959
BORN: 15 June 1903 in Piatra Neamt, Romania
PARENTS: Father a timber manufacturer who was involved in spiritualism
LIVED: Piatra Neamt 1903; Vienna, 1912; Brăila, Romania 1914; Bucharest 1916; Paris 1925;
Romania 1927; Paris 1930; Bucharest 1935; Paris 1938; South of France 1940; Paris 1945
PARTNERS: Married MARGIT KOSCH 1930; divorced 1939 ·
Married JACQUELINE ABRAHAM 1946
DIED: 12 March 1966 in Paris

VICTOR BRAUNER WAS BORN INTO an eccentric Jewish family in the Carpathian Mountains in north-eastern Romania in 1903. He was the third of six children and his father, who owned a lumber mill, was a spiritualist who held séances in the family home and who was involved in mystical Kabbalistic teachings. This exposure of the young Victor to occult rituals was said to have had a lasting impact on him.

During his childhood his family lived for several years in Hamburg and in Vienna, but when he was eleven they settled in the Romanian capital, Bucharest. At the early age of thirteen Victor was busy sketching and painting out of doors. One of his first pictures was of the tomb of a family who, like his father, believed in communicating with the dead. At school he developed a passion for zoology, heralding the presence of zoomorphic figures in his later paintings. When he was sixteen he enrolled at the Bucharest School of Fine Arts, but was later expelled for 'non-conformist behaviour' when some of his pictures were described as 'scandalous'. He then spent his time travelling around Romania painting and, even at this early stage of his career, had already adopted an avant-garde style incorporating cubist and futurist elements. In 1923 he finally settled in Bucharest and joined a group of poets and artists who shared his rebellious ideas. The titles of his paintings during this period reflect his revolutionary preoccupations. One, for example, was

called *Christ in the Cabaret* (exhibited 1924) and another had the title *Arson at the Credit Bank* (1925).

In 1924, at the age of twenty-one, Brauner was already well aware of the Dada movement because illustrations of his were appearing in a magazine to which the Romanian-born Dadaist, Tristan Tzara (1896–1963), was also contributing. In this year he held his first solo exhibition in Bucharest. When he was twenty-two, he left Bucharest for the avant-garde art world of Paris, where he managed to survive for two years until his money ran out and he had to return penniless to Romania. There he joined the military and spent the next two years serving in the infantry. In 1930 he married a jewellery artist called Margit Kosch and together they moved to Paris, where he made contact with his compatriot, the sculptor Constantin Brancusi. His close neighbour was Yves Tanguy, who introduced him to André Breton. In 1933 he formally joined the surrealist group and attended their café meetings. The following year he was given a solo exhibition, with Breton writing the preface to his catalogue. At this point Brauner was fully established as a member of the surrealist circle but, sadly, despite earning some money acting as a movie extra, he once again ran out of funds and he and his wife had to return to Bucharest. He kept in touch with the Parisian surrealists, however, and was able to continue exhibiting with them. In 1936 he was represented at the International Surrealist Exhibitions in London and in New York.

1938 was a traumatic year for Brauner, when he suffered a truly surrealist injury. There was an evening gathering at the Paris studio of the Spanish artist Esteban Frances (1913–1976) in Montparnasse. Another Spanish surrealist, Oscar Dominguez (1906–1957), was also there and he and his host began to quarrel. As the argument was in Spanish, Brauner did not understand what it was about, but he became alarmed when the verbal attacks rose to a crescendo. In Brauner's own words, 'suddenly they became pale and trembling with anger and leapt upon one another with a violence that I could not recall ever having seen before'. He and other guests threw themselves upon the assailants and separated them, but Dominguez broke loose, picked up a missile – a glass or a bottle – and hurled it at Frances. It missed Frances but instead struck Brauner in the face with such force that it knocked him to the ground. His friends phoned for an ambulance, picked him up and were carrying him outside when they passed a mirror. Brauner recalled: 'I didn't realize what had happened to me until in a split second as I passed a

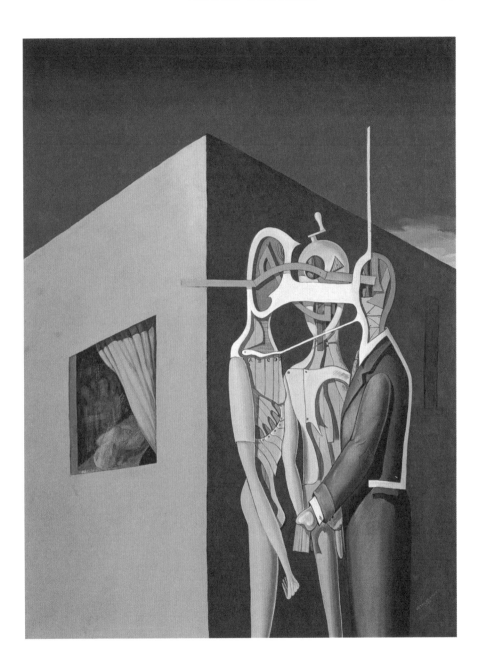

Victor Brauner, *Conspiration*, 1934.

mirror hanging on the wall, I saw my face, covered in blood and my left eye was no more than an open gashing wound.'

What makes this injury so strange was that seven years earlier, in 1931, Brauner had painted a portrait of himself in which he showed his face with one eye severely wounded. This bizarre coincidence was not lost on the semi-conscious Brauner, who told his doctor about it when he arrived at the hospital. The doctor confirmed that Brauner had indeed lost the sight of his left eye. Brauner would later accept the loss of his eye as 'a mark of destiny'. It also gave him a special authority among the other surrealists. He even managed to view it as a strange kind of advantage, writing to a friend:

> The hunter the better to aim, closes his left eye for a moment,
> The soldier, the better to shoot and kill, closes the left eye,
> The marksman, in games of accuracy, closes his left eye,
> the better to send a ball or an arrow to the centre of the target.
> … As for me, I have closed my left eye forever; it was probably by
> chance that I was given the opportunity to see the centre of life.

Despite this severe injury, Brauner was soon painting again and held several exhibitions of his work in Paris in 1939. In this same year he and Margit were divorced.

When the Nazis occupied Paris in June 1940, Brauner fled to the South of France. There, he went into hiding and eventually managed to obtain false identity papers that stated he was an Alsatian, rather than a Romanian Jew. Armed with these he made his way to Marseilles, where he tried to board a ship heading for Mexico, but failed to do so. Under the stress of this difficult situation, his health collapsed and he found himself in hospital with severe stomach ulcers. He would spend the rest of the war destitute and in hiding in the South of France. During these times of turbulent displacement, Brauner developed a way of adapting to the constant need to be on the move. He invented what he called his 'suitcase paintings', reducing the dimensions of his canvases so that they would fit into his luggage. In this way he could paint and re-locate, paint and re-locate.

After Paris was liberated in 1944, he returned there and occupied the studio that once belonged to Henri Rousseau (1844–1910). It became his home for the next fourteen years, shared with his second wife, Jacqueline Abraham, whom he married in 1946. In 1947 he was reunited with the returning

surrealists, back from their exile in the United States, but in the following year he clashed with Breton over the expulsion of Matta from the group. Brauner refused to sign the letter expelling the Chilean artist and publicly accused Breton of hypocrisy and of failing to meet the surrealist standards he himself had laid down. In this conflict it was Brauner who was the true surrealist, not Breton, who had ulterior motives. Two weeks later, Breton took the punitive step of publicly expelling Brauner from the group, accusing him of 'divisive activities'. Within a matter of weeks, however, Brauner was holding a major retrospective of his work in Paris and Breton was being seen more and more as a petulant bully.

During the next few years Brauner held many exhibitions of his work, but in 1953 was struck down again by a recurrence of his severe stomach ulcers. Convalescing in the south of France, he spent some time with Picasso, making ceramic plates at the Madoura factory in Vallauris. Back in Paris he continued to work and hold regular exhibitions of his paintings until, in 1959, he was formally reinstated as part of the surrealist group by André Breton. The 1960s saw many more exhibitions of his work, but in 1965 he was once again in hospital with stomach ulcers and in June 1966 he died after a long illness. On his tomb in the Montmartre cemetery the inscription reads: 'Painting is life, true life, my life'.

Brauner's richly varied work is a vigorous expression of the true surrealist spirit and it is difficult to understand why he is not more highly rated. If he were a Hollywood actor he would be rated as B-list rather than A-list. It remains to be seen whether his status will rise in future years, to match that of the other major surrealists. It certainly deserves to do so.

ANDRÉ BRETON

FRENCH • Founder of the surrealist movement

BORN: 19 February 1896 in Tinchebray (Orne) in Normandy

PARENTS: Father an atheist policeman; mother a cold, pious ex-seamstress

LIVED: Normandy 1896; Nantes 1914; Paris 1922; New York 1941; Paris 1946

PUBLISHED: Surrealist manifestos in 1924, 1930, 1942

PARTNERS: GEORGINA DUBREUIL 1919–20 • Married SIMONE KAHN 1921–31 (divorced) • LEONA DELACOURT (Nadja) 1926–27 • SUZANNE MUZARD 1927–30 • CLAIRE (Moulin Rouge dancer) 1930 • VALENTINE HUGO 1931 • MARCELLE FERRY 1933 • Married JACQUELINE LAMBA 1934–43 (divorced); one child • Married ELISA (BINDORFF) CLARO, a Chilean pianist 1945–66

DIED: 28 September 1966 in Paris

ANDRÉ BRETON WAS THE MOST CENTRAL, most important figure in the history of surrealism. It was he who defined it, described it and defended it against all comers. Nobody played a more significant role in organizing and promoting the surrealist movement and for that he must always be respected. He was also a notable surrealist poet and an occasional surrealist artist.

Having established that, it must be said that he was a pompous bore, a ruthless dictator, a confirmed sexist, an extreme homophobe and a devious hypocrite. He was widely disliked, even among his followers. Frida Kahlo described him as 'an old cockroach'. Giorgio de Chirico called him a 'pretentious ass and impotent arriviste'. Leonor Fini described him as a 'petit bourgeois'. And bizarrely, the Soviet writer Ilya Ehrenburg denounced him as a pederast – for which Breton struck him several times when he met him in the street. This last insult was clearly designed to cause the maximum outrage on the part of the passionately homophobic Breton. Ehrenburg was probably well aware of the fact that Breton was on record as saying that homosexuals disgusted him and of declaring: 'I accuse homosexuals of confronting human tolerance with a mental and moral deficiency which tends to turn itself into a system and to paralyse every enterprise I respect.'

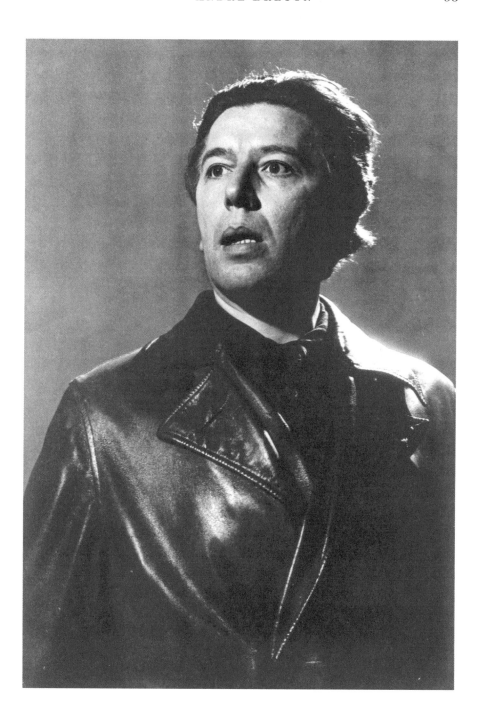

André Breton, 1930. Photo by Man Ray.

He even went so far as to say that, with one or two exceptions, he did not tolerate the presence of homosexuals around him.

He tolerated women, but only in a minor supporting role. As the muse or handmaiden of a male surrealist they were acceptable, so long as nobody took them too seriously. He also had a strong dislike of the traditional family unit and, in particular, of children. Once when a young mother's pram brushed up against his leg when he was walking in the street, he shouted out at her, 'Just because you've shit out a kid, doesn't mean you have to rub everyone else's nose in it'. In short, Breton saw gays as revolting, women as inferior, families as pathetic and children as excrement. This only left him with adult heterosexual males to be taken seriously as associates and companions, and it thus comes as no surprise to find that the surrealist group that he gathered around him were, indeed, all adult heterosexual males. For a man who was extolling the surrealist virtues of freeing the mind and creating a rebellion of liberated thought, his personal collection of extreme bigotries seem strangely out of place. They add up to the embodiment of contradiction that was André Breton.

Breton was born in Normandy at the end of the nineteenth century, to a father who was an atheist policeman and a mother who was a pious seamstress. His childhood was not a happy one because the father that he liked was dominated by the mother that he disliked. He would later describe her as authoritarian, petty and spiteful. When he was being punished, instead of hitting him in the heat of the moment, she would make him stand in front of her and then slap him in cold blood. Surrealism owes his mother a great debt, because it was her treatment of him that set him off on a lifelong search for the wonders of his lost childhood. In the fantastic daydreams and dark imaginings of a child's mind, in the infantile games and playful rituals of a child's world, Breton saw a possibility of a new kind of adult creativity, a creativity that showed no respect for objective analysis or moral restraint. If only he could somehow mature this juvenile wonderland into an adult form of creativity, he would perhaps, at last, be able to defeat his hated mother's suppression of his childhood joys. As a young man in his late twenties, this was precisely what he was able to do by founding the surrealist movement in Paris.

Gathering around him a small group of rebellious poets and writers, he laid out his masterplan in the form of a manifesto. Together they were to start working directly from the unconscious mind, without any rational,

moral or aesthetic censorship. They were to behave as adult children, letting their imaginations run freely and deliberately ignoring all the conventional teachings of the establishment. This new approach required a new set of rules and it was Breton who would present these in his manifesto. As the self-styled leader of the group, it was his task to devise the rules and then to ensure that they were obeyed. In this, he had set himself an impossible task. How could you ask your followers to let their minds run free and ignore all rules and regulations, and then promptly impose a rigid set of rules upon them and expect them to obey?

This was the basic contradiction of the surrealist movement that beset Breton with endless argument, dissention and debate for the rest of his life. He must have been aware of this, but the perverse truth was that he relished the disputes and the protests. He positively enjoyed the tensions at the very centre of the movement and sometimes seems to have deliberately inflamed the differences between the members of the group. The reason seems obvious enough – the more disagreement there was, the more important was his role as the judge and jury.

At first the surrealist movement was essentially literary, political and philosophical. The visual arts were not involved. Breton's surrealist co-founder, Pierre Naville, went so far as to say that, 'Everyone knows there is no surrealist painting'. The problem was that several brilliant visual artists were immediately attracted to the movement and wanted to join. The issue was resolved with the departure of Naville, leaving Breton in sole charge. He began to welcome the painters and sculptors, publishing a book, *Le Surrealisme et la peinture (Surrealism and Painting)*, in 1928, that justified his new position. From this point onwards, the visual artists became a more and more important part of the movement until, as the years passed, the world at large saw surrealism as a purely visual movement. Its literary and philosophical beginnings were forgotten, except by specialist French-speaking scholars. The visual artists, of course, faced no language problems and required no translators. Anyone, anywhere in the world, could enjoy the impact of a surrealist image, but only those fluent in the French language could fully appreciate the nuances of surrealist writings. André Breton would eventually find himself widely viewed as the founder of an art movement, rather than as the head of a rebellious philosophy that prescribed a whole new way life. He adapted to this situation,

and relished the fact that knowledge of his movement was becoming so widespread around the world.

The biggest problem that Breton now faced was that the stable of painters and sculptors he controlled were out of sympathy with one of his basic rules. This stated that full membership of the surrealist group required acceptance of collective action and the shunning of individuality. There was another rule that also troubled some of them: that they were only allowed to exhibit their paintings in surrealist exhibitions. If they participated, even briefly, in more general activities, this was frowned upon. These restrictions were ignored from time to time and Breton had to call meetings to discuss what was to be done. He frequently took a hard line and would formally expel an artist for his or her misdeeds, demanding that all members of the surrealist group who were present at the meeting should sign a document agreeing with his judgment. If you refused to sign, you too would be expelled, so there was nothing democratic about Breton's little world – it was a dictatorship.

It was this, more than anything else, that began to increase the number of enemies that Breton had to suffer. In addition to surrealists who were expelled from the group, there were others who rejected it and moved on. Others, who found the surrealist approach appealing, refused to join the group because of Breton's rigid rulings and became what have been called independent para-surrealists. Their work was clearly surrealist, but they would have nothing to do with the movement itself. The list of people that Breton expelled was impressive. Almost any surrealist artist of merit would, at one time or another, be rejected by him. In England a similar situation existed, with Edouard Mesens playing the Breton role. The list of artists expelled from the movement includes the following: Victor Brauner, Ithell Colquhoun, Salvador Dalí, Max Ernst, Alberto Giacometti, Stanley Hayter, Jacques Herold, Georges Hugnet, Marcel Jean, Humphrey Jennings, André Masson, Matta, Reuben Mednikoff, Henry Moore, Robert Motherwell, Grace Pailthorpe, Pablo Picasso, Herbert Read, Toni del Renzio and Yves Tanguy.

Artists who themselves rejected the movement at some point included Eileen Agar, Luis Buñuel, Edward Burra, Marc Chagall, Giorgio de Chirico, Paul Delvaux, Oscar Dominguez, Frida Kahlo, Paul Klee, René Magritte, Joan Miró, Paul Nash, Man Ray, Herbert Read, Graham Sutherland and John Tunnard. Others, who broke André Breton's rules but got away with it, included Hans Arp, Leonora Carrington, Marcel Duchamp, Conroy Maddox,

Roland Penrose, Dorothea Tanning and even the law-makers André Breton and Edouard Mesens themselves.

All these comings and goings kept Breton busy and maintained his role as the supreme leader. In his private life he found some difficulty in getting started with a female companion. The impact of his cold, domineering mother may have helped him launch into surrealism, but it did not help his attitude towards potential mates. One of his first encounters occurred when he was still a teenager, serving as a medical nurse during World War I. His seventeen-year-old cousin Manon visited him and was clearly expecting him to make sexual advances, but instead he spent the night with her on her balcony looking at the stars. She rebuked him for his timidity, but he proudly told a friend that he had 'surprised her by denying the omnipotence of her charm'. A little later he did sleep with her but was unimpressed, saying, 'A purely plastic beauty is Woman!'

When he left the army he soon became embroiled in the wild antics of the Dadaists in Paris and, inhabiting their uninhibited world, he did manage to have a brief affair with a highly emotional, intensely jealous young married woman called Georgina Dubreuil. The only female that made any real impact at this time was his formidable mother. She had read the press reports of Dadaist exploits and had dragged her reluctant husband to Paris to confront her wayward son. Waving the press cuttings angrily at him, she announced that she would rather have her son die in battle than disgrace the family name by his association with these disgusting Dadaists. She issued an ultimatum – either give up all this nonsense and get back to his medical studies, or leave Paris and come home with them, else he would be cut off from all future financial support from his family. Breton refused and was forced to earn a living working for a publishing firm and reading galley proofs.

His next set-back was even worse. His lover Georgina, in a fit of jealousy, went to his room and destroyed everything in it, including all his letters, his signed copies of books, and his collection of paintings, including works by Amedeo Modigliani, André Derain and Marie Laurencin. There followed a dark period when Dada was disintegrating in Paris and Breton was finding it hard to earn enough money to survive. Then he met and fell in love with a wealthy young Jewish woman called Simone Kahn. They planned to marry, despite the disapproval of both their families. Breton's devoutly Catholic mother disliked the idea of him having a Jewish bride and Simone's parents

André Breton, *Poem-Object*, 1941. Carved wood bust of a man, oil lantern, framed
photograph, toy boxing gloves and paper mounted on drawing board.

thought that Breton was not good enough for their daughter, since he had no money and no prospects. Breton struggled to earn a little more money and eventually the marriage did take place in Paris. His father turned up but his mother refused to be there. Simone's parents were generous and gave her a good dowry so, for once in his life, Breton had no financial worries. On their honeymoon they visited Vienna, where Breton had a disappointing meeting with Sigmund Freud. Freud had apparently been so dismissive that Breton refused to talk about it afterwards. When he wrote about it later, he described Freud as 'a little old man with no style'.

Back in Paris the following year, Breton and Simone moved into a new home, an apartment at 42 Rue Fontaine. It was Breton's first real home and would remain his address for the rest of his life, later becoming the very centre of surrealist activity, so much so that today a plaque on the wall outside commemorates the fact, stating: LE CENTRE DU MOUVEMENT SURREALISTE DE 1922 A 1966. Over the years Breton would fill this apartment with an astonishing art collection. Its walls were completely covered in tribal carvings and masks, and paintings by Picasso, de Chirico, Max Ernst, Francis Picabia, Man Ray, Derain, Marcel Duchamp, Georges Braque and Georges Seurat.

The next ten years would be the most important in Breton's life, as he founded, controlled and developed the surrealist movement in Paris. While this was going on, he and his wife Simone began to drift apart, spending more and more time away from one another. Both had affairs in the late 1920s, and in 1928 he wrote her a letter stating baldly that 'I have the duty to say that in fact I don't love you anymore'. He signed it formally 'André Breton', as though it were a business letter. After this, their previously friendly if distant relationship turned into a bitter conflict. In 1931 they were finally divorced, with Simone getting half of their art collection and Breton retaining the apartment at 42 Rue Fontaine, their skye terrier and the services of their maid.

One of Breton's brief affairs, before they were divorced, became famous because he wrote a novel about it. A deeply disturbed young woman who called herself Nadja entered his life in 1926 and he quickly became obsessed with her. Her eyes signalled a mixture of distress and pride that captivated him and he began a courtship that was eventually successful. He spoke of her in glowing terms saying that she was 'a free genius, something like one of those spirits of the air which certain magical practices momentarily permit

us to entertain'. However, as the days passed, her behaviour grew increasingly strange and Breton became alarmed. On one occasion she covered his eyes with her hands when he was driving, so that they would crash and be together in death. After only a few months, Breton ended their relationship. This unhinged Nadja and she was found screaming at hallucinations in her hotel foyer. The police took her away and she was committed to a psychiatric hospital. Breton romanticized her madness, calling it an escape from the hateful prison of logic. Cruelly, he made no attempt to visit her and eventually she was transferred to another hospital where she died of cancer fourteen years later, at the age of thirty-nine. Her real name was Leona Delacourt.

Another relationship that tormented Breton and hastened his divorce was with a flirtatious blonde called Suzanne Muzard, who had been rescued from a brothel and who was described as 'incapable of making anything except love'. They met in 1927 and enjoyed marathon sexual encounters that were usually followed by Suzanne leaving him to spend time with someone else. She was forever departing and returning, departing and returning, until Breton could stand it no more. In 1930 he fell for a young dancer at the Moulin Rouge called Claire and installed her in his apartment, but she would soon pack her bags, upset at his treatment of her. It was, of course, her youthful innocence that appealed to him but, at the age of twenty, this was a role she was trying to outgrow. In 1931 he was pursued by the artist Valentine Hugo, still awaiting her divorce from Jean Hugo and with a long-standing crush on Breton. He resisted at first but eventually succumbed and they enjoyed a brief affair until 1932.

In the late summer of 1933 Georges Hugnet brought his rather colourfully vulgar, red-haired lover, Marcelle Ferry, to one of the surrealist group meetings and as soon as she set eyes on the impressively dominant Breton she decided to change lovers and was in his arms before the night was out. The following day Breton summoned poor Hugnet to a meeting at a café and informed him that he was passionately in love with Marcelle. Because of his great respect for Breton as the leader of the surrealist movement, Hugnet had no option but to accept defeat. Marcelle, now nicknamed 'Lila' by Breton, immediately moved in to his apartment and could be heard singing rude songs at the top of her voice. Her flashy coarseness and blatant sexuality seemed to have had a special appeal for the erudite, scholarly Breton – at least until the novelty wore off.

The next major involvement in his life was an ambitious young artist by the name of Jacqueline Lamba. She was described as energetic, spirited, tempestuous and fiery. She was also intelligent and well read. Unable to survive on her painting, she was earning her living as a nude dancer in a Montmartre cabaret. Breton met her in May 1934, fell in love with her immediately and three months later had married her. The following year she gave him his only child, a daughter named Aube, and would remain his wife until 1943, when she finally tired of being treated as an inferior companion whose art was never taken seriously, and abandoned him for a younger man.

Breton's repeated sexual adventures left him sometimes angry, sometimes elated and sometimes deeply depressed. His moods were, unfortunately, often carried over into his surrealist group meetings, where, if his lovers had recently hurt him, he would become especially vindictive and would find a safety valve for his frustrations by expelling some unfortunate surrealist from the bosom of the group.

All these emotional upheavals were, however, soon to be reduced to the level of trivia by the outbreak of World War II. Now, Breton and the other surrealists had to make a choice – fight or flee. Most of them decided to flee and moved as quickly as possible down to the south of France in the hope of making a voyage to the New World, either to Mexico or the United States. Breton went with them and soon found himself, more or less penniless, in New York. Kay Sage and Peggy Guggenheim, rich supporters of the surrealist movement, bailed him out financially and he settled into an uneasy limbo, waiting for the war in Europe to end. His refusal to speak English isolated him and, as the months passed, he found himself losing his grip on the group. Breton the Magnificent had become Poor old Breton.

Worse was to come. In 1942 his wife Jacqueline fell in love with a young American sculptor called David Hare (1917–1992) and left Breton to live with him, taking their daughter Aube with her. This was the end of Breton's marriage and left him deeply depressed. A year or so later his spirits were revived when he found new love in the form of Elisa Claro, a young Chilean pianist. They met in a restaurant in New York when he was having lunch with Marcel Duchamp. She looked like Greta Garbo and had an appealing vulnerability about her. This was caused by the recent loss of her teenage daughter in a drowning accident. She and Breton, each dealing with a major emotional loss, found their chance meeting to be a mutual salvation. When

the war ended in 1945, Breton and Elisa left New York for Reno in Nevada, where it was possible to obtain a speedy divorce. On a single day in July he divorced Jacqueline and a few hours later married Elisa. Before long they were on their way to Haiti where Breton was to deliver a series of lectures. The youth of the country were so moved by his speeches that he found himself inciting a rebellion in the country.

Back in New York he and Elisa made their preparations for a move to Paris, where Breton hoped to re-form his surrealist group and re-invigorate the movement. After five largely unhappy years in America, in the spring of 1946 Breton was finally going home. His old apartment in the Rue Fontaine was waiting for him. His collection of paintings still adorned the walls, but windows were broken, there was no heating or telephone, and leaky pipes had caused considerable damage. But it was home, and being there filled Breton with optimism about the future. Above all, people everywhere were speaking in his beloved French and the hated English language was not to be heard.

As a way of re-launching surrealism in Paris, Breton began planning another major International Surrealist Exhibition. This took place in 1947 at the Galerie Maeght and made a considerable impact, but this was not sustained. Paris, so threadbare after the war, was in no mood for a revival of surrealism. The idea was met with either hostility or indifference. I recall my own efforts to locate centres of surrealist activity in the city in 1949. Apart from the Minotaure bookshop and a couple of minor surrealist artists, there was nothing. The famous cafés where the group had held so many meetings in the 1920s and 1930s were almost empty. There was a general feeling that the surrealist phase was over. It is true that, as an organized movement with collective action, group meetings and officially imposed rules, surrealism was running out of steam. From his return to Paris in 1946 until his death in 1966, Breton did his best to keep it going but it was only a pale shadow of its pre-war self.

The surrealist spirit lived on, however, because all the major surrealists kept working away in their now scattered studios. Few of them had returned to Paris, but wherever they were, many continued to produce surrealist works until their deaths. The difference was they were now all operating as independent individuals rather than as obedient followers. Some had been expelled by Breton, some had rejected him, and others had simply drifted away.

Breton's daughter Aube, who was living with her mother in America, came to stay with her father in Paris. He decorated her room for her so that every inch was covered in carefully selected masks, tribal artefacts and surrealist paintings, and as a finishing touch he hung a shrunken human head above her pillow, not perhaps the ideal way to welcome an adolescent girl from the States.

After his death, Aube put her father's art collection up for sale by auction. Many felt that it should have been kept together to form the basis of a public display but, despite Aube's repeated efforts over a period of thirty years, it was not to be. In 2003 it was scattered to the winds. There were over 4,000 lots, including works of art by Breton himself and other major figures such as Dalí, Magritte, Ernst, Tanguy, Arp, Duchamp, Man Ray, Miró and Picasso, not to mention his splendid collection of tribal art. There was a surrealist protest demonstration outside the auction, demanding that the collection should be considered as a National Treasure, but to no avail.

To sum up Breton's life: it is easy to make fun of him. It is true that he was a petty dictator, arrogant, contradictory, hypocritical, pompous and vindictive, but at the same time he was the central driving force of the surrealist movement and it would have been much the poorer without him. His charismatic presence gave surrealism its gravitas and elevated it from the level of an intellectual prank to become one of the major art movements of the twentieth century.

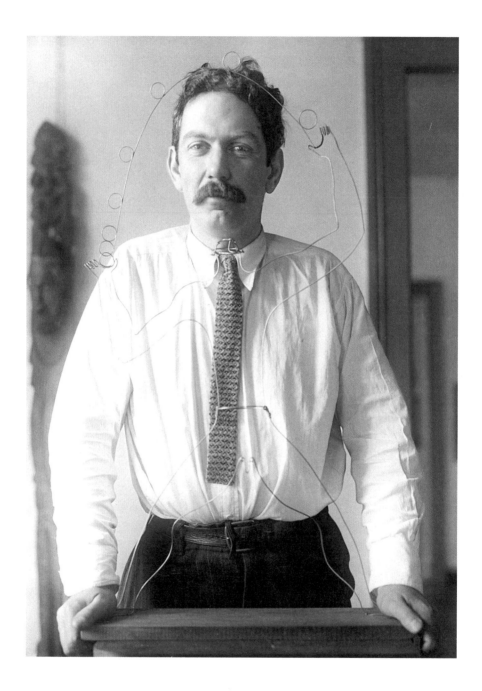

Alexander Calder with one of his wire sculptures at the Galerie Nierendorf, Berlin.

Date and photographer unknown.

ALEXANDER CALDER

AMERICAN · Active with surrealists in 1930s Paris, but later separated from them

BORN: 22 July 1898 in Lawnton, Pennsylvania

PARENTS: Father a sculptor; mother a portrait artist

LIVED: Lawnton 1898; Pasadena, California 1906; Philadelphia 1909; Hoboken, New Jersey 1915; New York 1923; Paris 1926; Roxbury, Connecticut 1933; Indre-et-Loire, France 1953

PARTNER: Married LOUISA JAMES in 1931; two children

DIED: 11 November 1976

WHEN YOU SHOOK HANDS with Alexander Calder it did not feel like the clasp of a highly refined artist, but more like the grip of a bearlike steel-worker. In conversation it was the same – you found yourself in the presence of a gruff construction engineer rather than an articulate surrealist. Yet barrel-chested Sandy Calder was one of the most original artists of modern times. What other artist has invented a form of art so uniquely his own that, should anyone else dare to copy it, they would immediately be accused of plagiarism rather than simply 'being influenced by'? Only Calder created *mobiles* – sculptural works that made their impact by moving in the wind. They were his unique contribution to modern art. It is no accident that he had the grip of a metal-worker, for that was precisely what he was. Photographs of him working in his studio are reminiscent of old pictures of a blacksmith toiling in his forge. Surrounded by rods and plates and wires and cut-out metal shapes, the huge space he inhabited looks like a chaotic engineering workshop.

Alexander Calder was born in Pennsylvania at the end of the nineteenth century. He was fortunate in having a mother who was a painter and a father who was a sculptor. His early interest in the arts was therefore encouraged rather than suppressed – a fate that befalls so many budding artists. As a result, he started young, producing his first sculpture at the age of eleven. Even before that, when he was only eight, he had his own personal workshop at home, where he began developing his manual craftsmanship skills by

making jewellery for his sister's dolls. Throughout his childhood his family kept moving from city to city – from Pennsylvania to Arizona, to Pasadena, to Philadelphia, to New York State, to San Francisco, to Berkeley, to New York City. In each place he somehow managed to set up his own workshop and develop his metal-working talents.

As a young adult, Calder continued to develop his childhood fascination with metal-working and, when he was twenty-one, he obtained a degree in mechanical engineering. He worked for several years as an engineer, first in the car industry and then in hydraulics, followed by a spell as a fireman in the boiler-room of an ocean-going passenger steamer. Next he found work in a logging camp in Washington State and was so impressed by the landscape that he wrote home asking for painting materials. He was twenty-four at this point and beginning to show an interest in the visual arts. The following year he returned to his parents' home in New York City and started attending art classes. By 1924 he was employed as an illustrator and in 1926, at the age of twenty-eight, he made his first formal wire sculpture.

In the summer of that year he worked his passage to Europe on a freighter, acting as one of the ship's crew whose job was to paint the exterior of the ship. He landed in England and then took a ferry to France, on his way to Paris, then the art capital of the world. Hanging out in the famous street cafés, he met Stanley William Hayter (1901–1988), the avant-garde British printmaker, and began to find his way around the art circles of the city. He took a studio and started work on what would become known as the *Cirque Calder* – an early example of performance art. It consisted of a miniaturized circus in the form of mechanical sculptures that were operated by Calder himself in front of an audience. The sculptures were made mainly of wire but also incorporated fabric, leather, rubber and cork. Among his audiences were Jean Cocteau and Man Ray.

In 1927 he returned to New York and earned a living making mechanical toys for mass production. He also performed his *Cirque Calder* there, transporting it in five large suitcases. He did not stay long and in 1928 was back in Paris where, before the end of the year, he was able to arrange an important meeting with Joan Miró in his Montmartre studio. He was frankly puzzled by Miró's work but persuaded him to attend one of his *Cirque Calder* performances. Although their personalities were very different, Calder and Miró soon became friends and would remain close for the rest of their lives.

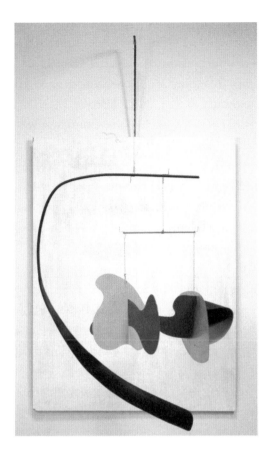

The diminutive, thoughtful Catalan Miró and the big burly American Calder made an odd couple in Paris, walking down the street with Miró wearing a bowler hat and a yellow bowtie and Calder an orange tweed suit.

The idea of Calder and Miró going to a boxing club together has a peculiar charm. According to Calder, they did little actual boxing, but Miró, who was on a keep-fit regime, persuaded Calder to carry out some special breathing exercises that involved a lot of loud whistling. Some years later, when Calder was visiting Miró in Spain, his earnest friend took him up onto the roof of

Alexander Calder, *White Panel*, 1936. Plywood, sheet metal, tubing, wire, string and paint.

the farm chapel one morning to continue their exercises, and was whistling so loudly as he performed his breathing ritual that Calder collapsed on the roof in a fit of helpless laughter. There is a famous photograph of the couple together with a laughing Calder holding Miró in a headlock, and another of Calder clasping Miró's cheek while he kisses him on the temple.

Travelling back to New York on a liner, Calder met an attractive young woman by the name of Louisa James, whose father had taken her to Europe to meet young intellectuals there, without much success. She and Calder became acquainted and he was invited to stay at their house in Cape Cod. She reported that he was the perfect guest who 'mended everything in sight and kept us in gales of laughter all day long'. After performing his *Cirque Calder* repeatedly in New York, the following year Calder was back in Paris again, where Louisa James visited him and decided to marry him because she felt he would make her life 'colourful and worthwhile'. He fashioned a gold engagement ring for her. They returned to New York where they were married in January 1931, a lifelong bond that would last until his death in 1976.

Returning yet again to Paris, Calder and his bride set up home there. At this point he was spending more time with surrealist artists such as Jean Arp and Marcel Duchamp, and became fascinated by the abstraction of natural shapes. In his own work he was about to experience a major breakthrough, leaving behind the figurative images of his wire circus and starting to create abstract organic shapes that floated in the air or were moved by small motors. These completely novel kinetic sculptures could not have been created without Calder's special double life – first as a sculptor and second as an engineer. It quickly became clear that he had invented an entirely original art form and it was Duchamp who christened these new works, calling them, in French, *mobiles*. Even in the English language they have, ever since, retained their French pronunciation, as have his later, non-moving works given the name *stabiles* by Jean Arp.

At the first exhibition of Calder's new work in Paris in 1931, Fernand Léger (1881–1955) wrote in the catalogue of the show: 'Looking at these new works – transparent, objective, exact – I think of ... Duchamp, Brancusi, Arp – these unchallenged masters of the unexpressed and silent beauty. Calder is in the same family.' Picasso visited the exhibition and agreed with Léger, but when Mondrian saw it he made the enigmatic statement that the *mobiles* did not move fast enough because they should be still.

In 1932 the Calders visited Spain and stayed with Miró and his family. An even closer friendship developed between the two artists and the following year Miró stayed with the Calders at their house in Paris. Also about this time Calder met Dalí and his wife Gala. The American was becoming an integral part of the surrealist circle, but somehow managed to achieve this without having to suffer the boredom of attending official surrealist meetings or having any contact with André Breton. Having spent time with Calder myself, I simply cannot see him sitting through those interminable theoretical debates. He was an intensely practical man who let his works speak for him. Despite this, Breton did see fit to include Calder in the 1936 International Surrealist Exhibition in London and also in the one in Paris in 1947. In the latter show Calder was classified by Breton among the artists who were, 'Surrealists in spite of themselves'.

In the summer of 1933 the Calders sold their house in Paris and moved back to the United States. Calder said that he and his wife did not like the rumours that Europe seemed to be heading for another war and they decided it was time to return to their home country. In this respect he was years ahead of the other surrealists, who did not leave Europe until it was almost too late. Back in America, Calder and his wife started house-hunting and eventually found a broken-down eighteenth-century farmhouse on eighteen acres in the small town of Roxbury in Connecticut. Over the years they renovated it and extended it with large studios, and it remained their home for the rest of their lives.

In 1935 the first of their two daughters was born. In 1937, when she was two, her parents took her to France for the summer. On this occasion Calder was involved, along with Picasso and Miró, in making major works for the World Fair that was being held in Paris. All three of them produced works that were protests against Franco and the fascists in Spain. Picasso showed *Guernica*, Miró contributed *The Reaper* – a huge mural of a Spanish peasant in revolt – and Calder installed the *Mercury Fountain*, in which the incessantly flowing mercury represented the ever-active Republican resistance to fascism. Many years later, Calder would donate his *Mercury Fountain* to the Miró Foundation in Barcelona as a mark of admiration for his friend.

In the autumn of 1937 the Calders moved across the Channel to England, where Calder had a successful exhibition at the Mayor Gallery in London. His imaginative jewellery was especially popular there. Back in America, in 1941,

Yves Tanguy and Kay Sage bought a house near to the Calders' home and they became close friends. In 1943 there was a tragedy when an electric fire destroyed Calder's large studio and part of the Roxbury farmhouse. Calder and his wife lived for a while with the Tanguys in their nearby house as their own property was being rebuilt. From this point onwards Calder's story was one of increasing success. His work had become immensely popular and he was being commissioned time after time to create huge *mobiles* and even bigger *stabiles* as public monuments all over North America. This success and his widespread popularity would continue until his death. After the war, in 1947, the Miró family arrived in New York and stayed with the Calders in Connecticut. Theirs was more than just a personal friendship. They were also great admirers of one another's work and made several exchanges.

During the last thirty years of his life, Calder received invitations for exhibitions and commissions for public sculptures from many different countries. As a result of these invitations and also because of the financial success they brought, he was able to undertake a great deal of international travel, visiting England, France, Monaco, Holland, Belgium, Germany, Italy, Finland, Sweden, Greece, Cyprus, Lebanon, Israel, Egypt, Morocco, India, Nepal, Mexico, Venezuela, Trinidad and Brazil. Honours were heaped upon him, including the Legion d'honneur in France and the United Nations Peace Prize. In the United States, just before his death, he was offered the Medal of Freedom by President Ford but rejected it for political reasons. After his death in 1976 it was awarded to him posthumously, but his widow refused to attend the ceremony in Washington.

In 1977 his old friend Miró, saddened by his death, wrote a touching poem for him that ended with the words: 'Your ashes will fly to the sky, / to make love to the stars. / Sandy, / Sandy, / Your ashes caress / The rainbow flowers/ That tickle the blue of the sky.'

LEONORA CARRINGTON

ENGLISH · Member of the surrealist group from 1937

BORN: 6 April 1917 in Clayton Green, Chorley, Lancashire

PARENTS: Father a textile magnate; mother Irish

LIVED: Lancashire 1917; London 1935; Saint Martin d'Ardèche in S. France 1938;
Spain 1940; Portugal 1941; New York 1941; Mexico 1943

PARTNERS: MAX ERNST 1937–39 · RENATO LEDUC, Mexican Ambassador 1941–44 ·
EMERICO WEISZ, photographer 1946–2007; two children

DIED: 25 May 2011 in Mexico City, of pneumonia

LEONORA CARRINGTON WAS ONE of those rebellious young women who were drawn to the surrealist circle in Paris in the 1920s and 1930s. They found the atmosphere of social freedoms, heated intellectual debates and deliberately improper behaviour irresistible. Carrington was relatively late arriving on the scene, joining the circle in 1937 when she was only twenty and newly out of art school. She had the advantage of being fluent in French and found the surrealist gatherings in Parisian cafés and bars exhilarating. After her stifled childhood, this was not surprising.

Carrington was born in Northern England, the daughter of a Lancashire textile tycoon, and grew up in a mansion with ten servants, a chauffeur, a nanny, a French governess and a religious tutor. Every moment of her young life was supervised and she was only allowed to visit her mother in her sitting room on set occasions. Despite the grandeur of her existence, she saw her family home as little more than a huge prison. Architecturally she described it as lavatory gothic. Her escape was into a world of private fantasy, aided by the fact that her Irish nanny told her wild folk tales that fired her imagination.

At school she was soon in trouble because she could write with both hands and even backwards. (It was said that in later life she could paint with both hands at the same time, surely a unique accomplishment.) The nuns who taught her told her that, instead of possessing a remarkable skill, this strange

Leonora Carrington in her apartment in Greenwich Village, New York, 1942.
Photo by Hermann Landshoff.

ability of hers was a disease. She was informed that she was abnormal and punished for not conforming. This was the moment when her distrust of religion began, a feature of her life that would grow stronger in later years. In one of her earliest acts of rebellion, when she was only fourteen, she pulled up her dress in front of a Catholic priest. She was wearing no underclothes and she asked him 'What do you think of that?' She was expelled twice for not collaborating with her teachers and was eventually packed off to a boarding school in Florence to prepare her for being presented at court. The year she spent in that beautiful city allowed her to study the great art of the past, an experience that would have a lasting impact on her as an artist.

After Florence she was sent to a finishing school in Paris where she was again expelled for refusing to conform. Her family, undefeated by her wayward behaviour, had her presented at court wearing a tiara, gave her a debutante's ball at the Ritz in London, and took her to the Royal Enclosure at Ascot races where, because she was not allowed to bet on the horses, she spent the day sitting in a corner, reading *Eyeless in Gaza* by Aldous Huxley. In her family's eyes she was now primed for a high society marriage or, as she herself put it, to be 'sold to the highest bidder'. For her, this was the moment of truth. She announced her rebellion and in 1935, at the age of only eighteen, left home permanently for the life of an art student in London. Her parents were so furious that they gave her little financial support, but she was free at last. At this point, her uncooperative behaviour disappeared and she applied herself obediently to instruction in painting and drawing.

Ironically, her introduction to the surrealists came in the form of a gift from her mother. It was Herbert Read's new book on the subject, called simply *Surrealism*, published in 1936. Carrington found it fascinating, especially the art of Max Ernst. She said that seeing his work was 'like burning inside'. In 1937 Ernst had a show in London and Carrington met him at a dinner party in his honour. Ernst had the reputation of being irresistible to women and Carrington certainly found this to be true. It was, she said later, love at first sight and, although he was a married man, she was very soon his lover and his protégé. When he left for Paris she followed him there, telling her outraged family that she was going abroad to live in sin with a married German artist twenty-five years her senior. Her father responded by telling her that she could never enter the family home again. She said

she was glad to be leaving behind the English, 'whose souls have the con-sistency of pork brawn'.

In Paris in 1937 Carrington became an active member of André Breton's circle. The self-confidence she had acquired during her childhood meant that she was no compliant groupie, but a force to be reckoned with. At one party, for instance, she arrived wearing nothing but a white sheet that she later allowed to drop, leaving her stark naked. She and Ernst were thrown out of the party. Carrington's family, either because they were worried about their daughter's welfare, or more likely because they were concerned about what she might do to their social reputation, kept tabs on her movements with Ernst. At one point they tried to get him arrested for showing pornographic pictures in London, but Roland Penrose stepped in to rescue him.

This period in the late 1930s was a productive time for Carrington, who found the atmosphere in Paris provocative and stimulating. In 1938, however, both she and Ernst started to tire of Breton's interminable squabbling with his group of followers and they left Paris to spend over a year in an old farm-house in a French village. It was, said Carrington, a time of paradise. Sadly, this would soon come to a juddering halt with the outbreak of World War II in 1939. Ernst, being German, was immediately interned in a French con-centration camp. While he was a prisoner, Carrington's attitude towards him started to change. She saw their relationship in a different light and when he was eventually released and was able to return to their farmhouse, he found that she had disappeared. When Ernst had been arrested, Carrington suddenly found herself isolated in a foreign country with war approaching and all her family ties broken. She was only twenty-three and it was all too much for her. She stopped eating, started drinking and began to suffer from hallucinations. She sold their house to a local farmer for a bottle of brandy and friends drove her south to Madrid, where her erratic behaviour became extreme. One day, she was discovered outside the British Embassy, screaming that she wanted to kill Hitler. Her father had her committed to a Spanish lunatic asylum where she was classed as incurably insane. While she was there, she was treated with chemical shock therapy. The drug she was given induced convulsive spasms and she spent her days tied to her bed with leather straps, fed through tubes in her nose. She nearly died.

Her worried parents arranged for her to be transferred to a mental insti-tution in South Africa and her father sent her old nanny over by submarine

to escort her. Their journey began in Madrid, from where they travelled on to Lisbon. Once in the Portuguese capital, she persuaded her guardian to let her go to a shop to buy some gloves. Ducking out of the back door, she made her way to the Mexican Embassy where the ambassador, Renato Leduc, was an old friend. She pleaded with him to get her out of the country, but this was not easy. The only way he could manage it was if he were to marry her, which he did. It was some months before they could sail off across the Atlantic and those were difficult times for Carrington because Ernst arrived in Lisbon, also on his way to America. Although he was now with Peggy Guggenheim, he was still desperately in love with Carrington and they spent a great deal of time together in Lisbon cafés, deep in conversation. He repeatedly tried to persuade her to return to him, but she blamed him for not rescuing her from the nightmare of the lunatic asylum and was no longer prepared to live with him.

After the crossings to America had been made and they were all living in New York, Ernst and Carrington continued seeing one another, causing Peggy Guggenheim, who was by now married to Ernst, sharp pangs of

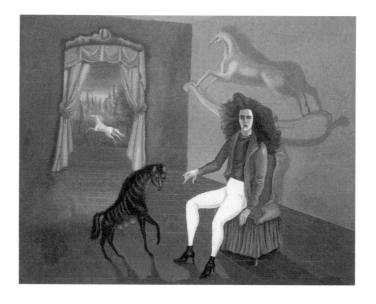

Leonora Carrington, *Self-Portrait: 'A L'Auberge du Cheval d'Aube'*, c. 1937–38.

jealousy. To her credit, she never allowed this to interfere with her assessment of Carrington's work, which she was happy to exhibit in her new art gallery. Carrington's behaviour while she was in New York was decidedly odd. On one occasion, when dining in a restaurant, she covered her feet in mustard, and on another she took a shower fully clothed when visiting s friend's house. It was not clear whether her eccentricities were surrealist events or moments of madness. Perhaps they were both.

In 1943 Carrington's Mexican husband-of-convenience moved back to his homeland and took her with him. Their special relationship ended a few years later and they were amicably divorced. In Mexico City she met Emerico Weisz, a Hungarian Jew who was a photo-journalist, and after a brief courtship they were married in 1946. They set up home together in Mexico and remained there as husband and wife for over sixty years, during which time she bore Weisz two sons and continued to paint well into her nineties. Her husband, known to everyone as Chiki, was something of a saint. He stayed with her to the bitter end, despite the fact that he was the victim of her sometimes raging temper and, on one occasion at least, was physically attacked by her. She took a number of lovers and left Chiki several times, but always returned to him.

Her paintings, always skilfully crafted in a traditional manner, take the viewer into a fantastic private world full of monsters and arcane rituals. Some are like demented fairy tales, others like elegant nightmares. As with many surrealist works, they make their impact on the viewer even though their precise meaning is obscure. When she was ninety years old, she was asked by an interviewer whether certain strange animals in one particular scene were acting as guardians. The question clearly made her uncomfort-able and she replied, 'I don't really think in terms of explanations'. Her view was that, if images come from the unconscious, they should also be received by it. When another interviewer asked her about the meaning of a painting of hers, she retorted sharply, 'This is not an intellectual game. It is a visual world. Use your feelings.' Octavio Paz, the Mexican poet, described Leonora Carrington as, 'The bewitched witch, insensitive to social morality, to aesthetics and to price'.

GIORGIO DE CHIRICO

ITALIAN • Was a major early influence on surrealism and joined the group in 1924; his later work was rejected by them and he broke with them in 1926

BORN: 10 July 1888 in Volos, Greece

PARENTS: Father Sicilian; mother Genovese

LIVED: Volos 1888; Athens 1899; Munich 1905; Milan 1909; Florence 1910; Paris 1911; Italy 1915; Rome 1918; Paris 1925; Italy 1932; Rome 1944

PARTNERS: Married RAISSA GURIEVICH, a Russian ballerina 1925 •
Married ISABELLA PAKSZWER FAR, a Russian 1930

DIED: 20 November 1978 in Rome

Giorgio de Chirico, 1936. Photo by Carl Van Vechten.

DE CHIRICO'S LIFE STORY as an artist is split into two. In the early part, that runs from 1913 to 1918, he produced a group of 'metaphysical' paintings of sinister figures and street scenes that are among the greatest surrealist works ever made. What is more, they preceded the surrealist art movement and acted as the herald for it. In the later part of his life, his work, produced between the age of thirty and ninety, was, in the eyes of the surrealists at least, complete rubbish. They found it hard to understand how an artist who had been so good could then become so bad.

De Chirico was born into an Italian family living in Greece in 1888. His father was an engineer who was in charge of building a new railway line. The small boy showed a talent for drawing and was sent to study in Athens where he spent six years learning to paint. When he was sixteen his father died and his mother took him and his younger brother to Italy and then on to Munich, where Giorgio was given a further two years of formal art training. In 1909 he moved back to Italy, where he lived with his domineering mother and his brother in Milan. Now twenty-one, he produced his first metaphysical painting in this year. He had been able to make visits to Florence and Rome and had become fascinated by the architecture he saw there, an influence that would soon come to dominate his early paintings. He suffered from poor health at this point and experienced periods of melancholy and depression.

In 1911 the family settled in Paris but, the following year, Giorgio volunteered for military service in Italy. Realizing his mistake, he quickly deserted and fled back to Paris, where he would soon start exhibiting his paintings. Following the outbreak of World War I, he turned himself in to the military authorities in Italy and was sent to join an infantry regiment. He managed to get a posting as a clerk at a military HQ, a position that gave him plenty of free time in which to paint. He suffered ill heath again and was sent to a military hospital, where he was able to continue with his painting. It was during these war years that he produced his most important metaphysical works. When the war ended he moved to Rome where, in 1919, he held a solo exhibition of his metaphysical paintings. A book illustrating these paintings was praised by André Breton.

One of his strangest early paintings, called *The Child's Brain* (1914), was exhibited in the window of a Paris gallery in 1923 where it was seen by Breton, who said that he could not rest until he had acquired it. Before he had done so, however, the work was also seen by a young Yves Tanguy. Like Breton, he

had been travelling by bus down the street where the gallery was situated, when he spotted the painting and was so excited by it that he leapt off the bus while it was still moving, in order to examine it more closely. What he saw changed his life, converting him from being a merchant seaman to devoting the rest of his life to painting.

During the 1920s de Chirico's art underwent a change that saw it diverge from its surrealist beginnings. In 1925 he returned to Paris and attended some of André Breton's surrealist gatherings. His descriptions of these evening events make it clear that, although the surrealists had praised his early work so passionately, he had strong reservations about them as a group. He records that, in an atmosphere 'of false meditation and ostentatious concentration André Breton walked about the studio reading in a sepulchral voice … declaiming foolish remarks … with a severe and inspired expression'. De Chirico's welcome at these surrealist gatherings was to be short lived, for he was about to hold an exhibition of his new, more conventional work. The surrealists were horrified by what they saw. In their eyes, he had developed into a boring traditionalist. The man they had admired so much had, for them, become an embarrassment. They launched an attack on him and all bonds of attachment were completely broken.

One of the tactics they employed to ridicule his new work was to make cheap parodies of it in the window of another gallery, where, at the same time, they were showing his early metaphysical work. They bought children's toys in the shape of little rubber horses and placed them on a pile of sand, surrounded by blue paper. This was their insulting version of one of his new paintings that depicted horses by the sea. De Chirico did not take this lying down and went on the counter-attack. In his memoirs he wrote that, shortly after reaching Paris, 'I found strong opposition from that group of degenerates, hooligans, childish layabouts, onanists and spineless people who had pompously styled themselves *surrealists*'. Warming to his theme, he continued, 'André Breton was the classic type of pretentious ass and impotent *arriviste*'; Paul Eluard was 'a colourless and commonplace young man with a crooked nose and a face somewhere between that of an onanist and a mystical cretin'.

Bizarrely, he accused the surrealists of buying up all his early metaphysical paintings as cheaply as possible and then, by means of publicity and 'skilfully organized bluff', planning to sell them 'at extremely high prices

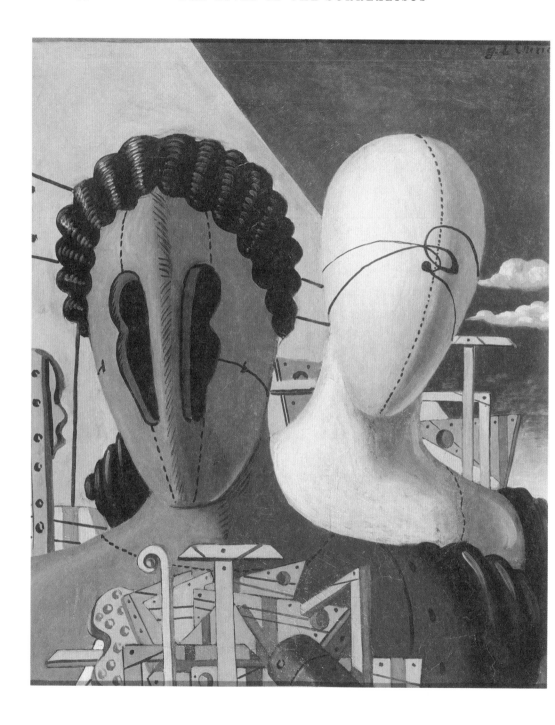

Giorgio de Chirico, *The Two Masks*, 1916.

and pocket stacks of money'. He argued that it was because his new style of painting spoilt their plan that they were opposing him. To strengthen his position he even went so far as to describe his early work as worthless and 'admired only by snobs'. His ranting counter-attacks on the surrealists reached such a pitch that they eventually became laughable. He accused them of 'behaving like hooligans and petty delinquents' and said they were 'so persistent, so hysterical in their envy – which resembled that of eunuchs and old maids' that they organized widespread boycotts of his work. This battle with the surrealists would rumble on and on and, in 1928, Breton summed up the situation in his book *Le Surrealisme et la peinture*, where he stressed his admiration for de Chirico's pre-1919 work and his condemnation of his later work. Despite the now hostile relations between the surrealists and de Chirico, and despite the abuse he hurled at them, they would never abandon their admiration for his early work that had meant so much to them in their formative years in the early 1920s.

SALVADOR DALÍ

SPANISH • Joined surrealist group in Paris in 1929; almost expelled
by Breton in 1934 and finally expelled in 1939
BORN: 11 May 1904 in Figueres, Spain
PARENTS: Father a lawyer and notary
LIVED: Figueres 1904; Madrid 1922; Paris 1926; Port Lligat 1930;
New York 1940; Port Lligat 1948
PARTNER: Married GALA ELUARD (born Elena Ivanorna Diakonova) 1934
DIED: 23 January 1989 in Figueres, Spain, of heart failure

WHEN A FRIEND OF MINE SHOWED DALÍ a painting made by my chimpanzee Congo, he studied it carefully and then announced that, 'The hand of the chimpanzee is quasi-human; the hand of Jackson Pollock is totally an-ee-mal'. This was an astute response because the hand of the chimpanzee was, indeed, struggling to make some kind of order out of the lines it was placing on the paper, creating a primitive form of composition, while the lines of Jackson Pollock deliberately destroy any form of composition, creating a uniform, overall pattern. This comment of Dalí's says a great deal about what happened to surrealism after its birth in 1924. In his first manifesto Breton defined surrealism as 'pure psychic automatism' – a phrase that applies perfectly to what Pollock did when he flicked paint onto the canvas. By that definition, Pollock would seem to be the ultimate surrealist and Dalí, by comparison, would look more like an Old Master. But, although Dalí may have used the painting technique of an academic artist, his imagery was anything but traditional. For Dalí belonged to that special kind of surrealist who painted traditionally, but whose moment of creative surrealist irrationality came before the painting began, when a wildly irrational, unconscious idea flashed through his brain.

Dalí was, without question, the most skilful, most accomplished of all the surrealists. In his early work he was also the most darkly imaginative and inventive. Sadly, after he was expelled from the movement by Breton,

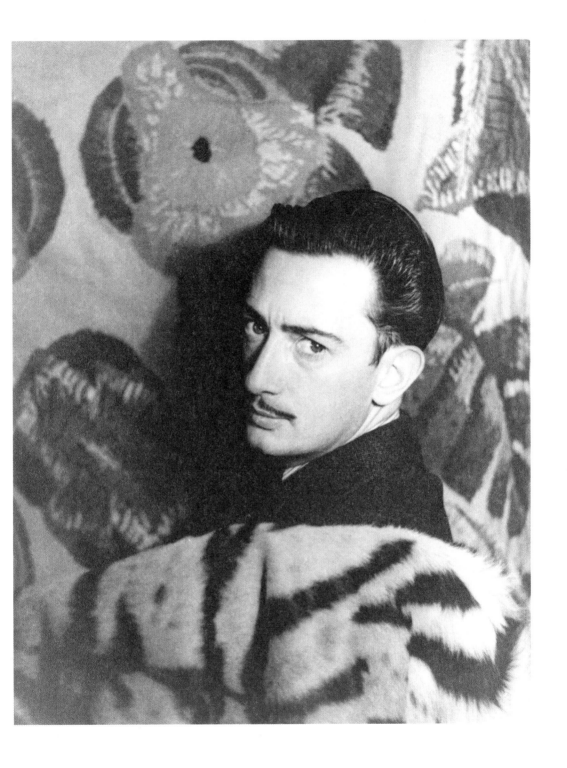

Salvador Dalí, 1936. Photo by Carl Van Vechten.

he eventually lost his way and some of his later works can only be described as religious kitsch. He also enjoyed acting the fool in public, a device that made him well known to a wide audience. As a result, he became the most famous of all the surrealists in the public mind, to a point where he could boldly make the public proclamation that 'I AM surrealism'. However, these later aberrations should not be allowed to overshadow the fact that, in his early days, he created some of the greatest surrealist paintings ever made.

Dalí was born in Northern Spain in 1904, making him slightly younger than most of the other key surrealists. (Arp, Breton, de Chirico, Delvaux, Duchamp, Ernst, Magritte and Man Ray were all born in the nineteenth century.) His birth was a strange experience for his parents. Three years earlier his mother had given birth to another Salvador Dalí, a much loved baby who sadly died in 1903. When she gave birth to a second baby nine months later he was given the same name, as if to bring the first Salvador back to life. As a child, the second Salvador Dalí was often taken to see the grave of the first Salvador Dalí and stood there staring at what appeared to be his own name engraved on the headstone. Later, as an adult, Dalí would declare that his notorious excesses were the result of his attempt to prove, over and over again, that he was not his dead brother.

Dalí's father was a successful notary in Figueres and the family lived well. His mother, not wanting to lose a second child, was wildly over-indulgent and the young Dalí soon discovered that he could get away with appalling behaviour. If he raged and screamed to get his own way, she would try to soothe him and would never discipline him. His father was made of sterner stuff and became his hated enemy. Dalí was bullied at school and paid little attention to his teachers, losing himself in daydreams. At home he persuaded his parents to let him have a small studio where, at the age of ten, he produced his first oil painting, in which he had already worked out problems of perspective. Thanks to his mother he had become a self-centred, spoilt child, but had also found a private way of expressing himself in paint.

With the arrival of adolescence came an obsession with masturbating. His behaviour became increasingly eccentric and at fifteen he was expelled from school as a disruptive influence. Only when he was painting did he take life seriously. When his work was exhibited, the teenager's talent was already recognized, a local newspaper predicting correctly that 'he will be a great painter'. When he was seventeen his doting mother died of cancer

and Dalí's childhood was over. He now faced the world, externally as a wildly self-confident eccentric, internally as a timid introvert. Armed with this dual personality, he left Figueres to attend art school in Madrid. There he continued his eccentric behaviour but was also a serious student who spent many hours in the basement of the Prado studying the paintings of Hieronymus Bosch, works that would have a massive impact on him.

Although as a youth he had homosexual tendencies, these were always of a strongly inhibited kind. His close friend, the gay poet Federico García Lorca, did his best to seduce Dalí, but to no avail. On one occasion Dalí promised Lorca that he would at last submit to his friend's advances and invited him to his bedroom late at night. When Lorca arrived and slipped into bed he found himself clasping not Dalí, but a naked female prostitute that Dalí had installed there. Dalí himself was watching with glee from a corner of the darkened room. Dalí's sex life was certainly bizarre, as was his willingness to write about it in explicit detail, even to the extent of recording that he had a very small penis – something few men would wish to put on public record. Essentially he was a voyeur and a masturbator. He seemed to hate actual physical contact and it is claimed that, in his entire life, he only enjoyed full sexual intimacy on one single occasion.

In 1925, at the age of twenty-one, Dalí made his first trip to Paris, armed with an introduction to visit Pablo Picasso at his studio. In the eyes of the young artist, it was like an audience with the Pope. He told Picasso that he had given him precedence over the Louvre, to which Picasso replied 'Quite right'. The impact of Paris was such that Dalí decided then and there to somehow enter its avant-garde world, away from the restrictions of Figueres. Back in Madrid he had tired of his classroom existence and, when taking his final examinations, informed the examining jury that he was withdrawing from the exam because his professors were incompetent to judge his work. He was promptly expelled and took pleasure in his father's distress.

Dalí spent the next three years quietly painting in isolation in Figueres and his work began to show the first signs of his future genius. In 1927 he was excited by a visit from Joan Miró, who asked to see his work. Miró later wrote to Dalí's father, urging him to send his son to Paris, because he saw a brilliant future for him as an artist. This did not in fact happen until 1929, when Dalí finally persuaded his father to give him enough money to move

there and to make a film with his old friend Luis Buñuel, who was by now an official member of the surrealist group. The film was *Un Chien Andalou* and it was to be Dalí's introduction to the world of Parisian surrealism.

Arriving alone in Paris, Dalí went straight to a brothel but could not bring himself to touch any of the girls there. The kindly Miró took him out to dinner several times, but then Dalí found himself alone in his cheap hotel room. He spent a miserable week by himself, masturbating in a frenzy. He would regularly burst into tears and was on the verge of a nervous breakdown when, eventually, he started working with Buñuel on their outrageous film. The film made Buñuel ill and both the main actors would eventually kill themselves. It contained images so shocking that it created a sensation when it was shown. Breton declared it the first surrealist film. When the film was completed, Dalí returned to Spain where he began work on truly surrealist paintings, dredging the images up from the deepest recesses of his unconscious mind. Sometimes he would sit in front of his canvas waiting for several hours for a new image to suggest itself. It was then that he met Paul Eluard's wife Gala and started an intense relationship with her. Dalí was twenty-four and still a virgin when Eluard and Gala came to stay with him in Spain. Gala was a confessed nymphomaniac and fell for Dalí. She now faced the almost insurmountable task of persuading him to make love to her. On one occasion, when her husband was away, she finally managed it and drove Dalí on to what seems to have been his one moment of sexual penetration.

Despite Dalí's sexual oddity, Gala realized that, if she managed his life well enough, his amazing abilities as an artist could make them both rich, so she left Eluard and set her sights on Dalí, even though she knew that they would never again have normal sexual relations. Over the years, their major sexual outlet would become simultaneous masturbation. Some years later Dalí wrote a novel called *Hidden Faces*, in which he invented his own personal sexual perversion – Clédalism. In this, a couple would reach simultaneous orgasm without touching one another, or themselves. It was like an extension of his own sex life with Gala. Another sexual outlet they enjoyed consisted of Dalí rounding up a group of young men and allowing Gala to fondle them until she found the one she liked best. She would then have sex with the young man she had chosen while Dalí watched and masturbated.

When Gala returned to Paris, leaving Dalí painting furiously for his first solo show in Paris, she approached Breton to persuade him of Dalí's

importance as a surrealist. She had already started on her campaign to promote her new partner. Arriving in Paris Dalí had two goals – to join the surrealists because they would afford him a valuable platform, and to destroy them because he hated the idea of a collective. His fragile mental state was calmed by his association with Gala, who effectively became his housekeeper and his accountant. Dalí's first exhibition in Paris was a huge success and he sold every painting in the show. He made a final break with his father and, marking the event with a ritual, shaved off all his hair, buried it on a beach, and made Paris his home. He became increasingly active in the surrealist circle and was soon an official member of Breton's select group. He courted Parisian high society and acquired a number of important collectors of his work. Back in Spain, he and Gala bought a fisherman's cottage in Port Lligat and converted it into a snug home for themselves, with a quiet studio where Dalí could paint in peace. Undisturbed solitude was important to him to allow his darkest dreams to escape from his brain onto his canvases.

Buñuel re-entered his life to create a sequel to *Un Chien Andalou*. Called *L'Age d'Or*, it was given its first showing in Paris in 1930 and caused an outrage. Violet ink was hurled at the screen, smoke bombs and stink bombs were thrown, spectators were bludgeoned and an exhibition in the foyer was attacked. Paintings by Dalí, Miró, Ernst, Tanguy and Man Ray were all destroyed. The film was banned and the Chief of Police in Paris was asked to stamp out the surrealist movement. As far as Dalí was concerned, he had gained in fame but had lost some of his most important collectors, who felt it wise to distance themselves from the controversial Spaniard. Dalí and Gala went through a period of stark poverty but then, in 1931, exhibitions of his new work in Paris and New York were a resounding success. His painting *The Persistence of Memory* dates from this year and his soft watches would live on to become one of the icons of twentieth-century art. The next two years saw repeated exhibitions by Dalí and continued success. Then, in 1934, there was another scandal. Dalí had expressed his fascination for Hitler in a letter to Breton, saying that he dreamed of the Führer as a woman and as a great masochist, and that he warranted the admiration of the surrealists because he was planning to reduce the established order to rubble. Hitler's view of the surrealists was rather different. He commented that they should be handed over to those who dealt with the sterilization of the insane.

In 1934 Breton took action against Dalí, calling a special meeting to expel him from the surrealist group for his 'glorification of Hitlerian fascism'. The gathering did not, however, go as he planned. Dalí was running a temperature and arrived at Breton's studio with a thermometer in his mouth and wearing many layers of clothing. While Breton paced up and down reciting Dalí's crimes, his victim was busy checking his thermometer. Finding that it read 101.3, Dalí started undressing, taking off his shoes, his overcoat, his jacket and one of his many sweaters. Then, worried that he might cool down too quickly, he put the jacket and the overcoat back on again. Breton demanded that Dalí defend himself, which he did with the thermometer still in his mouth so that, when he spoke, his spittle splashed on Breton. The essence of his slurred defence was that Breton's criticisms of him were based on moral considerations that were alien to Breton's own definition of surrealism. Dalí then took off his overcoat and jacket again, removed a second sweater, threw it at Breton's feet and put his overcoat and jacket back on again. When he then repeated this process, so that he was down to his sixth sweater, the assembled surrealists could stand it no longer and collapsed in helpless laughter, leaving Breton looking ridiculous.

Dalí then struck hard, attacking Breton for operating a vice squad and insisting that he, Dalí, was a total surrealist and that no morality, no censorship, no fear, would stop him. He reminded Breton that all taboos were forbidden and that if you were a surrealist you had to be consistent. Breton had no reply. Dalí then went through his sweater-removing routine once more and Breton again demanded that Dalí withdraw his remarks about Hitler. Dalí then fell to his knees and proclaimed his support of the poor fishermen of Port Lligat. Breton's attempt to create a serious atmosphere of debate had been reduced to a shambles by Dalí's irrational behaviour – behaviour that made Breton look like the moralizing authoritarian and Dalí the true surrealist champion. The net result of the evening was that Dalí was not expelled from the surrealist circle.

Gala had just married Dalí, her reason having nothing to do with sexual intimacy, but instead the need to inherit his estate should he go mad or be killed. They were happy together and his work was progressing well, with important new sponsors. They decided to visit America, but were short of cash. Picasso generously helped them out and they sailed for New York, with Dalí full of apprehension. He was so eccentric in his behaviour when he

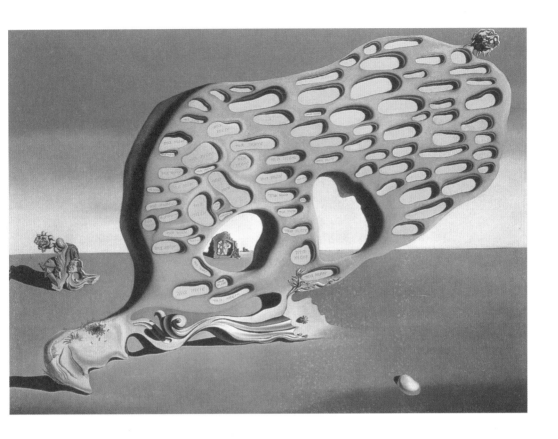

was greeted by the press that his arrival was reported in the papers and his exhibition was a great success. He made so much money that he and Gala gave a surrealist ball on the eve of their departure. It caused such an uproar that nobody in New York was now unaware of Dalí the crazy surrealist. In New York in 1934, Dalí WAS surrealism. It was the start of a lifelong love affair between Dalí and the Americans.

Back in Europe, Dalí and Gala divided their time between Paris and Port Lligat and the years 1935 and 1936 saw him hard at work in his studio and

Salvador Dalí, *The Enigma of Desire, or My Mother, My Mother, My Mother*, 1929.

exhibiting with increasing success. Dalí's next escapade was to be his lecture at the International Surrealist Exhibition in London in 1936, an occasion when, famously, he nearly died. He arrived leading two Russian wolf-hounds, carrying a billiard cue and dressed in a deep-sea diver's suit, with a jewelled dagger in his belt. The title of his talk was *Paranoia, The Pre-Raphaelites, Harpo Marx and Phantoms*. Speaking from inside the diving helmet he was inaudible, so it was not immediately noticed that he was starting to suffocate. Friends of his rushed on stage and desperately attempted to turn the bolts of the helmet, but without success. A spanner was sent for, but by the time it had arrived and the helmet was undone, Dalí was nearly dead.

Dalí and Gala were dining at the Savoy in London a few days later when he was told that Civil War had broken out in Spain. Dalí commented that he was not interested. Wars had nothing to do with him. When pressed, he supported the Republican cause, but later, when it was clear that Franco was going to win, Dalí the opportunist decided to side with him instead, much to the distress of many of his friends. To Dalí, all that mattered was that he should be able to return to Spain after the war to paint in his studio there. He was on whichever side would make this possible. To him, his painting was more important than any war.

With the approach of World War II, Dalí became more and more distanced from the surrealist group in Paris. He was preparing to take America by storm again with another important exhibition of his work in New York, and no longer gave much importance to Breton and his clique. In his own mind he was now bigger than them. Unable to resist teasing Breton, he wrote to him saying that in his opinion the world's problems would be solved if the white race would promote 'the reduction of all coloured people to slavery'. He was clearly teasing Breton, but Breton took it seriously and formally expelled Dalí from the surrealism movement. This time he did not attempt to do it face to face, for fear that Dalí might make him look a fool, as he had done before. Dalí didn't care about this expulsion as he was about to reject Europe as a whole and devote himself to the conquest of America. He did this in his usual spectacular fashion. He had been asked to design two shop window displays for Bonwit Teller in Manhattan and what he did was so distasteful to the owners of the store that they modified it without telling him. When Dalí discovered this, he was furious and started wrecking the display. In the process, he smashed the huge plate-glass window and it collapsed in pieces

on the sidewalk. Dalí was arrested and placed in a police cell full of drunks and tramps. He was later released on the understanding that he would pay for the broken sheet of glass.

André Breton, with typical inconsistency, was horrified by the wave of publicity that followed Dalí's action. As an act by an artist defending his surrealist composition against censorship, Breton should have praised it. But the truth was that he saw Dalí stealing his crown as the world's most important surrealist, and was deeply envious of the Spaniard's fame. He knew he was being upstaged but found it hard to compete. Worse was to come because the press coverage of Dalí's action turned him into a public hero in America and his exhibition there became a triumph. Dalí's final dig at Breton and others like him came in the form of a manifesto that he wrote before sailing back to Europe. In it he said that all the problems in the art world had 'come about entirely through the middle-men of culture who, with their lofty airs and superior quackings, come between the creator and his public'.

Back in Paris, Dalí and Gala were horrified to find that war was about to break out and they decided to leave the city for the south of France. Dalí no longer enjoyed erotic dreams about Hitler – he was now terrified of him. He told his neighbour Leonor Fini that he was thinking of buying a suit of armour to protect himself against invading Nazis. His isolation in the south of France proved valuable as it allowed Dalí the solitude to paint sixteen important works in a space of only eight months. These were all shipped off to New York for his next exhibition there. Dalí and Gala would soon follow themselves, as the horror of what was happening in World War II bit home. As a Russian Jew, Gala was scared that she might be caught and sent to a concentration camp. They had to escape through Portugal, but managed it, and soon found themselves settling into life in New York, where they would stay for the next eight years. The other surrealists were also gathering there at the same time, but Dalí kept his distance from them and Breton would have nothing to do with him.

1942 saw the publication of Dalí's autobiography *The Secret Life of Salvador Dalí*. It had one unfortunate side-effect. In it he happened to mention that his old friend Luis Buñuel was an atheist. At the time, Buñuel had an important post in the film department of the Museum of Modern Art, working on anti-Nazi propaganda films. When the Catholic Church authorities in New York discovered that he was an atheist, they put pressure on the State Department to get him fired. The Museum was told to dismiss

him, but did their best to keep him on. In the end, he was so disgusted that he resigned and then confronted Dalí in a New York bar. In his memoirs Buñuel comments, 'I was beside myself with rage. He was a bastard, I told him ... his book had ruined my career ... I kept my hands in my pockets so as not to strike him.' All Dalí would say was that his book had nothing to do with Buñuel. It was the end of their longstanding friendship. Dalí's book, full of wild exaggerations, inventions and deliberately obscure phrasings, was not well received. George Orwell said of it, 'If it were possible for a book to give a physical stink off its pages, this one would'. It was Oscar Wilde who had said that every man should invent his own myth, and Dalí was doing just that.

When Dalí and Gala returned to Europe in 1948, they would settle once again in Port Lligat and Dalí would resume painting in his studio there. But something had changed – Dalí had returned to the Catholic Church. His paintings, although still containing strange, fantastic elements, became increasingly religious. He was at last leaving surrealism behind. Occasionally Dalí would revert to a genuinely exciting surrealist composition, as if even he was tiring of his new preoccupations, but his late output, from the 1950s until his death was generally disappointing.

It was in the 1960s that Dalí acquired the old theatre in the centre of his home-town of Figueres and started converting it into a personal museum. The building had stood as a ruin since the end of the Civil War, and it took time and money to convert it. It finally opened in 1974 and contained a treasure trove of Dalínian conceits. Years later, when he died, his body was entombed there below the centre of the old theatre stage. Dalí was by now a strong supporter of Franco and when the dictator condemned some Basque terrorists to death, Dalí sent him a congratulatory message. News of this leaked out and Dalí was subjected to considerable abuse, with savage graffiti being scrawled all over the outside of his Port Lligat house. The restaurant chair that he always sat in when he visited Barcelona was blown up and this scared him so much that he fled to New York as soon as possible. After Franco's death, Dalí, ever the opportunist, transferred his allegiance to the Spanish royal family. As a result of this he would later be rewarded by them, when he was elevated to the Spanish nobility.

Before this, his health went into a steep decline. His body started to shake and he would have violent fits, falling to the floor, kicking and screaming and

shouting that he was a snail. His doctor described it as a case of attempted auto-suicide. This was largely brought on by the way that Gala, now aged eighty-six, was starting to bully and brutalize him. For years he had relied on her to control his life and now she seemed only interested in abusing it. In 1981 matters reached a climax when Dalí could stand Gala's behaviour no longer and attacked her with his cane. She punched him in the face, giving him a black eye, but it was she who came off worse because Dalí went on striking her until she had two broken ribs and lesions on her limbs. The eighty-seven-year-old woman was found lying by her bed and rushed to hospital. The following year she was dead and Dalí was not at her funeral. However, a few days later, he went alone to her tomb late at night, and was found there weeping uncontrollably.

Dalí was now a shell of himself. Honours were heaped upon him and in 1982 he was made a marquis. His title was now Marqués de Dalí de Pubol. He managed a little painting, but his strength was waning. A large staff, including four nurses, was looking after him and he used to drive them mad, constantly ringing the bell by his bed to summon them to him, as he felt so lonely. One night he pressed his buzzer so many times that it short-circuited and set fire to his four-poster bed. Dalí was trapped in the flames. In hospital it was discovered that nearly one fifth of his body surface had been severely burned and skin grafts were necessary. Against all the odds Dalí recovered from his burns and rallied sufficiently to give press interviews and receive the King of Spain. But death was not far away and in 1988 he was taken to a clinic, where his first request was a television set on which he could watch the reports of his impending death.

Such was the life and death of one of the most extraordinary figures in the history of surrealism.

PAUL DELVAUX

BELGIAN • Associated with surrealism from 1930 but never joined the movement

BORN: 23 September 1897 in Antheit, Liège, Belgium

PARENTS: Father a lawyer at the Brussels Court of Appeals

LIVED: Antheit 1897; Brussels 1916; France 1949; Brussels 1949

PARTNERS: Married SUZANNE PURNAL 1937–47 (divorced)

• Married ANNE-MARIE DE MAERTELAERE 1952 (his first love)

DIED: 20 July 1994 in Veurne, Belgium

HAVING WOKEN UP ONE MORNING at Roland Penrose's house to be confronted with a large Delvaux (*The Call of the Night*, 1938) that filled almost the entire wall at the foot of my bed, I can safely say that the impact of one of his major works, seen at close quarters, is impressive. The painting was the same width as the large bed and I recall that, in the moment of half-awakening, I was convinced that one of Delvaux's famous, life-sized nudes was about to get into bed with me. The intensity of the atmosphere in his early paintings is remarkable and, because of their large scale, they transport you instantly into his dreamworld, whether you wish to enter or not. Delvaux is without doubt one of the great atmospheric surrealists. André Breton summed him up perfectly when he wrote: 'Delvaux has turned the whole universe into a single realm in which one woman, always the same woman, reigns over the great suburbs of the heart.'

Paul Delvaux was born in Belgium at the end of the nineteenth century and died at the end of the twentieth, at the remarkable age of ninety-six. He was the son of a lawyer and appears to have been a rather scholarly schoolboy, studying Latin and Greek and reading Homer. To the alarm of his family, he decided to become an artist and enrolled at the Academy of Fine Arts in Brussels in 1916. When his studies were completed and he had done a period of military service, he started painting in earnest. At the age of twenty-five he became obsessed with railway stations and these would reappear as background themes in many of his later paintings.

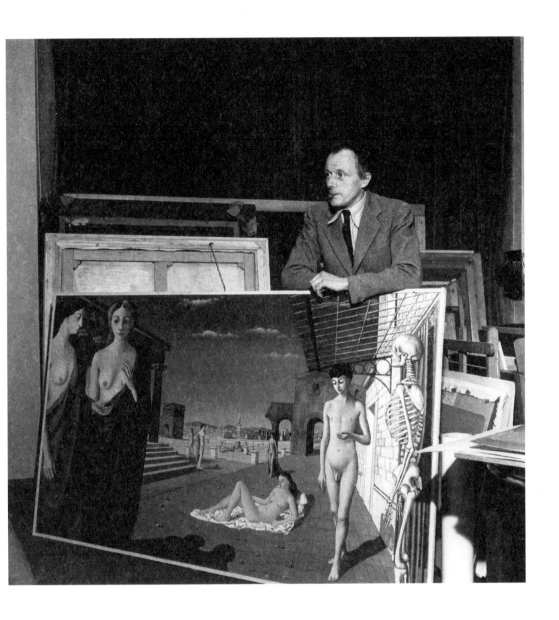

Paul Delvaux, Brussels, 1944. Photo by Lee Miller.

1926 was a crucial year for him because it was then, at the age of twenty-nine, that he paid a visit to Paris and encountered for the first time the early paintings of Giorgio de Chirico. He wrote: 'He is the poet of emptiness. He was an extraordinary discovery for me, a point of departure.' What had impressed him most of all were de Chirico's silent, almost empty city streets with their eerie atmosphere. Another moment of revelation occurred at the Brussels Fair in 1930 when he saw a strange tableau, the centrepiece of which was a naked girl lying on a velvet couch. She was asleep and, as he watched, her chest rose and fell gently with each breath she took. She was accompanied by two skeletons. Closer examination revealed that she was, in fact, a cleverly operated mechanical mannequin. Delvaux was fascinated by this figure and described her as 'an amazing revelation ... a very important turning point'. She became the model for all his later nudes.

At this stage in his career, his work was straightforward and, to be honest, rather boring, but then surrealism began to take hold of him and in 1936 he entered a phase of painting in which his subject matter began to focus on a strange, silent city where figures, frozen in time, were caught going about their daily lives. It was impossible to date the city because it was a mixture of ancient Greece and modern Europe. Some of the figures were fully clothed, while others were conspicuously nude. An occasional male appeared, but the vast majority of his figures were naked females. Or, to be more precise – as Breton pointed out – the same naked female, over and over again.

One of the curious features of Delvaux's canvases is that his cast of nudes and other figures seem to be playing the children's party game of 'Statues'. All of his scenarios are made up of groups of figures that appear to have frozen when some imaginary music suddenly stopped. Skeletons sometimes stand or sit looking at them. The human figures are engaged in some sort of ritual but we will never know precisely what this is. There is an eerie silence and we find ourselves in an alien world, very similar to our own and yet so odd that it might be on a parallel planet. This is a precisely delineated dream world, academically painted and carefully composed, yet dredged from the unconscious mind of the artist.

To an uninitiated observer the art of Paul Delvaux is clearly surrealist, but historically his link with the movement is tenuous. He himself said of surrealism: 'What attracts me is the poetic meaning. What repels me is the theory.' He was prepared to exhibit with the surrealists, which he did on a

number of occasions, but he kept his distance from their meetings, their philosophizing and their politics. He loved the freedom that surrealism gave to the artist – the freedom to allow the imagination to run riot – but did not see why this had to be embedded in a straightjacket of official rules and regulations. Like many artists who also enjoyed the release they got from surrealism, he probably felt that the restrictions of surrealist theory were fundamentally opposed to its most valuable idea – allowing the unconscious mind to express itself during the creative act. It would be reasonable to suppose that his attitude towards the surrealist movement would mean that Breton would be against him, but strangely the opposite was the case. Breton was keen to invite Delvaux into the surrealist fold and was happy to include him in important group exhibitions.

Closer to home, the Belgian surrealist group were highly critical of him, attacking both his style of painting and his lack of political commitment. As a result he and the Belgian surrealist circle kept their distance from one another. Magritte accepted that he was a skilful painter, saying, 'He is an artist through and through', but was scathing about him as a person, remarking that he was 'quite pretentious at bottom, unshakeable in his respect for what they call "order" at its most bourgeois'. Magritte also felt the need to denigrate Delvaux's choice of subject matter, commenting that 'his success is based solely on the quantity of naked women that he tirelessly reproduces on enormous panels'. Magritte's protégé, the acid-tongued Marcel Marien (1920–1993), went much further, calling Delvaux 'one whose moral sense is confined, at best, to a respect for the sacred host and bank accounts'. Marien was horrified to discover that the great Breton was praising him and insisted that 'it would take no more than a few minutes talk with Delvaux to leave Breton forever convinced of his laughable mental degeneracy'.

To sum up, the Belgian surrealists viewed Delvaux as a pretentious, devout, money-grubbing, laughable, degenerate purveyor of naked female flesh. To say that this is unfair is an understatement. His crime was not that he painted bad pictures, but that he was too orthodox in his social and religious attitudes, too admired by the establishment, and too successful financially. Also he was too reserved and not interested in joining their jokey little gang, forever up to surrealist pranks.

When asked to look back in 1970 and recall how he felt when he heard Marien's harsh words, Delvaux replied rather abruptly, 'I don't remember

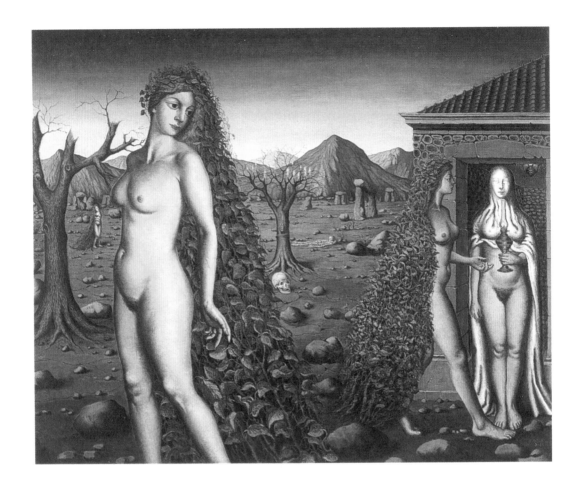

Paul Delvaux, *The Call of the Night*, 1938.

Marien', adding 'I'm not interested in politics'. For him, surrealism was not a way of life, it was a way of painting. It nevertheless meant a great deal to him, even if he kept apart from group activities. Looking back in later life, he commented that, 'For me surrealism represents freedom and as such was extremely important to me. One day I was granted the freedom to transgress rationalist logic.'

Delvaux's most important period of painting started in 1936 and ended in the mid-1940s at the conclusion of World War II. Surprisingly, his very best work was done during the darkest days of that war, as if his escape

from the reality of the outside world then became even more important to him. His most successful work, the *Sleeping Venus* of 1944, was painted in Brussels while the city was being bombed and one can imagine him, standing in front of his huge canvas and getting lost in his dream world, shutting out everything else. After the war ended, his paintings continued in the same vein but lost some of their intensity. The colours became paler and the nudes less impressive. Critics have not been kind to his late work, some calling it 'chocolate boxy' and others saying that it 'verged all too often on discreetly erotic kitsch'. In Belgium, however, he is viewed as a National Treasure and in 1982, while he was still alive, he was honoured in a way that few modern artists have enjoyed – a museum devoted entirely to his work was opened in the Belgian seaside resort of Saint-Idesbald.

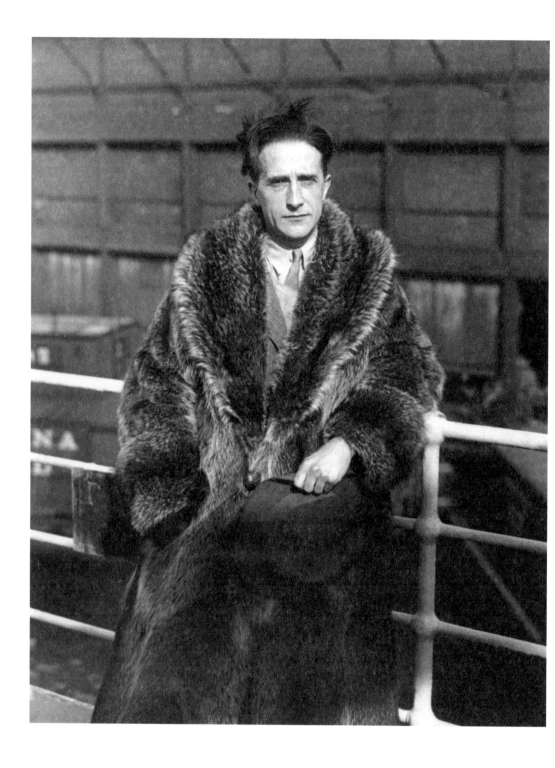

Marcel Duchamp in a fur coat, New York, 1927. Photographer unknown.

MARCEL DUCHAMP

FRENCH / AMERICAN • Active with the surrealists from 1934

BORN: 28 July 1887 in Blainville-Crevon, Seine-Maritime, Normandy, France

PARENTS: Father a notary; mother the daughter of a painter

LIVED: Blainville 1887; Rouen 1895; Paris 1904; New York 1915; France 1919;
New York 1920; Paris 1923; Europe 1928; Paris 1933; New York 1942

PARTNERS: JEANNE SERRE 1910, an artist's model; one child (in 1911)
• YVONNE CHASTEL 1918–22 • MARY REYNOLDS 1923 (secretly for 20 years)
• Married LYDIE SARRAZIN-LEVASSOR 1927 (divorced in 6 months) • MARIA MARTINS 1946–51
• Married ALEXINA SATTLER 1954–68 (ex-wife of Pierre Matisse)

DIED: 2 October 1968 in Paris

MARCEL DUCHAMP IS A PARADOX. He was the artist who was an anti-artist, the artist who destroyed art. When he exhibited everyday objects in art galleries – objects such as a bicycle wheel, a bottle-rack, a comb or a urinal – he made them into art by virtue of their context, not their form. He had not lovingly created them, nor chosen them as unique, accidentally beautiful objects found on a beach or a rubbish tip. They were cheap and mass produced. When asked what made them different, apart from their context, he replied, 'They were signed by me and limited in number'.

The acceptance of Duchamp's 'readymades' as serious works of art changed forever the values put upon traditional, skilfully crafted works by trained artists toiling away in their studios. It heralded in the new phase of art history in which everything from blank canvases, to tins of baked beans, to small piles of bricks, to pickled sharks and unmade beds were all potentially considered as art. In 2004 a survey was carried out, involving 500 art experts, who were asked to name the most influential work of art in modern times. Top of the list came Duchamp's *Fountain* (1917), an object that was no more than a bog-standard urinal, signed and dated. At an exhibition of Duchamp's work in London in 2013, one critic referred to him as a 'modern genius', but another argued that his impact had made art increasingly sterile. One author

called him the most influential artist of the twentieth century, while another referred to him as a failed messiah. So, was he a giant in the history of art, or a second-rate charlatan? The jury is still out, but what are the facts?

Duchamp was born in 1887 in Normandy, the son of a notary. He began painting at the age of fifteen and his early work was typical of its period – post-impressionist portraits, scenes and landscapes. Then in 1911 he started to move inwards, away from the observed external world and into a realm of the imagination. He met Francis Picabia (1879–1953) at an exhibition at about this time and a deep friendship began between them. The year 1912 was a key one for Duchamp, when he produced a series of brilliantly original paintings, with echoes of both cubism and futurism, but with a strongly surrealist flavour – and at least a decade ahead of their time. The cubists were not happy with his work, however, and his most famous painting – *Nude Descending a Staircase* (1912) – was rejected by them from a major exhibition. It was at this moment that Duchamp declared he would never again become a member of a group of artists, but would always work alone, as an independent.

When asked in later years about how he had arrived at such an original form of painting, Duchamp replied that he was rebelling against what he called retinal art – art that appealed to the eyes. What he was seeking was to put painting 'at the service of the mind'. In other words, visual pleasure was to be replaced by cerebral stimulation. The traditional values of visual beauty and conventional aesthetics were to be thrown out of the window and replaced by images that appealed to the complex thought processes of the human brain. He was at pains to distinguish what he was doing from the process of abstraction.

Also in 1912 he told Picabia's wife, Gabrielle, that he had fallen in love with her. They arranged a secret meeting in the waiting room of a railway station and spent a romantic night together there, although without making physical contact with one another. She later recalled, 'it was utterly inhumane to sit next to a being whom you sense desires you so much and not even to have been touched'. Had he been a hot-blooded Mediterranean artist, he might have found a hotel for them, but being a cool Northerner, passionate but restrained, he held himself painfully in check. In the autumn of that year Duchamp made a highly significant remark, the first time that he had shown his fascination for objects that were not works of art, but which impressed him enormously. He was visiting an aircraft exhibition with Constantin

Brancusi, when he stopped in front of a large aeroplane propeller and said to Brancusi, 'Painting is finished. Who can do better than that propeller?'

In the following year, Duchamp put this thought into action when he fixed a bicycle wheel on top of a kitchen stool and watched it spinning round. This has been called his first 'readymade' but he denied this, saying that he simply liked seeing the way the wheel rotated in his studio, operating in complete isolation from its practical function on the road. He insisted that, at this early date, he had no idea of creating a new kind of art form. Also in 1913, *Nude Descending a Staircase* was exhibited in America and caused a sensation. It was included in the International Exhibition of Modern Art, generally referred to as the Armory Show, and was savagely attacked, enough to make it an infamous work, described in the press as 'an explosion in a shingle factory'. In notoriety it completely overshadowed the work of Picasso and the cubists.

When World War I began, Duchamp was found to have a heart condition that excused him from military service and he left Europe for the United States where, thanks to the Armory Show, he already had a reputation as an art world rebel. There, he met Man Ray, who became a close friend and, with Picabia and himself, made up the core of the New York Dadaists. Like similar groups in Europe, it was their aim to undermine the establishment and one of their most significant contributions was the 'readymade'. According to Duchamp, it was in 1915 that readymades were born as a new form of expression. He later wrote, 'It was around that time that the word "readymade" came to my mind to designate this form of manifestation'. It was then that he started introducing more commonplace objects as creative works. What made them creative was not their aesthetic quality, but the fact that, thanks to his intervention, one was forced to look upon them in a new light. He aided this process by giving them new names. He bought a snow shovel at a hardware store, for example, and wrote a title on it: *In Advance of the Broken Arm* (1915). In 1916, forgetting his determination not to belong to any group, Duchamp became the founding member of the Society of Independent Artists. It was a membership that lasted for only a year, however, because in 1917 he resigned when *Fountain* was rejected from one of the Society's exhibitions. The urinal subsequently gained in fame because of this rejection.

That is the official story of how Duchamp introduced the readymade to the world and changed the course of art. Unfortunately for Duchamp it

has since come to light that he may have borrowed the idea from a German acquaintance of his in New York, a woman by the name of Baroness Elsa von Freytag-Loringhoven. It was she and not Duchamp who was the first person to present a readymade as a work of art. In 1913 she took a large metal ring that she found in the street and claimed that it was a female symbol representing Venus. She gave it the title *Enduring Ornament* and said that if she commanded something to be art then it *was* art. Her most famous readymade was a piece of plumbing in the shape of a sink trap, mounted on a carpenter's box and exhibited under the deliberately inflammatory title, *God.* The baroness had a passionate attachment to Marcel Duchamp that appalled him. He had to issue an order that she was not allowed to touch his body. (Although he did make a film of her pubic hair being shaved off.) Her bizarre response to his rebuttals was to pleasure herself with a photograph of one of his paintings.

The baroness was herself a work of living Dada. She was described as 'the only one living anywhere who dresses dada, loves dada, lives dada'. She would appear in public as a work of art: 'One side of her face was decorated with a cancelled postage stamp. Her lips were painted black, her face powder was yellow. She wore the top of a coal scuttle for a hat, strapped on under her chin like a helmet. Two mustard spoons at the side gave the effect of feathers'; or she 'dressed in a bra composed of tomato cans and a birdcage (with live canary), arms adorned with curtain rings, hat garnished with vegetables'. Her head was shaved and lacquered with iodine to give it a deep vermilion colour. On her rump she wore a battery-powered bicycle tail-light. She must have been a nightmare for Duchamp. Here was he, seriously pretending to be crazy in the service of the anti-establishment philosophy of Dada, and here was she, truly crazy, making him look like an intellectual poseur. It is amusing to read the hostile reactions of Duchamp's supporters at the way she out-Dada-ed him.

The matter came to a head with the arrival of the most celebrated of all the readymades, the white ceramic urinal called *Fountain* and signed 'R MUTT 1917'. It was like a companion-piece to Baroness Elsa's plumbing readymade called *God.* The name of the fictitious artist R MUTT may also have been an invention of hers because it was a play on words in the Baroness's native tongue, *armut* in German meaning poverty. She also kept stray dogs that were called 'mutts'. It appears that she gave the urinal to Duchamp to place

Marcel Duchamp, *The Bride*, 1912.

in the exhibition because he was a member of the committee running the show. If he wanted to claim it as his own, Duchamp's mistake was to write a letter to his sister in which he made the telling admission: 'One of my women friends, using a masculine pseudonym, Richard Mutt, submitted a porcelain urinal as a sculpture; since there was nothing indecent about it, there was no reason to reject it.' He probably thought that this letter would not survive, but unfortunately for him it did and it appears to expose as false his later claim to have invented the readymade *Fountain*.

Recently, however, some scholars of surrealism have suggested that the involvement of the Baroness Elsa has been exaggerated, and that it may have been another female friend of his who sent in the urinal, rather than the Baroness herself, as part of a scheme orchestrated by Duchamp. The fact that the Baroness had already created other readymades is ignored by this view, but the matter remains highly controversial. The truth is that we will never know the exact circumstances of the creation of the *Fountain* as a work of art unless new archival material surfaces. Duchamp's letter to his sister does, however, make one wonder whether, perhaps, the whole idea of readymades was Elsa's rather than his. In 1913 he had his bicycle wheel and independently she had her iron ring. He was adamant later that he did not call his wheel a readymade and that he only invented the term in 1915. Elsa's *Enduring Ornament* of 1913 was the first readymade to be given a fancy title, and this places her ahead of Duchamp in the matter of innovation.

The Baroness Elsa was a tragic figure. When the Dada period came to an end she returned to Europe and, in 1927, turned on the gas in her apartment, went to sleep and never woke up. Unavailable to defend herself, she was airbrushed out of the history of modern art, with Duchamp taking all the credit for the outrageous urinal *Fountain*. If Duchamp himself had been challenged on this issue he would no doubt have shrugged and said, 'She may have invented the readymade but it was I who transformed it from a childish prank into a philosophy of anti-art.' And that is perfectly true. She may have been the crazy inventor, but it was he who was the salesman who marketed the invention. And market it he certainly did, for there are now no fewer than twenty copies of it in museums and collections around the world.

In 1918 Duchamp met Yvonne Chastel, the ex-wife of the artist Jean Crotti (1878–1958), and spent nine months in Buenos Aires with her. He told

Picabia that he had no particular reason for going to Argentina and that he knew nobody there, but that New York was no longer much fun. With the war over, Duchamp returned to Paris in July 1919, where he made a further assault on traditional art by disfiguring a reproduction of the most famous painting in the world – the Mona Lisa. Like a naughty schoolboy defacing a poster, he added a moustache and a beard and gave this 'modified readymade' the title of *LHOOQ*. Pronounced phonetically in French this title roughly translates as 'She has a hot arse'. Later he compounded the joke by signing another reproduction of the painting – this time unmodified – and giving it the title *LHOOQ Shaved* (1965). The nonsense game continued when Picabia wanted to put the original work on the front of a magazine he was editing. He could not get the original postcard from Duchamp in time, so he went out and bought one himself and added a moustache, but forgot the beard. Much to Duchamp's amusement it was published like that. Later, Jean Arp brought a copy of the magazine to show to Duchamp, who promptly added the beard and wrote an inscription in blue ink that read: 'moustache par Picabia/barbiche par Marcel Duchamp'. In this way, ridicule was heaped upon ridicule, in the juvenile game of joyfully destroying traditional art.

Towards the end of 1919 Duchamp made a startling discovery. By chance he met an early lover of his, an artist's model called Jeanne Serre. Back in 1910 they had enjoyed a brief affair and, unknown to him, the following year she had given birth to his daughter. The girl, Yvonne, was now seven years old and was being raised as the daughter of Jeanne's second husband. She would prove to be Duchamp's only child.

Early in 1920 he was back in New York again, posing bizarrely as a transvestite called Rrose Sélavy (= eros c'est la vie, 'eros, that's life'). In the following years he would shift back and forth a number of times between Paris and New York and it was in Paris in 1921 that he met André Breton. Breton was immediately impressed by Duchamp's intelligence and his ability to get to 'the critical point of an idea'. He recognized that Duchamp had 'the mind that one finds at the origin of every modern movement'. Breton had such respect for Duchamp that, later on, when surrealism had taken over from the Dadaist movement, he was always willing to treat him as an important presence, even though Duchamp never became an official member of Breton's inner circle. He would, however, later become a significant contributor to the major surrealist exhibitions from the 1930s through until 1947.

In 1923 Duchamp made the momentous decision to cease being a creative artist and to devote himself to playing chess. In this year he also began a secret affair with Mary Reynolds in Paris, who was described as a college graduate, a beautiful dancer, a war widow and a heavy drinker. Amazingly, their affair would last for twenty years, thanks to her forgiveness when he was bedding other women. She said that he was incapable of love and protected himself by having sex repeatedly 'with very vulgar women' who posed no threat to his neurotic need for complete freedom.

Both of Duchamp's parents died in 1925 and he received a modest inheritance but it was soon running out and, when he found himself penniless in Paris, he decided to take a wife and settle down. He was fed up with his vagabond existence of wandering around with a suitcase full of Picasso prints that he tried to sell to make ends meet. So in 1927 he married Lydie Sarrazin-Levassor, the sweetly innocent, overweight daughter of a wealthy industrialist. It was a callous undertaking that underlined the cruel streak in Duchamp's personality. He wrote to a friend describing Lydie as 'not even attractive'. He thought only of himself and treated his young bride as a 'hapless ready-maid', as one author aptly described her. Unfortunately for Duchamp, his new wife's astute father suspected that Duchamp was a cheap gold-digger and took the precaution of severely restricting the money he made available to his married daughter, condemning the marriage to failure right from the start.

Lydie would later write an account of their brief marriage using the title of Duchamp's work *The Heart of the Bride Stripped Bare by her Bachelor, Even*. In this, she recounted how a friend of her family was having an affair with Francis Picabia and that Picabia's forty-year-old friend Marcel Duchamp was seeking a wife. A meeting was arranged and Duchamp started courting her, seducing her with his charm. At their wedding, Picabia was the witness and Man Ray filmed the ceremony; afterwards they dined at Constantin Brancusi's studio. Lydie adored Duchamp and did everything she could to please him, even shaving off her pubic hair because of his hatred of female body hair. For a while she lived in Duchamp's studio, but then he managed to acquire a separate apartment for her and moved her out. He then told her that old-fashioned ideas of marriage were nonsense, that having sex was no more important than having a dinner for two, and that she should have affairs whenever she felt like it. At one point she became so upset by the way he preferred playing chess for

hours on end while she sat and waited for him to finish, that, one night when he was asleep, she glued all his chess pieces to the chess-board. After that, she only saw him on rare occasions and, within a few more months, the marriage had collapsed and she had divorced him for desertion.

The perversity of his character was extraordinary. He was offered good money to start painting again, but refused, saying he had done all he wanted to do and was not going to start repeating himself, just for cash. He was offered even more money to run a New York gallery, but again he refused. Instead, he lived a life of sponging off rich friends and occasionally winning chess contests. He also made money by issuing limited editions of his most famous readymades. He enjoyed a money-spinning arrangement with Arturo Schwarz in Italy, who produced for him copies of each of his most important objects. These sold well because every museum in the world wanted examples of his work. The local visitors to the museums, of course, were often ignorant of the fact that the fountain, bottle-rack or bicycle wheel they were looking at was not the original. In reality, the original 'fountain' was smashed up and lost after being rejected for exhibition, and the original bicycle wheel on a stool was thrown out by Duchamp's sister when she was clearing up the mess in his old Paris studio.

In 1946 Duchamp had an affair with Maria Martins, the attractive wife of the Brazilian ambassador to the United States. It lasted until 1951, when her husband was posted abroad. In 1954, at the age of sixty-seven, he married the American Alexina Sattler, the ex-wife of the art dealer Pierre Matisse, and the following year he became a naturalized American citizen. Known by the nickname Teeny, Duchamp's second wife had the advantage that she was a good chess player. More importantly, she had a generous divorce settlement from Matisse, who was paying a heavy price for having had an affair with Matta's wife Patricia. As a result, Duchamp was, at last, able to enjoy a pleasant lifestyle free of money worries, and he and his second wife divided their time between New York, Paris and Cadques in Spain. The marriage lasted for fourteen years, until Duchamp's death in 1968.

Despite Duchamp's often unscrupulous character, one has to admit that, even with his limited output, he nevertheless managed to change the course of modern art.

MAX ERNST

GERMAN • Member of Paris surrealist group; he was expelled in 1938 & again in 1955

BORN: 2 April 1891 in Brühl, near Cologne

PARENTS: Middle-class Catholics; father a teacher of the deaf, a disciplinarian

LIVED: Brühl 1891; Bonn 1909; German army 1914; Cologne 1918; Paris 1922; Southeast Asia 1924; Paris 1925; South of France 1939; New York 1941; Sedona, Arizona 1946; South of France 1953

PARTNERS: Married LUISE STRAUS, art historian and museum director, 1918–22 (divorced); one child (died in Auschwitz 1944) • GALA ELUARD 1924–27; ménage à trois with PAUL ELUARD • Married MARIE-BERTHE AURENCHE 1927–37 • LEONOR FINI 1933 • MERET OPPENHEIM 1934–35 • LEONORA CARRINGTON 1937–39 • Married PEGGY GUGGENHEIM 1941–46 • Married DOROTHEA TANNING 1946–76

DIED: 1 April 1976 in Paris

MAX ERNST WAS THE ULTIMATE surrealist. André Breton referred to him as 'my dearest friend' and said that he had 'the most magnificently haunted brain' of any of the surrealists. Ernst himself said, 'I believe the best thing to do is to have one eye closed and to look inside, and this is the inner eye. With the other eye, you have it fixed on reality, what is going on around you in the world.' This was a more profound description of the surrealist process than the extremism of André Breton, who demanded only the internal, irrational element. Ernst knew it was a synthesis between the unconscious inner eye and the conscious outer eye that would create memorable images.

Technically, he was the most exploratory of all the surrealists, restlessly inventive and forever trying out new techniques. Very early on he developed collage into a new art form. He experimented with frottage, with decalcomania, and with the addition of solid objects to embellish his paintings. He showed Jackson Pollock how to drip paint onto a canvas. His imagery ranged from near-realism to near-abstraction, with all the intermediary stages in between. It should be stressed, however, that his near-realism was never conventional. If he employed a traditional technique, it was always

Max Ernst in Arizona, 1947. Photo by Henri Cartier-Bresson.

combined with some outrageous subject matter, as with his painting of *The Virgin Spanking the Infant Jesus* (1926). And even his most abstract works always had a surrealist flavour.

Ernst was born in Germany a few miles from the city of Cologne, in 1891. His father was a teacher of the profoundly deaf and also a meticulous painter of traditional scenes. Max recalled how his father was completely dominated by the idea of accurately copying what he saw around him in the external world. On one occasion, for example, he had painted a landscape scene, but had omitted one tree that did not fit in with his composition. Later, to Max's astonishment, he chopped down the tree to make the real landscape match what was in his painting. The Ernsts were devout Catholics; his bourgeois father was good-natured but strict; his mother was loving and humorous with an appreciation of fairy tales. It was a 'not unhappy' childhood, he said later, but full of duties, duties, duties, especially as he had six younger siblings.

The young Ernst was fascinated and frightened by the mystery of forests and by telegraph wires. The story goes that, when he was five, he sneaked out of the house one afternoon to explore the secret of the telegraph wires. Barefoot, with blond curls, blue eyes, wearing a red nightgown and carrying a whip, he encountered a group of pilgrims who declared that he must be the Christ Child. Caught by the police and taken home, his father, when told this story, painted little Max as the Infant Jesus. From an early age, Max would watch his father painting and was soon doing so himself. He went on drawing and painting throughout his childhood, but never had any formal art training. At university he studied philosophy, art history, literature, psychology and psychiatry and became fascinated by the art of the insane, visiting asylums to study it closely.

In 1912, when he was twenty-one, he saw work by Pablo Picasso that made a big impact on him and in the same year he started exhibiting his own paintings. In 1914 he met Hans Arp in Cologne and they developed a strong friendship. Then war broke out and Arp fled to Paris. Max was called up to serve in the Field Artillery in the German army. The war years were a misery for him, although there was a glimmer of light in 1916 when he heard about the Dadaists and their activities in Zürich. In 1918 he was given special leave to get married; in 1914 he had fallen in love with Luise Straus, an art history student, and she was now an assistant director at a museum in Cologne. Not long after their wedding, a cease-fire was declared and he was released from

the army. He settled with his wife in Cologne and started a Dadaist group
there similar to the one in Switzerland, as an act of rebellion against the
society that had permitted the slaughter of the World War.

The following year he met Paul Klee (1879–1940) and also encountered
the early work of Giorgio de Chirico for the first time – both important influ-
ences on his own work. In 1920 he and Arp organized a Dada exhibition in
Cologne, with dramatic results. Angry visitors to the show destroyed some
of the exhibits, which had to be replaced with new ones. The organizers were
accused of fraud, pornography and creating a public scandal. The police
dropped the charges but closed the show. The twenty-nine-year-old Ernst
was now on the threshold of a life devoted to surrealism, a devotion that
would last for over half a century. In 1921, André Breton, then a member of
the Paris Dada group, contacted Ernst and invited him to hold an exhibition
in the French capital, which he did in the spring of that year.

Intrigued by his work, the French surrealist poet Paul Eluard and his
Russian wife Gala visited Ernst and his wife Luise in Germany and there
was an immediate attraction between Ernst and Gala. Their attachment for
one another developed headlong in full view of their spouses, and it exposed
a streak of cruelty in Max. One rainy afternoon when the four of them were
together, Max was being rude to Gala, causing his wife to remark that he
would never speak like that to her. Max's response was to say casually, 'But
I've never loved you as much as I love her'. The following year his marriage
collapsed and he moved to Paris, where he began a strange ménage à trois
with Gala and Paul Eluard. Living in Paris, Ernst had no money and had to
do odd jobs to survive. The Eluards took pity on him and let him stay with
them in their house, with Gala openly having sex with both men. Eluard
defended his role as a cuckold by saying that he loved Max much more than
he loved Gala, but this was a brave lie, for he loved them both and was in a
constant state of tension.

As time passed, Gala's attachment to the beguiling Ernst became stronger
than that to her husband and Paul Eluard's bold sexual experiment of sharing
his wife was starting to collapse. One night in 1924, he got up from his table
in a Paris restaurant, saying he was going to buy some matches, walked out
of the door, and simply vanished. Of the three of them, he was the one with
money and he now decided to spend some of it on a long voyage to the Far
East via the Pacific, to escape the pressures of his complex life in Paris. After

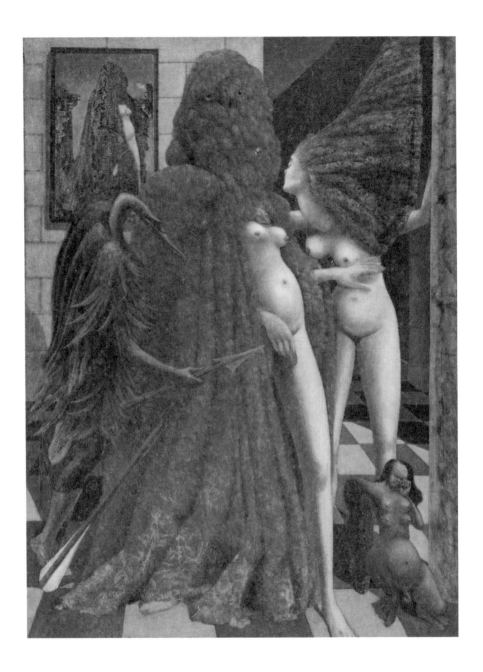

Max Ernst, *Attirement of the Bride (La Toilette de la Mariée)*, 1940.

he had crossed the Atlantic and reached the Panama Canal, he sent a letter to Paris asking Gala to follow him, saying 'I hope you pass this way soon'. In fact, she would take the other route to the East, through the Suez Canal and, instead of being alone, she would have Ernst with her.

She and Max had to sell a large number of paintings from Eluard's collection to raise the fare, and this took some weeks. Sixty-one works were sold altogether, including six Picassos and eight de Chiricos. It was a high price to pay for solving a love triangle. They set off for Singapore, where they met up with Eluard, who had arrived there via Australia. Then, reunited as a trio, they sailed together for Saigon. Once there, it was Eluard who came off best. Gala, a woman who always had one eye on the money, was now forced to choose between the two men in her life; she opted for the bank account of her husband over the seductive charm of the impecunious Ernst. The Eluards sailed for home in comfort on a Dutch liner. Ernst followed them a month or so later on a scruffy little steamer, after exploring more of Southeast Asia by himself. In the long term, however, it was Ernst who would benefit most from this strange episode. Eluard would soon lose his wife to Salvador Dalí and Ernst's work would be greatly enriched by his experiences of the exotic flora and fauna, and the unfamiliar cultures and arts, of the Far East.

Back in Paris, Ernst kept his distance from Gala but, amazingly, his friendship with Paul Eluard endured and they cooperated on a number of surrealist projects. In need of female company, in 1927 Ernst began a passionate romance with a teenager called Marie-Berthe Aurenche. Her parents were furious and called the police, claiming that he was interfering with a minor, but he and the girl managed to elope and get married. They remained a married couple for the next ten years, but during that time Ernst the womanizer was in action once again and there were a number of infidelities, including two notable affairs with female surrealists – Leonor Fini in 1933 and Meret Oppenheim in 1934. Then, in 1937, Ernst fell deeply in love with a young English artist, Leonora Carrington. Carrington was a twenty-year-old art student when she met the forty-six-year-old Ernst at a dinner in his honour in London. She already knew his work and found it fascinating. Encountering him in person, she also found his sexual charisma irresistible and soon followed him to Paris. Again, there was parental fury and, in this case, a failed attempt by her rich father to get Ernst arrested

for pornography. In Paris, Ernst and Carrington became inseparable and his marriage to Marie-Berthe collapsed.

The following year, 1938, saw Ernst and Breton clash. On political grounds, Breton had severed all contact with his old friend and ally, Paul Eluard, and was now insisting that all official members of the surrealist group should do everything in their power to ruin Eluard's reputation. Ernst would have none of this and was so resentful of Breton's pettiness that he left the surrealist group, thereby robbing it of one of its key figures. He and Carrington moved out of Paris and spent a year or so living blissfully together in rural France. Carrington later described this as her period of paradise. It was ruined by the outbreak of World War II, an event that saw the German Ernst interned and Carrington stranded and alone. She had a complete nervous breakdown and the next time she saw Ernst was in Lisbon, where they were both trying to escape Europe and travel to the United States. He was still in love with her, but her breakdown had destroyed her feelings for him and she rejected his pleading that they should rekindle their relationship.

It was the rich American Peggy Guggenheim who rescued Ernst and got him safely to New York. There, he and Peggy entered into a marriage of convenience in December 1941 to enable him to stay in the city. It only lasted for a couple of years before they became separated, and in 1943 he started an affair with the American surrealist Dorothea Tanning. Ernst and Guggenheim were divorced in 1946 and he immediately married Tanning at a ceremony in, of all places, Beverly Hills. It was a double wedding, shared with Man Ray and Juliet Browner. Following their Los Angeles wedding, Ernst and his new wife settled in Sedona, Arizona, where they bought some land and built a house. Two years later, Ernst became an American citizen. In 1949 he and Dorothea visited Paris and he was able to meet up again with his old friends. Throughout the 1950s he would divide his time between the house in Arizona and studios in France.

In June 1954 Ernst was delighted to win the financially rewarding Grand Prize at the Venice Biennale. The young, more zealous members of the official surrealist group that had re-formed around the now aging André Breton were not happy about this award. They felt that it was against the strict, disciplinarian rules of the surrealist movement and a meeting was called to expel Ernst from the movement for a second time. Breton, who had long ago forgiven Ernst for his self-expulsion when he supported Paul Eluard

in 1938, opposed the eager young guns, but was overruled by a democratic vote. News of this expulsion hurt Ernst, who had been attending some of the meetings in the 1950s, and who saw nothing wrong with accepting the Biennale prize. He was, in fact, sufficiently annoyed to make a rather blunt riposte: 'It seems to me that all those who have made the discoveries and the greatness of surrealism, have over the last twenty years either left or have been excluded. For me, surrealism will continue to be represented by poets such as these, rather than by the mediocrities clinging to the masthead of André Breton. No wonder he is lonely! I feel sorry for him.'

Despite this rejection, in 1958 Ernst changed nationality again, this time becoming a French citizen and in 1964 Ernst and Dorothea settled in the south of France, where they would stay until his death in 1976. He seemed to have reached an age when his sexual adventures were in the past and he was finally able to enjoy a relaxed married existence with Dorothea for the last thirty years of his life. During this final period, he also enjoyed many major exhibitions and a global acceptance of his work. In 1966 France awarded him the Légion d'honneur and he was flattered when the poet René Crevel summed him up by giving him the title 'Max Ernst, the magician of barely detectable displacements'.

Leonor Fini, 1936. Photo by Dora Maar.

LEONOR FINI

ITALIAN • Associated with the surrealists but never joined the group

BORN: 30 August 1907 in Buenos Aires, Argentina

PARENTS: Father an Argentine businessman & religious zealot; mother Italian

LIVED: Buenos Aires 1907; Trieste, Italy 1909; Milan 1924; Paris 1931; Monte Carlo 1939; Rome 1943; Paris 1946

PARTNERS: PRINCE LORENZO ERCOLE LANZA DEL VASTO DI TRABIA 1931 • ANDRÉ PIEYRE DE MANDIARGUES, a writer, 1932 • MAX ERNST 1933 (briefly) • JULIEN LEVY, an art dealer, 1936 (briefly) • Married FEDERICO VENEZIANI 1939–45 (were lovers in 1937) • STANISLAO LEPRI, Italian Count, 1941–80 (when he died) • SFORZINO SFORZA, Italian Count 1945–52 (remained friends) • CONSTANTIN JELENSKI, Polish writer, 1952–87 (when he died)

DIED: 18 January 1996 in Paris

LEONOR FINI WAS ONE OF THE EXOTICS of the surrealist movement, as fascinating in her person as in her art. Her adult love life was colourful to say the least, but the dramas in her life story began much earlier, when she was still a baby. Fini was born in Argentina in 1907, the daughter of a rich, highly religious Argentinian businessman and an Italian mother. Before she was even one year old, her parents had ended their relationship badly. The following year, her mother scooped up her infant and fled back home to Italy. This made Leonor's tyrannical father furious and he hatched a plan to kidnap his daughter and have her brought back to Argentina. He hired some men to do this and they grabbed Leonor as she walked down a street in Trieste. Their attempt was foiled by some passersby who rescued her as she was being carried away.

Leonor's mother fled south, in case there was another kidnap attempt. Terrified that she would lose her child, she adopted the subterfuge of pretending that she had a son. She disguised Leonor as a boy whenever they ventured out of the house and this trick seemed to work. She kept this up for six anxious, stressful years until at last the father gave up and admitted

defeat. As the childhood years passed, Leonor turned against religion and would become a lifelong atheist. At school she was a rebel and was expelled three times. Her mother found that the one thing she loved was drawing and sketching and started to encourage this.

At this point, it looked as though Leonor Fini could at last start to enjoy a normal existence, but it was not to be. After a few years, when she reached her early teens, she developed a serious eye disease – rheumatic conjunctivitis. As part of the cure, she had to wear bandages over her eyes for two and a half months. During this enforced darkness she started to fantasize and create an inner world of her own. She may have cursed the bandages that cut her off from typical teenage social life, but in the long run they served her well. They were instrumental in fostering her obsession with visual fantasies and with placing on canvas or paper her innermost thoughts. As soon as she was able, Fini plunged into the world of art galleries, art museums, art history and art books and was soon, at an early age, creating images that caught the eye of established artists in Italy.

During this period she developed the curious habit of visiting mortuaries to look at the corpses there. She would stare at them for ages, until they became pure aesthetic forms. She wrote that 'after my visits to the morgue I admired the perfection of the skeletons, the fact that they are the least destructible parts of the body, and ... can be reconstructed like beautiful sculptures'. She held her first solo exhibition in Milan at the age of twenty-two, and began protesting against authority by dressing in an unconventional way and adopting an eccentric public persona. She had become a natural surrealist, both in her images and her personal behaviour. There was only one place where she could freely express herself and that was Paris – the centre of the avant-garde.

At the age of twenty-four Leonor fell in love with a handsome young Italian prince and, much to his mother's dismay, he moved to Paris with her and they set up home together. The young man's mother could not accept that her son would live with a woman who was so strongly opposed to marriage, family life and bearing children. She need not have worried because the relationship soon collapsed and the prince returned to Milan the following year, leaving Leonor behind in Paris. She lost no time in finding a new lover. In the summer of 1932 she met a writer called André Pieyre de Mandiargues in a hotel bar and within a week had moved to his flat. Although

in the years ahead she would take many other lovers, she always maintained a close friendship with Mandiargues and between 1932 and 1945 it is known that they exchanged a total of 560 letters.

In the social whirl of the French capital Fini proved to be an overnight success. The surrealists wanted to meet her and she appeared at the designated café dressed as a cardinal, saying she wanted to find out how it felt to wear the clothes of a man who would never know a woman's body. Max Ernst, René Magritte and Victor Brauner were all excited by the startling new arrival and introduced her to the regular surrealist meetings. However, although she was surrealism personified, things did not go smoothly. She took an intense dislike to Breton's authoritarian control of the group and considered his endless tracts, theories and manifestos to be the sign of a 'typical petit bourgeois mentality'. She would have none of it and shocked those surrealists who admired her unconventional approach to life when she refused to join their group. She accused Breton of being both a misogynist and a homophobe and she was correct on both counts. As a protest she announced that she was not a surrealist, but what she meant was that she was not one of Breton's surrealists. In reality she behaved and painted in a totally surrealist manner but did so as an independent rather than as a party member. According to one observer she was 'the embodiment of the surrealist ideal ... equalled by few surrealists'.

Fini's beauty became the talk of Paris. When she went to a party or a private view at a gallery, she always made a dramatic entrance, dressed outrageously in extreme forms of haute couture. Picasso became infatuated with her and Paul Eluard wrote poems to her. Jean Genet composed letters of praise about her and Jean Cocteau called her a 'divine heroine'. Max Ernst was fascinated by her 'scandalous elegance' and soon became her lover, but she had reservations about him because she discovered that he was always involved with four or five women at the same time. She developed a close intimacy with the photographer Henri Cartier-Bresson (1908–2004) and they travelled to Italy together, where he took some highly explicit photographs of her. It is not clear just how close they became, but much later, in an interview, he remarked that his body still bore the claw-marks of Leonor Fini. Whether these were real or metaphorical we do not know.

When Julien Levy, an American art dealer, visited Fini in Paris in 1936, he described her as having the 'head of a lioness, mind of a man, bust of a

woman, torso of a child, grace of an angel, and discourse of the devil'. They had a brief affair and he introduced her to Salvador Dalí. Dalí was a little wary of her, probably because he spotted that, in terms of showmanship, she was a female version of himself and therefore a potential rival. Her relationship with Julien Levy ended badly when Leonor was visiting New York for an exhibition he was giving her there. In a letter she wrote: 'This morning I quarrelled with Levy, who was drunk ... I kicked him ... He slapped me and I spat in his face. Then he threw me to the ground. So I scratched him and punched him in the face and I took a large glass plate ... and launched it into the air ... which broke into a thousand pieces ... Levy was furious ... He said he would smash my paintings. I replied that I would strangle his grandchildren, then I threw the pieces of glass in his face.' The moral is – you don't mess with Fini.

When the war came in 1939, Fini left France for Monte Carlo. While she was there she married her Italian friend Federico Veneziani. They had become lovers back in 1937, and that was how their relationship was supposed to remain but, as he was Jewish, she felt that marriage to her might afford him some protection. However, before long, she met the Marquis Stanislao Lepri, an aristocratic Italian diplomat, and started a passionate affair with him in 1941. Their loving relationship would survive for many years, even after she had acquired other lovers. She painted his portrait and kept it in her bedroom for the rest of her life. When her husband Federico found out about her affair, it was the end of their marriage-of-convenience, which was finally annulled in 1945.

At the height of the war, in 1943, she and Lepri moved to Rome, where he gave her a revolver to defend herself if the need arose. It was a troubled, violent time, and she was greatly relieved when the Americans liberated Rome in 1945. Along with the liberators came a handsome young Italian Count, Sforzino Sforza, who had taken on American citizenship. She fell in love with him and they started an affair. In 1946, with the war over, she returned to her beloved Paris. It was at this point that she began to acquire a whole menagerie of pet cats, the only 'children' she would ever care for. She also developed the habit of surrounding herself with both past and present lovers – an entourage that she somehow managed to control without any outbreaks of animosity between the men involved. The building in which she settled in Paris also housed André Pieyre de Mandiargues, Stanislao Lepri

and Sforzino Sforza. They even took their holidays together and the press referred to the arrangement as the 'Republic of Leonor'.

In her own apartment, she was soon living in a surreal world, surrounded by as many as twenty-three cats. Her favourite breed was the long-haired Persian and they often featured in her paintings. They also shared her bed and were allowed to roam the dining table searching for tasty morsels of food. Any guest who complained about this was in serious trouble. If one of her cats became ill, she sank into a deep depression. Like several of the female surrealists, she hated the idea of giving birth, saying 'I have never been attracted by fecundity' because it involves 'a humility nearly inconceivable in the modern world ... a brutalized passivity ... Physical maternity instinctively repulses me.' She once said that the only time she felt suicidal was on

Leonor Fini, *The Ends of the Earth*, 1949.

the one occasion that she became pregnant and there was some difficulty in arranging an abortion. Her return to Paris heralded a period of creative productivity and solo exhibitions. All was going well when, in 1947, she fell ill and underwent a serious operation to remove a tumour. Part of the operation involved a hysterectomy, which she was delighted to have, because it ruled out even the faintest possibility of bearing a child.

At about this time, she happened to mention that, in addition to the many men in her life, she also occasionally enjoyed making love with women. It was the erotic tenderness of making love with a woman that seemed to appeal to her and she made a point of saying – mentioning Max Ernst, Julien Levy and Stanislao Lepri by name – that she did not like the demands of some men who wanted to have 'frenetic sex'. Making public her interest in female bedmates caused quite a stir. Well known as a glamorous, dominant, independent female celebrity in Paris, she was then targeted by eager, activist lesbians seeking her support for their cause. 'They harass me like flies,' she said, 'I find all these feminists grotesque.'

In 1952, during a visit to Rome, Fini met the Polish writer Alexandré Constantin Jelenski, whose nickname was Kot. She was delighted when she discovered that this was Polish for 'cat' and they quickly became lovers. He followed her back to Paris and joined her entourage. He would become a major figure in her life, managing her business affairs, organizing her exhibitions and protecting her from the mundane intrusions of daily life so that she could devote herself to her painting. For the rest of her years, Fini the artist enjoyed a productive life in Paris, accepting commissions for portraits, set designs and costume designs, although her main focus always remained her painting. Her social life was as busy as ever and in the 1960s she decided to have a facelift to maintain her glamorous reputation.

Fini's paintings were always technically skilful and in all her best work there is a sense of some strange ritual taking place, fuelled by unconscious thoughts from the deeper recesses of the artist's brain. Sexual tension is clearly a major theme in almost all of her imaginative work, and it is this for which she will mostly be remembered. When she died in 1996 at the age of eighty-eight, her obituaries spoke of her creation of 'an erotic dream-world where women were in control ... a world of dream or nightmare'. One art critic commented that it was impossible to think of her as being old, describing her as 'the vampire we would most like to visit us'.

WILHELM FREDDIE

DANISH · Danish surrealist who was imprisoned for his work

BORN: 7 February 1909 Copenhagen as Wilhelm Frederik Christian Carlsen

PARENTS: Father a laboratory supervisor at the University Pathology Institute

LIVED: Copenhagen 1909; prison in Copenhagen for 10 days 1937; Copenhagen 1937;
Stockholm, Sweden 1944; Copenhagen 1950

PARTNERS: Married EMMY ELLA HIRSCH 1930 (died 1934); one child in 1929
· Married INGRID LILIAN BRAEMER 1938 (dissolved 1953); one child
· Married ELLEN MADSEN, a teacher, 1969–95

DIED: 26 October 1995

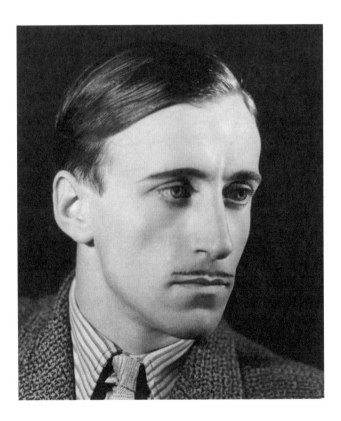

Wilhelm Freddie, January 1935. Photographer unknown.

THE DANISH PAINTER WILHELM FREDDIE has the distinction of being the only surrealist artist to have been imprisoned because of the images in his works of art. Today they would hardly raise an eyebrow, but in the 1930s, when he first attempted to exhibit them, they brought the wrath of the establishment down on his head. He was a total surrealist who would accept no compromise and would resist any attempt to persuade him to modify his work. He made his position clear when he said: 'Surrealism is neither a style nor a philosophy. It is a permanent state of mind.'

Freddie was born in Copenhagen in 1909. His father was a supervisor in the Institute of Pathology at the University and Freddie spent many hours there during his early years. As a teenager, being surrounded by pickled embryos, detached limbs and preserved bodies in glass jars had a darkly stimulating effect on his youthful imagination. For nearly two years he had an apprenticeship carving sculpture in wood, but then, at the age of twenty, he discovered the surrealist movement that was flourishing in the late 1920s in Paris. It made a huge impact on him and the following year he was the first person to introduce surrealism to the Danish public, with a painting that he submitted to the Autumn Exhibition in Copenhagen in 1930. The reaction to his painting was negative in the extreme, one critic saying that anyone who considered buying it should be locked up. This did not deter him and in 1931 he had his first solo exhibition in Copenhagen. This time, a critic wrote, 'Without doubt, he is in need of fresh air'. In 1930 Freddie had married Emmy Hirsch, with whom he had already had a son. Sadly, she died in 1934 aged only thirty.

In 1935 Denmark saw its first ever International Surrealist Exhibition, with all the major figures of the movement showing their work. The Danish art critics maintained their assault on surrealism, describing the works as 'the depths of all that is disgusting and nauseating'. A few months later, Freddie tried his luck in nearby Norway. In a mixed exhibition in Oslo, he incurred the wrath of the head of the Norwegian diplomatic corps, who included the words 'dirty, smutty, brutal, perverted, foul, and depraved' in his description of the work on show. He threatened to have the exhibition closed down. Freddie was not put off by this and had several more exhibitions before the end of the year. One of these shows was described as pornographic by a well-known psychiatrist, and the police removed one of Freddie's paintings from the window of the gallery.

The following year Freddie visited Paris, where he met Alberto Giacometti, and Brussels, where he met René Magritte. Through his contacts with the other surrealists he was invited to send work to the big International Surrealist Exhibition being organized in London. He sent five works: two paintings, a surrealist object and two drawings. The drawings got through because he posted them directly to the show's organizers, but the other three works were confiscated by the British customs as pornographic. The law stated that they must be destroyed, but after vigorous interventions by the organizing committee of the exhibition, the authorities relented and sent them back to Denmark in a sealed box. On hearing about this, Danish journalists had no sympathy, asking why Danish customs couldn't ban them too.

Later that year Freddie's paintings were sent to a Danish festival but were taken down by the festival's director who declared, 'If anyone puts them back I will have them thrown out'. Also in 1936, he exhibited in Odense, but the local police commissioner visited the show before it opened and had certain of his works removed. In the autumn of that year, one of his paintings on show in another exhibition was so savagely criticized by other artists that Freddie himself withdrew it in protest. Even the King of Denmark got involved. Looking at one of Freddie's paintings he asked, 'Has this man been locked up?' The following year that is precisely what happened.

Freddie held a show of his work in a Copenhagen restaurant in 1937. Saboteurs tried to close the show and one of them jumped on Freddie and attempted to strangle him. As a result, the police confiscated all the exhibits. He did not get them back for three months, but then promptly put them on show again in a Copenhagen gallery. This time the German authorities demanded the removal of one of the paintings that they found offensive towards Hitler. The Danish authorities complied, the painting was removed and Freddie was told that he could never set foot in Germany. After a prolonged court case, Freddie was fined one hundred crowns and sentenced to ten days in prison for producing pornography. Three of his works were confiscated and he would not see them again for many years.

In 1938 Freddie married again, this time to Ingrid Braemer. With the arrival of World War II, his situation became hazardous. When Denmark was occupied by the Nazis in 1940, many Danes were sympathetic towards the Germans and Freddie's life, as a 'degenerate' artist, was not easy. On one occasion, a gang of youths accosted him in the street, called him a pervert

and spat in his face. Matters worsened and in 1943 he had to go into hiding. The following year he was told that the Gestapo were searching for him and he had no choice but to flee the country. He travelled north to Sweden where, after spending some time in a refugee camp, he ended up living in Stockholm. He was able to paint and exhibit there, and at last, his work attracted more favourable reviews.

After the war he received a long, friendly letter from André Breton urging him to participate in a major surrealist exhibition that he was organizing in Paris. Freddie did so and visited the show where, for the first time, he met Breton. Although he was deeply impressed with Breton's role in controlling and promoting the surrealist movement, he did not take to him as a person, commenting, 'He is a man that likes people to dance attendance on him and that doesn't suit my book very much'. He bonded well with some of the other surrealists, however, and, most importantly, his work was praised at last – something he must have thought would never happen. It was the start of a new period in his life, with his art at last being fully appreciated. In 1950 he left Sweden and returned to his hometown of Copenhagen. His six years of exile were finally over.

Such were the early life and times of the Danish rebel, Wilhelm Freddie. He was an undiluted surrealist who refused to kowtow to the Danish authorities, at considerable cost to himself. He could have toned down the erotic content of his pictures and enjoyed a quieter life, but this he was not prepared to do. He fought for the right of the artist to express himself in any way he wished and, I suspect, privately enjoyed the scandals that he created.

The second half of his life was filled with far less negativity. It must have come as something of a shock for him to read the words of a German reviewer of an exhibition of his paintings in 1953 that said, 'I estimate that Freddie is one of the most important artists in Europe today'. A few years later, a French critic wrote 'Freddie's works are all richly significant'. The tide had finally turned in his favour and, in 1961, this emboldened him to apply for the return of his confiscated works of art – the three paintings of his that had been kept in the criminal museum in Copenhagen since 1937 when he was convicted of exhibiting pornography. A Danish magazine supported him, demanding the return of these paintings to put right 'an absurd and shameful mistake in Danish cultural jurisprudence'.

After much deliberation, the authorities refused to return the three works, so Freddie, still with fire in his belly, defied them by making exact copies of them, which he exhibited at a gallery in Copenhagen. The artist Asger Jorn (1914–1973) went to the show with the intention of buying one of the works and donating it to a museum, but the police arrived and closed the gallery within minutes of its opening. To make matters worse, they then confiscated the three copies of the original works. There followed endless

Wilhelm Freddie, *My Two Sisters*, 1938.

legal wrangling, but this time Freddie had many people on his side. When he was finally called to court in 1962, his counsel stated, 'It is a case without precedent in world history, an artist is held accused for his manner of painting'. Despite this, Freddie was found guilty on ten counts and fined twenty crowns, provoking a public demonstration in his favour. The following year the case went to appeal and, at last, all of Freddie's confiscated works were returned to him by the police. It was the end of a surrealist legal drama that lasted for thirty-six years.

On the occasion of an exhibition of his work in Copenhagen in 1965, Freddie was glowingly described by an art critic as, 'Our first real artist. Our first surrealist. One of the few Danes on the international scene.' By the end of the 1960s, he was being given retrospective exhibitions and his works were being acquired by museums. The battle had finally been won. Flushed with victory, some of the critics spilled over into hyperbole and Freddie must have been embarrassed when he read, 'By his struggle against hypocrisy and towards the freedom of man, Freddie has helped mankind'. In 1969 Freddie married his third wife, Ellen Madsen, a teacher, and together they travelled abroad to attend his exhibitions, not only in Europe, but as far away as Japan. In the later years of his life he received honours for his work and his early troubles faded into history. In 1970 the Danish Academy of Fine Art awarded him their Gold Medal, the highest honour that can be bestowed on a Danish artist.

José Pierre, renowned historian of the surrealist movement, described Freddie as 'one of international surrealism's greatest figures'. Despite this, he is not as well known as the other major surrealists. The reason for this is essentially geographical; he was too isolated from the main group. Had he moved to Paris when he first discovered surrealism in 1929, and integrated with Breton's circle there, he might have fared better, but his lonely defence of surrealism in Scandinavia cut him off. This is neatly summed up in the title of the catalogue of his first ever solo exhibition in London, which did not take place until as late as 1972: 'Where has Freddie been?'

ALBERTO GIACOMETTI

SWISS • Member of the surrealist group in Paris from 1930; left it in 1935

BORN: 10 October 1901 in Borgonova, Graubünden, Switzerland

PARENTS: Father a post-impressionist painter

LIVED: Borgonova 1901; Paris 1922; Geneva 1941; Paris 1945

PARTNERS: FLORA MAYO 1925–27 • ISABEL DELMER 1945 • Married ANNETTE ARM 1946 (until his death) • CAROLINE TAMAGNO 1959 (until his death)

DIED: 11 January 1966 in Chur, Graubünden, Switzerland

GIACOMETTI'S LIFE AS AN ARTIST was, as they say in football, a game of two halves. In the first half he created some of the most exciting surrealist sculpture ever seen. In the second half he abandoned surrealism and focused on making elongated, emaciated, rough-surfaced human figures in bronze that make L. S. Lowry's matchstick men look overweight.

Giacometti was born at the turn of the last century in a small village in the Italian-speaking region of the Swiss Alps. His father was a post-impressionist painter and, with his encouragement, Alberto started sketching from nature when he was only nine years old. By the age of thirteen he was already an accomplished painter and later attended art school in Geneva to study sculpture. With his father's guidance, he was able to study the great art of the past in Venice, Rome and Florence. When he was only twenty he arrived in Paris, which would become his home for the rest of his life. For several years he was trained in making sculpture from nature, but gradually a feeling came over him that it was impossible to do natural forms justice and he abandoned that work and began to make figures from his imagination. His fellow students, recognizing that he was unusual, said he would either go far or go mad. They called him the crazy genius and played jokes on him, which he took with good grace.

His relationship with girls was strange. He loved staring at their faces with the eyes of a sculptor, but always avoided getting emotionally involved. He much preferred the company of prostitutes because, he said, with them

you only have to pay up front and that is the end of it; with a girlfriend you have to keep on paying. The penalty for this attitude was a life that frequently involved solitude which, however, he seemed to relish. There was one exception in the shape of a young American woman called Flora Mayo. She arrived in Paris in 1925 and enjoyed a brief affair with Giacometti, the climax of which was when, with her permission, he carved his initial into her arm with the penknife that he used to carve his initials on his statues. It was as if, bizarrely, having made love to her, he then saw her as one of his works and therefore she had to be signed. Even in his amours, such as they were, he remained a sculptor first and a lover second. Flora wanted to marry him, but a childhood ailment had made him sterile and he was not interested in settling down.

Giacometti had three studios in Paris, the first two briefly and the third one for the rest of his life. This last one was so small and primitive that he had to sleep in a nearby hotel until he could afford to buy the studio next door, to use as his living quarters. He was never interested in creature comforts and, even when he was rich towards the end of his life, he still lived a simple existence, obsessed with his work.

His first imaginative sculptures were influenced by cubism but then, in 1929, he met André Masson and, through him, the other surrealists, who were in the first flush of their exciting new art movement. He became an official member of the group and at the age of twenty-nine exhibited his new work alongside that of Joan Miró and Hans Arp. He now became active at the surrealists' meetings, signed some of their formal declarations and exhibited in their group shows. For four and a half years, between 1930 and 1935, he was a dedicated follower of André Breton and the surrealist circle. His first one-man show in Paris was in 1932 and he had another in New York two years later. In order to earn extra money, he made designs for such things as lamps and chandeliers. His brother Diego would take these designs and produce the objects for sale. Diego was important to Alberto, helping him in his studio with practical matters such as making his casts, setting up his armatures and patinating his bronzes.

A valid question about surrealist sculpture is how can it be made intuitively, directly from the unconscious mind? The act of painting can be a more direct process that lends itself to the immediacy of an idea, but sculpture involves complicated practical procedures that take time. Giacometti took

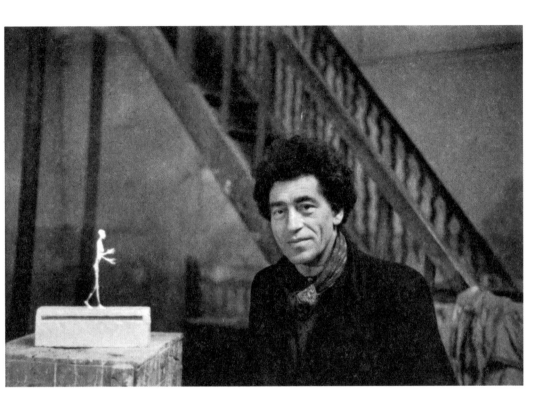

the trouble to answer this question in his own words: 'I have only realized sculptures which have presented themselves to me in a finished state ... forms which are very close to me although I am often incapable of identifying them, which always makes them more disturbing to me.' In other words, he produced his surrealist sculptures in the same way that René Magritte, for example, painted his surrealist pictures. With both artists, the irrational moment of visual discovery was made before the work began. Then, the surrealist image would be carefully retained in the mind while the detailed and often time-consuming work was carried out.

Alberto Giacometti in his studio in Paris, 1945–46. Photo by Henri Cartier-Bresson.

Giacometti's works of 1932, such as *Woman With Her Throat Cut* and *The Palace at 4am*, would become surrealist icons. His pure surrealist phase was, however, short-lived thanks to the impact of the work of a close friend of his, the Polish artist Balthus (1908–2001). When Giacometti visited an exhibition of his works at the Galerie Pierre in Paris, he was so profoundly moved by the skill of his young friend that he made the momentous decision to return forthwith to figurative art and to turn his back on surrealism. In 1935 he started working from nature again, often using his ever-helpful brother Diego as a model. The surrealists were horrified by this change and it was decided that he should be excluded from the group. Yves Tanguy declared 'he must be insane' and Max Ernst (correctly in my view) said that, in leaving his surrealist work behind, their Swiss friend was giving up the best part of himself. At a surrealist meeting, matters came to a head, but when Giacometti found himself being criticized, he exploded. 'Everything I have done until now has been no more than masturbation,' he told a shocked André Breton. A formal expulsion was about to be administered by Breton, but before he could organize this, Giacometti cried out, 'Don't bother, I'm going', and swept out. It was the final moment of his involvement with surrealism.

During the late 1930s he stopped exhibiting and earned his living by making decorative objects with his brother. In 1938 he was involved in a road accident when a drunken driver ran over his right foot and crushed it. He was in a cast for weeks and then on crutches for a long time after that. It was a period of deep thought for him and for taking stock. With the arrival of the 1940s came a new phase in his sculpture, a phase that would last for the rest of his life. His work remained figurative, but now it was created from the imagination rather than from a model. An obsession developed that frightened him. He said, 'to my terror the sculptures became smaller and smaller ... they became so minuscule that often with a final stroke of the knife they disappeared into dust.' Despite his apprehension, he worked on these minute figures until he left Paris in 1941 and went to Geneva to visit his widowed mother. Unable to return to Paris because of visa restrictions, he stayed in a hotel in Geneva for three years, making more of these tiny pieces. It was during this time that he met Annette Arm, who would join him in Paris in 1946 and become his wife. Towards the end of 1945, Giacometti had a brief affair with Isabel Delmer, an old friend of his, but it only lasted for a few months, ending, to his dismay,

when she walked out of a party with a handsome young musician she had met earlier that evening.

There is a legend that, when Giacometti returned to France after the war, he carried several years' work with him in a handful of matchboxes. His brother, who had stayed behind to mind his studio, was not impressed. There was nothing to sell and they needed money to survive. Back in his Paris studio, Alberto now started work on what would become his famous, skeletal figures. His tiny figures grew taller and taller, but retained their emaciated body shape. It was a unique case of sculptural anorexia and, just as anorexic individuals feel that they are fat even when they are skinny, so too did Giacometti feel that his figures were overweight even when they were little more than vertical rods. In his own words, 'all I do is subtract, yet it keeps getting so big that I have the impression it's twice as thick again as it really is. So I have to go on taking more and more off.'

Frustratingly, he was never satisfied with his new work. His obsession with thinness was so extreme that one gets the impression that he would only have been truly content if he could have created a standing human figure that was one metre tall and one millimetre thick. He once said, 'From 1935 on I never made anything the way I wanted, not even once'. How amazed he would have been had he been alive to see one of his spindly figures sell at an auction in America in 2014 for over $100 million. In 1947 Giacometti exhibited these figures for the first time at a show in New York. Throughout the 1950s he had many more major exhibitions of this later work in France, Switzerland, Italy, Germany, England and America. He became internationally famous and, at last, had plenty of money. Despite this, his lifestyle did not change.

His daily routine was unusual, to say the least. He would get to bed at about 7 a.m., sleep for seven hours and rise at 2 p.m. After washing, shaving and dressing, he would walk to a nearby café, drink several cups of coffee and, despite his severe smoker's cough, smoke half a dozen cigarettes. He would then work in his studio until about 7 p.m., when he would return to the café, eat ham and eggs, drink some wine and more coffee and smoke many more cigarettes. Back in the studio, he would then work again until midnight or even later. After this he would take a taxi to Montparnasse, enjoy a good meal, and then visit the local bars and nightclubs. Before dawn he would taxi back to his studio and work again on his sculptures until it was

daylight, when he would finally fall into bed. It is little wonder that he looked much older than his real age.

His wife Annette slept normal hours. It was a strange relationship, and tensions were beginning to show. In 1956, at a party given in his honour, an attractive young admirer of his work came up to congratulate him and he impulsively kissed her on both cheeks. To everyone's horror, his wife Annette starting screaming with rage and then rushed out. She had some reason to be angry with her husband. Now that he was rich and famous he was generous with money with everyone but her. He gave plenty to his brother, his mother and even the girls he met in the bars of Montparnasse when they were down on their luck. But he expected his wife to live the same simple, frugal existence that he imposed upon himself. His clothes were so shabby that an old lady in a bar once offered to buy 'that old tramp over there' a cup of coffee. Told that he was a famous artist, she refused to believe the barman and insisted on helping the poor old boy out.

Later in 1956 Giacometti found an unusual way to make his wife happy. A Japanese professor who was visiting Paris was posing for a portrait by Giacometti when it became clear that he was attracted to Annette, and she to him. Giacometti deliberately left them alone together and they began a passionate affair. Far from being jealous, he encouraged it and gave them many opportunities to be by themselves. He was so pleased to see how happy this made his wife that, when their new friend had to return to his own wife and family in Japan, they were both deeply saddened by his departure and begged him to return. This he did, and the ménage à trois repeated itself for several more months.

In 1959 Giacometti began an affair with a twenty-one-year-old prostitute who called herself Caroline. As he got to know her, he discovered that she was in fact involved with gangsters and robbers. He was fascinated by her, but, at this point, something unusual happened. The Hollywood star Marlene Dietrich arrived in Paris with forty-four pieces of luggage and a strong desire to meet Giacometti, whose work she had seen, and loved, in New York. She sat in his dusty little studio, watching him work. She drank with him in his local bar, where nobody recognized her. He was entranced and gave her one of his sculptures. His gangster's moll, Caroline Tamagno, was not happy about this, and at one point issued an ultimatum to him – either you stand her up when she is expecting you, or I am finished with you. Surprisingly,

Alberto Giacometti, *Woman With Her Throat Cut*, 1932. Bronze.

Giacometti obeyed her and failed to keep his next appointment with Marlene. Soon the great star had swept out of Paris, but she did cable him her good wishes from Las Vegas shortly afterwards.

His affair with Caroline continued but then, in 1960, she suddenly vanished. He investigated and found that she was in prison accused of committing a crime of some sort. When she reappeared some weeks later, Giacometti decided to make her his principal model, much to the annoyance of his wife. After this, there were shouting matches in public places, with Annette hurling abuse at her husband at the top of her voice. His brother Diego was also becoming hostile towards Caroline, viewing her as little more than a tawdry whore who was fleecing Alberto. Eventually, Giacometti solved his difficult domestic situation by buying an apartment for Annette, another for Caroline and a house for Diego. His exhibition successes meant that he now had plenty of money to spare and was able to keep everyone happy while he himself could remain in the dingy, cramped quarters he loved so much.

The following year he was angry when Caroline announced without warning that she was now married. But the crook who had become her husband was soon in jail and she promptly divorced him. Once again, she was the centre of Giacometti's life and he lavished money on her. She was

becoming eccentric, filling her apartment with pets, including thirteen toads, a dog, a cat and a tame crow. Annette, his long-suffering wife, became insanely jealous as Alberto continued to please Caroline with pearls, diamonds and gold jewellery, while she herself received little.

In 1962, at the age of sixty-one, Giacometti was diagnosed with cancer of the stomach and underwent a major operation to have a large tumour removed. He convalesced at his mother's home in Switzerland and when he returned to Paris found that, as usual, his faithful brother Diego had kept his studio ready for him and that both Annette and Caroline were pleased to see him back. In the 1960s Giacometti's worldwide fame increased and he was fêted with major exhibitions in Europe and America; however, this period of his life would not last for long as his health was rapidly deteriorating, not helped by his habit of smoking four packets of cigarettes a day. The cancer did not return, but his heart and lungs were giving up the struggle.

When he was dying in hospital, his wife Annette and his mistress Caroline came face to face in the corridor outside his room. Caroline accused Annette of killing him, an insult that finally pushed her over the edge and she punched her rival in the face. A struggle ensued after which, amazingly, they both calmed down and arrived together at Alberto's bedside. Later when he had breathed his last, there was another struggle when Annette tried to prevent Caroline from reaching out to touch his body. She lost that struggle and eventually Caroline was left alone with her dead lover. Giacometti had created a strange love triangle that lasted to the bitter end.

ARSHILE GORKY

ARMENIAN/AMERICAN • (American citizen from 1939)

Declared a surrealist by André Breton

BORN: 15 April 1904 as Vosdanig Manoug Adoian in Turkey

PARENTS: Father fled to USA in 1908 to avoid draft; mother died
of starvation in 1919 fleeing from genocide in Turkey

LIVED: Turkey 1904; Russia 1915; Watertown, Massachusetts 1920;
Boston 1922; New York 1925; Connecticut 1946

PARTNERS: SIRUN MUSSIKIAN (Ruth French), an Armenian model 1929 • Married
MARNY GEORGE, art student, 1934 (briefly) • CORINNE MICHAEL WEST, art student, 1935–36
• LEONORE GALLET, a violinist, 1938 • Married AGNES 'MOUGOUCH' MAGRUDER in 1941,
daughter of Admiral John H. Magruder; two children; she left him in 1948

DIED: 21 July 1948 in Sherman, Connecticut; suicide by hanging

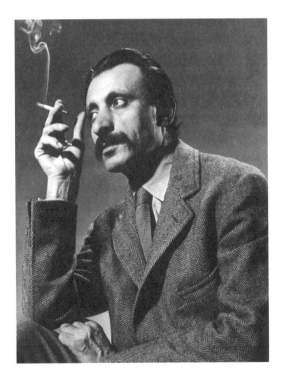

Arshile Gorky, 1940. Photo by Gjon Mili.

GORKY'S LIFE STORY is the most tragic of any of the surrealists. His childhood was a nightmare that he barely survived. Born in 1904 in the Turkish Armenian village of Khorgom near Lake Van, he was only four when his father fled the country to avoid being drafted into the Turkish army. During World War I the Turks began a mass slaughter of the Armenians and drove the survivors from their land. Gorky was a backward child who did not speak his first word until he was five. To escape the Turkish onslaught, he and his three sisters fled north with their mother, reaching the city of Erivan after a brutal forced march of 125 miles. Arriving there penniless, they had no choice but to live on charity. After several months of extreme poverty, Gorky's two older sisters left for America. His mother, desperate to protect Gorky and his younger sister, kept moving about seeking some kind of respite, but failing repeatedly until, in 1919 at the age of only thirty-nine, she finally died of starvation. This left the fourteen-year-old Gorky in charge of his twelve-year-old sister and the two orphans began a long journey on foot in an attempt to find a vessel that could take them to America to join their father and older sisters. It took them a year to achieve this, but after a period of unspeakable misery and hardship they finally arrived at Ellis Island in the United States in 1920. During the next five years Gorky drifted around America but details of how he survived are sparse. He managed to spend some time with his father, but could not forgive him for having remarried, which he considered an insult towards his beloved, martyred mother. He survived by taking various jobs, mostly manual labour such as washing dishes in a restaurant, until he finally arrived in New York in 1925, at the age of twenty.

His adult life began at this point and, far from having been cowed by the terrors and horrors of his childhood, he seemed to have been strengthened by them. They had moulded him into a darkly mysterious young man and he was now ready to face the world, fired by a deep-seated anger. He changed his surname to Gorky, meaning 'the bitter one', and adopted a first name, Arshile, that was derived from the wrathful Achilles of Homer's *Iliad*. He pretended to be the cousin of the famous Russian author Maxim Gorky. The unfortunate fact that Maxim Gorky was itself a pen-name did not escape some of his critics, but he soldiered on, creating a cultured persona for himself and earning a living as a tutor in a New York school of art. He had been making drawings since his early childhood and his talent was at

last being recognized so that, by the mid-1920s, he made the bold decision to become a full-time artist.

All was going well for him at last, when he was suddenly hit by the stock-market collapse and the great depression of the 1930s. The childhood nightmare of poverty loomed once again and he could not even afford to buy any paints. During this period he entered into several sexual partnerships, including a brief marriage, but his relationships were always doomed by the deep insecurities caused by his traumatic childhood experiences. He was so mentally scarred that he seemed to be incapable of normal, intimate relationships. Even his passionate love letters, some of which were published, later turned out to have been made up of paragraphs stolen from the writings of Paul Eluard, André Breton and Henri Gaudier-Brzeska. His life was full of pretence and tall tales. He wrote to his young sister telling her of favourable reviews of a show of his in Paris, but the truth was that no such exhibition had ever taken place. He had become associated with a rebel group of New York artists who were experimenting with abstraction and he regaled them with contradictory, fictional versions of his past life. It was as though fate had treated him so badly that he no longer had any respect for reality and preferred to present an imaginary version of himself.

During World War II Gorky married an admiral's daughter called Agnes Magruder, who remained with him for the last seven years of his short life, from 1941 to 1948, and gave him two daughters. He was also fortunate during this period to come into direct contact with the major surrealists who had fled the war in Europe and were now living as rather forlorn refugees in America. André Breton was among them and was deeply impressed by Gorky's work, grandly informing him that he was to be considered one of them. His compositions were sufficiently organic and biomorphic to be seen by Breton as more than the mere pattern-play of the full-blown abstract art that the surrealists despised. Indeed, it was Breton who wrote the foreword to the catalogue of Gorky's first solo exhibition in New York in 1945.

With a degree of artistic success in his grasp at last, he and his family moved to the country and he set up a large studio in Connecticut where he was able, for once in his life, to work in an atmosphere of untroubled tranquility. This idyll was, however, short-lived. It was as if the wretched Gorky was suffering from a lifelong curse that forbade him any peace and quiet. In 1946 a fire started in his studio and destroyed everything, including

twenty-seven major paintings. As if this were not enough, shortly afterwards he was diagnosed with rectal cancer and underwent a colostomy. He was beginning to show signs of recovery when he discovered that his friend, the Chilean surrealist Matta, was having a passionate affair with his beloved wife, Agnes. It was said that, much as Gorky loved her, he had also physically abused her, and was increasingly succumbing to violent rages. As a result, she had sought comfort elsewhere.

It appeared that things could not get much worse, but they did. He was involved in a serious road accident. His art dealer Julien Levy was driving him home in the rain when their car went out of control, skidding down a hill and ending up on its side. Both men broke their collarbones and Gorky, in addition, broke his neck. After leaving hospital he discovered that his right arm – his painting arm – had gone numb and was now useless for work. He

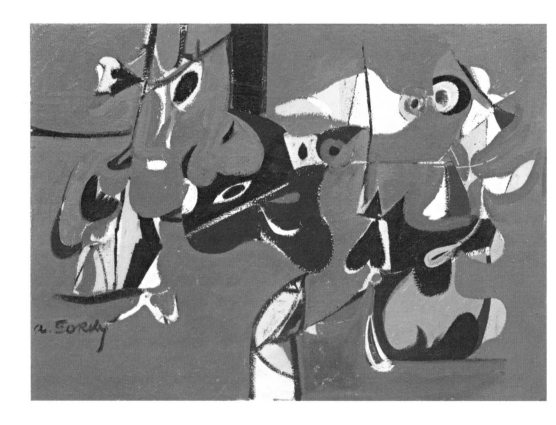

Arshile Gorky, *Garden in Sochi*, 1941.

sank into a deep depression. This was too much for his wife, who finally left him and took their children to live at her parents' estate in Virginia. A few weeks later Gorky went into a barn near his studio, wrote the words 'Goodbye My Loveds' on an old crate, threw a clothesline over one of the rafters and hanged himself. It was discovered that the clothesline had stretched under the weight of his body so that his feet ended up only a few inches from the ground.

When André Breton learned of Gorky's tragic end he was furious. Since returning to Paris he had continued to champion Gorky's work and had insisted on his inclusion in the major surrealist exhibition of 1947. Now he was gone and Breton, completely ignoring the evidence of the studio fire, the cancer, the broken neck and the paralysed painting arm as possible causes for the Armenian artist's suicide, placed all the blame on Matta's head. When Matta telephoned Breton to discuss the issue, Breton, that well-known admirer of the writings of the Marquis de Sade, suffered a moment of conformist outrage and shouted 'Murderer' at the startled Matta, before slamming down the phone. The Great Leader of the surrealist movement immediately called one of his infamous expulsion meetings at which every-one had to sign a piece of paper formally expelling Matta from the group on the grounds of 'moral turpitude'. Breton managed to obtain twenty-five signatures, but Victor Brauner to his great credit refused to sign, accusing Breton to his face of 'bourgeois morality'. Breton's response to being shamed in this way was to call another meeting, two weeks later, at which he formally excluded Brauner for 'factious activities'. Such were the contradictory ways of André Breton, the man who had famously defined surrealism as being 'exempt from any aesthetic or moral concern'.

Gorky's suicide was not the end of his tragic story. His great murals were all destroyed. One of his major paintings was damaged in a fire in 1958; another was burned in 1961. And fifteen of his best paintings, being flown to California for an exhibition, were destroyed when the plane carrying them crashed. Misfortune haunted him even after death. Against this catalogue of disasters can be placed one major achievement, for it was Gorky's unique form of organic abstraction that acted as a pioneering influence on the development of the New York school of abstract expressionism that was to gain such importance in America in the mid-twentieth century and was to shift the nerve-centre of the world of modern art from Paris to New York.

WIFREDO LAM

CUBAN • Active member of the surrealist movement from 1938
BORN: 8 December 1902 in Sagua La Grande, Villa Clara, Cuba,
as Wifredo Óscar de la Concepción Lam y Castilla
PARENTS: Father Chinese; mother Congolese/Cuban
LIVED: Sagua La Grande 1902; Havana 1916; Madrid 1923; Barcelona 1937;
Paris 1938; Marseilles 1940; Havana 1941; Paris 1952; Albissola, Italy 1962
PARTNERS: Married EVA PIRIZ 1929; one child (both died in 1931)
• BALBINA BARRERRA 1935–37 • Married HELENA HOLZER 1944–51 (divorced)
• NICOLE RAOUL 1956–58; one child • Married LOU LAURIN,
a Swedish painter, 1960; three children
DIED: 11 September 1982 in Paris

WIFREDO LAM WAS BORN in a small coastal town in Cuba in 1902. His ancestry was complex. His father, who was eighty-four when Wifredo was born (and would live to be 108), was a Chinese immigrant labourer brought in to work in Cuba's sugar-cane fields. His mother was part Congolese and part Spanish, a product of the relationships that occurred between the Spanish colonialists and their African slaves. One of her ancestors was known as Mano Cortado (Severed Hand) because of the punishment he had received for attempting to escape from slavery. Wifredo was the youngest of eight children and his father, who had risen to become a respected local shopkeeper, had high ambitions for his son, sending him off to Havana in 1916 to study law. He was already devoted to drawing, however, and eventually persuaded his family to let him go to the art academy in Havana to study painting.

In 1923 he gained a grant to go to Madrid, where he studied at the art school attached to the Prado Museum. When he left home his family gave him a belt lined with pieces of gold. Within three years he had used up his grant – and the gold – and was in serious financial difficulty, but was rescued by his room-mate's family, who took him in and looked after him. He earned some money by painting portraits and landscapes in a traditional manner.

In 1927 he met a Spanish girl by the name of Eva Piriz and two years later they were married. The couple moved back to Madrid, but were desperately poor and their deprived lifestyle led to tragedy when Eva and their infant son both died of tuberculosis in 1931. Lam blamed himself for not having cared for them sufficiently and was heartbroken, saying, 'My grief deprived me of all enthusiasm for life, even of the strength to go on living'.

Wifredo Lam seated at his easel, 1946. Photo by Gjon Mili.

He did survive, however, and was soon involved in the build-up to the Spanish Civil War. It was about this time that he first encountered the work of Pablo Picasso and it made a massive impact on him. In particular, he was 'surprised by the energy of the form ... and it was in front of Picasso's work that I at last understood'. It was indeed Picasso's powerful images, combined with Lam's ancestral African influences, that would later determine his mature style.

In 1937 he was photographed in uniform holding a rifle. Alongside him, also holding a rifle, was the new love interest in his life, Balbina Barrerra, a young woman he had met on one of his visits to the Prado. He painted a nude portrait of the two of them together in a bedroom, her white body contrasting vividly with his much darker skin. During his service for the Republican cause he was making explosives in a factory, where the chemicals in the air poisoned him and he was confined to hospital near Barcelona. When he was released, he settled for a while in Barcelona where he met Helena Holzer, who was working in a medical laboratory there. Some years later she would become his second wife. It was a fortunate meeting because one of her friends gave him a letter of introduction to Picasso – a letter that would change his life. It was soon clear that the Republican cause was being crushed, and Lam decided to leave for Paris before it was too late, arriving there in 1938 with the letter of introduction to Picasso in his pocket. He walked all the way to Picasso's studio from the railway station and when Picasso greeted him he was rather surprised to be taken immediately into a room full of African tribal carvings. Picasso told him that he should be proud of these wonderful works of art because he, Lam, had African blood in his veins.

The following year, Picasso, who had developed an unusually warm relationship with Lam, introduced him to André Breton, who also had a collection of tribal art and, in no time at all, Lam found himself a welcome member of the surrealist inner circle in Paris. A solo exhibition of his work was arranged and was well received. At a dinner party after the opening of that show, Picasso drank a toast in honour of his new friend and then took him off to a Montparnasse cabaret where there was a black woman dancing to African tom-toms. This focusing on Lam's African roots could be seen as slightly patronizing, but it was done in a spirit of genuine admiration for tribal art forms and Lam appeared to appreciate it without any reservations. He was also greatly in Picasso's debt when the influential Spaniard arranged

studio space for him at a time when he was in desperate straits. The combined impact of Picasso's personality and the emphasis on African tribal art forms led to a change in Lam's imagery. His paintings began to show motifs that were clearly derived both from Picasso's paintings and from African carvings. It was the beginning of a slow shift in Lam's art, from the traditional to the highly personal style of his later, mature period.

When the Nazis arrived in Paris in June 1940, Lam had to make a hurried exit. Others had departed some months before him, but he left it until the last moment, grabbed a few gouaches and fled. He travelled south by train, then walked for three days on roads clogged with refugees, sleeping in farm outhouses at night. After that, he managed to find a train that would take him to Marseilles, where he discovered Breton and the other surrealists all waiting for a berth on a ship to take them to safety in America. Arriving late, he found himself recorded as No. 998 on the list of 'artists to be helped' by the Emergency Rescue Committee. It took eight months to find him a ship, but at last, in March 1941, he was on his way, a passenger on an ancient freighter.

The trip was a nightmare. Jam-packed with 350 fleeing intellectuals, including André Breton and his family, the vessel could offer only two cabins with seven berths and two hastily erected communal toilets. Apart from the seven lucky ones in the berths, the passengers had to make the crossing on straw mattresses in the holds, without light or access to outside air. When they finally reached Martinique in the Caribbean, a number including Lam were interned in an old leper hospital. Breton, who had managed to avoid this indignity, would visit the internment centre, which was little better than a concentration camp, to take Lam some much needed extra food. Forty days later, their voyage continued and on reaching Santo Domingo in the Dominican Republic they split up, with Breton heading for New York and Lam for Cuba. When he finally set foot back on his native soil, Lam's journey from Marseilles had taken seven months – five months longer than that of Christopher Columbus. Its only compensation was that it had strengthened the bond between Lam and Breton.

What Lam found in Havana in 1942 did not please him. He had been away for nearly two decades and had returned to find a city full of corruption, gangsters, gamblers and rich tourists serviced by 60,000 local prostitutes, with the darker-skinned Cubans still living in poverty. Lam was horrified, saying, 'What I saw on my return was like some kind of hell'. Writing to a

friend, he said: 'If you want to know my first impression when I returned to Havana, it was one of terrible sadness ... The whole colonial drama of my youth seemed to be reborn in me.' He decided to devote himself to work that would oppose the decadence he found there. 'I refused to paint cha-cha-cha. I wanted with all my heart to paint the drama of my country but by expressing ... the beauty of the plastic art of the blacks. In this way I could act as a Trojan horse that would spew forth hallucinating figures with the power to surprise, to disturb the dreams of the exploiters.' He did not do this in an obvious way, however, instead celebrating his roots by creating a private, subjective world of his own.

It was in this frame of mind that he settled down to paint. In 1942, despite all the upheavals in his life, Lam produced over a hundred new pictures, and he would soon be at work creating his masterpiece, *The Jungle* (1943), now in the Museum of Modern Art in New York. His two decades in Europe had

Wifredo Lam, *Your Own Life*, 1942.

moulded him and he was about to launch himself on a forty-year explora-
tion of his highly distinctive world of surrealist images, part tribal and part
Picasso, but by this stage with these influences well digested and skilfully
transformed into pure Wifredo Lam. His humanoid beings, with mask-like
faces, portrayed as if in the process of metamorphosis, and intermingled
with botanical motifs, became the mature style to which he would remain
faithful for the rest of his life.

As he settled back into a Cuban existence, Lam married for the second
time. His bride in 1944 was Helena Holzer, the young German scientist who
had accompanied him in his flight from Europe and had been at his side ever
since. In the winter of 1945–46, Lam and his wife spent six months as invited
guests in nearby Haiti. André Breton was there at the same time, giving
lectures, and he and Lam attended the local voodoo ceremonies together.
In 1950 Lam's wife Helena moved to New York, but Lam himself was unable
to obtain a resident's permit there. In May of the following year the couple
were divorced. Apart from the short spell in Haiti, Lam remained in Cuba
painting throughout the 1940s and into the 1950s; but then, in 1952, he left
his homeland for Europe for a second time and returned to Paris. While
he was there, he had an affair with a French actress, Nicole Raoul, and in
1958 they had a son. In 1960 he married for a third time, to Lou Laurin, a
Swedish painter, who would give him three more sons. In 1962 they moved
to the artists' seaside colony of Albissola near Genoa and made Italy their
main home until Lam's death. While living in northwest Italy, he became
enthusiastically involved in the local ceramic industry, producing over four
hundred pieces within three years.

Lam lived long enough to see his fame as an artist spread worldwide. The
Castro regime in Cuba honoured him and invited him to visit the island on
several occasions in connection with cultural events. He and his family also
travelled extensively during his later years. This continued until 1978 when
Lam suffered a major stroke and received treatment in Switzerland, Paris
and Cuba. Despite being physically disabled, he continued to work in his
studio and was celebrated in major exhibitions in France, Spain and Cuba.
He died in Paris in 1982 and, at his request, his ashes were taken to Havana
to rest on Cuban soil.

CONROY MADDOX

ENGLISH • Active member of the British Surrealist Group from 1938

BORN: 27 December 1912 in Ledbury, Herefordshire

PARENTS: Father a seed merchant and publican

LIVED: Ledbury 1912; Chipping Norton 1929; Birmingham 1933; London 1955

PARTNERS: Married NAN BURTON 1948–55; two children • PAULINE DRAYSON 1960s
and 1970s • DEBORAH (DES) MOGG 1979–2005

DIED: 14 January 2005 in London

Conroy Maddox, 1930s. Photographer unknown.

IN ITS EARLY DAYS, when surrealism was an active movement, there was a special category of surrealist – the group leader. In Paris, of course, it was André Breton. His counterpart in London was Edouard Mesens. And in England's Second City – Birmingham – it was Conroy Maddox. I was lucky enough to join Conroy's group in 1948 and later wrote about it:

> As soon as I arrived in Birmingham in 1948 I set about exploring the local art scene and found a thriving surrealist group centred on the home of the painter Conroy Maddox. Perhaps painter is the wrong word for him – he was a theorist, an activist, a pamphleteer, and a writer, as well as an artist – in fact, the total surrealist.

He was as much concerned with surrealist ideas as with the production of art objects. Frequently it was enough simply to have an idea, without bothering to carry it out. For example, one winter evening Conroy suddenly announced to the assorted group of students, painters and poets who, time and again, were drawn to his Birmingham home, that he would like to buy a piece of land and have a house built on it. It would be an ordinary-looking house, made of bricks. Ordinary except for one detail: it would be completely solid. Solid right through. No rooms – all bricks. And when it was finished, he would simply leave it there. There would be no announcements, no fanfare. It would quietly make its own statement.

His solid brick house was only one of a flood of surrealist images that flowed incessantly from his fertile, eccentric brain. Some, like the house, remained no more than ideas; others, like his savage typewriter, with inverted, sharp nails where the keys should have been, and a streak of blood on the paper coming out of the roller, were actually realized; still others were rendered as collages or paintings. Paint as paint, however, was of little interest to him. Although he was a meticulous craftsman, it was the symbol, the concept that was all-important. If an idea could be expressed better with glued photographs than with oil paint, so be it. For Conroy, the message was the message, and to hell with the medium. Such was the intensity of his ambiguously erotic, obscurely sinister visions, that they had the power to convert even the most commonplace magazine cut-outs into vivid works of art.

Conroy Maddox was born in the market town of Ledbury about forty miles south of Birmingham in 1912, the son of a seed merchant. His father was wounded in World War I and Conroy's earliest memory was of visiting him in

hospital. As with many surrealists, this experience started him off on a lifelong hatred of the establishment. In 1933 the family moved to Birmingham, where his father was employed in the wine trade. He himself began earning a living as a solicitor's clerk. By 1935 he was working as a commercial designer, but in this year he discovered surrealism in the city library and was fascinated by the possibilities that it offered.

1936 was a key year in his development because it was then that the major International Surrealist Exhibition was put on in London. It made the headlines and the young, twenty-four-year-old Maddox travelled to the capital to attend the extraordinary opening ceremony. It made such a powerful impression on him that, sixty-five years later, during an interview, he recalled every detail, especially the lecture given by Salvador Dalí, wearing a deep-sea diver's suit, carrying a billiard cue and holding two Russian wolfhounds on leads: 'He nearly died. They screwed the headpiece up and it was very hot in those suits. And they couldn't find the spanner. He was twisted up with a couple of Russian wolfhounds on a lead, and they got twisted around his leg, so he clomped along – and of course the audience thought it was marvellous. He was sitting there trying to recover and Mesens introduced me to him.' Conroy would later write a book about Dalí.

After this colourful encounter with the surrealists, he knew that he had to go to Paris to learn more about the movement and made two lengthy visits there in 1937 and 1938, meeting, among others, Marcel Duchamp and Man Ray. On his final visit in 1939, he decided to leave when he saw workmen putting sandbags around public monuments. He sailed on the last-but-one ship to leave France before World War II broke out.

Back in England, he had become part of the London Surrealist Group, attending their meetings and exhibiting with them. Even during the war, when he was working for a firm making parts for warplanes, he managed to keep in touch with the other surrealists in London. At one point, some of his rather sinister collages were seized by the police in a raid on the house of a friend of his. Bizarrely, they suspected that these were somehow a means of sending coded messages to the enemy. The irony was that, at this particular point, Maddox himself was now engaged in secret war-work, drawing blue-prints for aircraft parts.

It was during the war years that he met a lively, strong-minded young woman by the name of Nan Burton. Although she was married, they began a

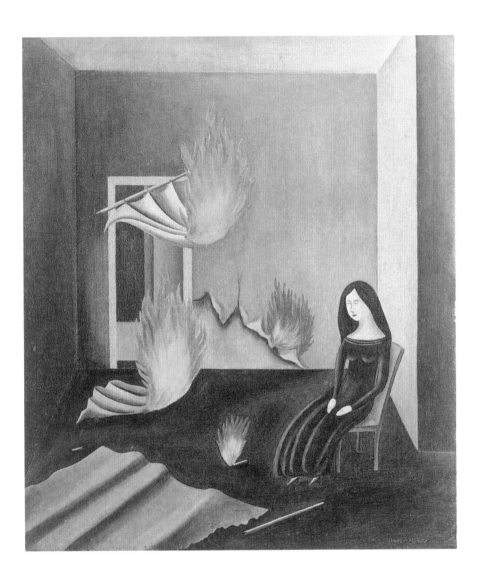

Conroy Maddox, *The Poltergeist*, 1941.

lengthy affair and had two children together. Eventually, in 1947, she obtained a divorce and she and Conroy were married early in 1948. This was the year when I first met him and I was impressed by the fact that Nan was more than a match for his waspish tongue and his black humour. Their relationship was an entertainment in itself. When she was suffering from jaundice, he wrote to me, unsympathetically, that there were evenings when he didn't switch the light on but 'just bathed in a marvellous yellow glow'. He never minced his words. His comments about other modern artists were nearly always scathing, unless they happened to be card-carrying surrealists. Even the work of close friends was criticized if they strayed from the surrealist path – 'not too unsuccessful' was the best he could offer them.

His own work consisted of three distinct types. There were his collages in the classic surrealist tradition established by Max Ernst; his small, colourful gouaches of biomorphic beings parading in a simple landscape; and his major works, all of which were in oil on canvas. In these less colourful oils he portrayed meticulous, dreamlike scenes that were stylistically somewhere between de Chirico and Magritte, but with his own special flavour. If anyone asked him to explain one of his paintings, he was stubbornly uncooperative: 'You can't explain an image like this and you shouldn't. A surrealist does not know what he is doing. Dalí didn't know what he was doing. I don't know what I'm doing. Something happens and it develops, but you don't analyse it. By doing that you destroy a surrealist image.'

One of his passions was attacking religion. A later painting of his that is hardly ever shown, called *Short-cut to Calgary* (1990), depicts Christ with his cross getting a ride to his crucifixion in a vintage motor-car. He also dressed his wife up as a nun and then proceeded to have himself photographed assaulting her, after which she did her best to crucify him by nailing his hands to a wall. He is on record as describing religion as 'a brutal insignia of a slow moral decomposition'.

When his Birmingham group had finally dispersed, Maddox moved to London in 1955. His marriage to Nan collapsed, although she continued to visit his exhibitions. When I expressed surprise at seeing her there, she smiled and replied, 'Just checking the sales'. He would later enjoy two more long-term relationships – the first with Pauline Drayson in the 1960s and 1970s and the second, from 1979, with Des Mogg, who was fifty years his junior – but he never remarried. During his first years in London he had to

earn a living as an advertising designer but, as the years passed, surrealist paintings enjoyed better sales, especially in the case of someone who had originally been active in the 1930s and, as he reached old age, he was at last able to survive financially from his art alone.

He did hit one snag, however, due to his disdain for what he called 'the art merchants'. Angry that his earlier paintings were selling better than his (much more accomplished) later ones, he decided to make a stand against the commercialism of the art world. He went round his studio changing the dates on his canvases, making them thirty or forty years older than they really were. If people were stupid enough to pay for the date of a painting rather than for the work itself, much fool them. Unfortunately he came unstuck when he put an early date on a collage that contained part of a photo from a magazine that had not been published then. The game was up and the galleries were furious with him. This damaged his selling power for quite some time, but after his death at the age of ninety-two, the true value of his work, regardless of its date, was once again being recognized.

One of the attitudes that made him cross was the idea that surrealism had passed into history in the 1950s and was now a dead movement, confined to a time-slot in the history of art. For Maddox, surrealism was an act of rebellion that, once initiated, would live forever in one form or another. He said: 'The work of surrealism can never be conclusive. It is more of an exploration ... and a struggle ... I will remain on my quest for surrealism until my last breath.' In 1987 he wrote to me, saying, 'Surrealism is dead, long live surrealism'. Nobody did more than Conroy Maddox to keep its spirit alive into the twenty-first century.

René Magritte, c. 1924–25. Photographer unknown.

RENÉ MAGRITTE

BELGIAN • Joined surrealist group in Paris in 1927

BORN: 21 November 1898 in Lessines, Belgium

PARENTS: Father a tailor and textile merchant; mother a suicidal milliner

LIVED: Lessinge 1898; Brussels 1916; Paris 1927; Brussels 1930

PARTNERS: Married GEORGETTE BERGER 1922–67 • SHEILA LEGGE 1937 (briefly)

DIED: 15 August 1967 in Schaerbeek, Brussels, of pancreatic cancer

MAGRITTE WAS AN ARTIST addicted to contradiction. The biggest contradiction was between how he painted and what he painted. His method of painting was boringly conventional. His colours were drab and his textures were flat. This was deliberate because he wanted to maximize the contrast between the ordinariness of his traditional painting style and the extraordinariness of his subject matter. If his depiction of a bowler-hatted businessman looked as though it had been done by a run-of-the-mill portrait artist, then the fact that the businessman had an apple where his face should have been became all the more shocking. The mundane style of painting heightens the shock of the irrational imagery.

Every single element in a Magritte painting is realistically portrayed and immediately recognizable. There is no stylization, distortion or exaggeration. Everything is matter-of-fact. Everything, that is, except the relationship between the elements. These relationships are anything but realistic. They are irrational, illogical, paradoxical, disturbing, dreamlike and, above all, contradictory. Magritte spent his whole adult life trying to think up novel ways of insulting the commonsense values of everyday existence. He used ten main devices:

The composite: He combined two different things as one

 A nightdress hanging in a wardrobe has a pair of breasts

 A pair of boots has human toes

 A seated human figure has a birdcage as a body

 A bottle has a neck in the shape and colour of a carrot

The switch: He reversed the elements of a subject

 A mermaid has the head of a fish and the legs of a girl

The see-through: He painted a solid object as if it were an opening through which we could see beyond

 Through a flying bird we can see a cloudy blue sky

 Through a flying bird we can see a green forest

 Through the cornea of a human eye we can see a cloudy sky

The out-of-scale: He altered the size of a subject

 A green apple fills a room

 Miniature businessmen fall as raindrops

 A railway train emerges from a tunnel that is a fireplace

 A cloud rests on a wine glass

The out-of-place: He added an element that was completely out of place

 An eagle wears a man's jacket

 A lighted candle is burning in the middle of a nest of eggs

 A jockey is riding his horse on top of a car driving down a road

 A small white cloud creeps into a room through an open door

The out-of-time: He interfered with the time-scale of a subject

 An artist paints a portrait of an egg, but the canvas shows a bird

 The sky is broad daylight but the land is nocturnal

 The root of a tree has grown over the axe that felled it

The anti-gravity: He depicted solid objects floating in the air

 A giant rock floats above an ocean

 Two men are standing talking to one another high in the sky

 Loaves of French bread hover in the sky

The mis-named: He wrote an irrelevant name under a familiar object

 A horse is labelled 'the door'

 A leaf is labelled 'the table'

 A jug is labelled 'the bird'

The transformation: He showed one subject changing into another

 Growing plants develop the heads of birds

 A mountain peak has become the head of an eagle

The substance change: He showed an object made of another material
>A yacht is made of ocean waves
>A nude has skin with a wood grain
>A bowl of fruit is made of stone
>A standing human body is a paper cut-out

Magritte himself summed up his approach to painting with the following statement in 1940:

> I made paintings where the objects were represented with the appearance they have in reality, in a style sufficiently objective ... I showed objects situated where we never find them ... The creation of new objects, the transformation of known objects, the change of material for certain objects, the use of words combined with images ... the utilization of certain visions from half-sleep, or dreams, were other means employed with a view to establishing a contact between consciousness and the external world.

The titles of his paintings have puzzled many people. Anyone struggling to find hidden meanings in them should be warned that Magritte would invite his surrealist friends around for the evening to see who could come up with the most outlandishly meaningless titles for his latest paintings. Magritte's actual method of painting was extremely odd. He had no studio as such, and worked at his easel dressed in a business suit, in a small room with a fancy carpet on the floor. I know of no other artist who painted in this remarkably neat and tidy way.

He was also a man with a long string of personal dislikes, saying, 'I detest ... professional heroism ... beautiful feelings ... decorative arts, folklore, advertising, voices making announcements ... boy scouts, the smell of mothballs, events of the moment, and drunken people.' Reading his various comments, and looking at his pictures, it is clear that Magritte was a very odd man indeed but, as a friend of his put it, he managed to conceal this fact by living a bourgeois existence disguised as an ordinary man.

Magritte was born at the end of the nineteenth century in Lessines, about twenty miles southwest of Brussels. His father owned a tailor's shop and his mother had been a milliner. When Magritte was growing up, his mother had become increasingly depressed and had attempted suicide by trying to drown herself in the water tank in the family attic. She failed, and after that

incident had to be locked up in her bedroom for her own safety. One night
she managed to escape and threw herself into the nearby river where she
drowned. Her body was swept downstream and was not found for several
days. When it was eventually discovered, her nightdress had been dragged
up to cover her face like a mask. Magritte was a boy of fourteen when this
happened and it has been pointed out that cloaked faces appeared later in
some of his paintings, suggesting that he was haunted by this image of his
dead mother. Magritte himself denied this, but that may have been because
he hated people trying to interpret his paintings, often saying that they must
be enjoyed only as mysteries.

The following year, when he was fifteen, Magritte was visiting a fair-
ground when, on a roundabout, he encountered a beautiful young girl called
Georgette, who would later become his wife. He left home at seventeen and
moved to Brussels where, the following year, he enrolled at the art academy
and spent the next five years learning how to paint. When he was twenty-two
he met Edouard Mesens, who would become a lifelong friend and a fellow
surrealist. At about the same time he met Georgette again, who was now
working in the city. They came across one another by chance, walking in the
botanical gardens. He upset her by lying that he was on the way to see his
mistress. Despite this joke in poor taste, they fell in love and two years later,
in 1922, they were married.

In 1923 Magritte saw for the first time the early work of de Chirico – work
that would inspire other surrealists as well – and it had a profound effect
on him. He pondered on the strangeness of de Chirico's scenes and, after
a while, began to paint in a new way himself. (For the record, de Chirico
was less enthusiastic about the work of Magritte, calling it 'witty and not
unpleasant to look at'.) In 1927 Magritte wanted to forge a connection with
the French surrealists and he and Georgette left Brussels for Paris. He soon
got to know them and, in 1929, André Breton made him an official member
of the inner circle. In the winter of that year, however, the new friendship
between Breton and Magritte was shattered when Breton insulted Georgette.
He had invited the couple to dinner, along with Luis Buñuel and his fiancée,
but had sulked throughout the evening. Something was making him angry
and he finally exploded. According to Buñuel, writing in his autobiography,
'he suddenly pointed a finger at a small cross that Madame Magritte was
wearing around her neck, announced that this cross was an outrageous

provocation and that surely she might have worn something else when she came to his house.'

Georgette must have been very upset by this unexpected attack, especially as the cross she was wearing was a much loved gift from her grandmother. Needless to say, Magritte was not going to take this lying down and came to his wife's defence. Buñuel continues: 'Magritte took up the cudgels on his wife's behalf, and the dispute went on energetically for quite some time. The Magrittes made a sterling effort and did not leave before the end of the evening, but for some time afterward the two men did not speak to each other.' Amusingly, thirty years later, when being interviewed by an American author, the Magrittes did their best to play down this incident. According to them, they were at one of the regular surrealist evenings when Breton made a general remark about it being bad taste to wear religious emblems, but did not direct it at Georgette. Magritte, however, took offence and he and his wife left the room. These are two very different versions of an incident that would not be important were it not for the fact that, soon after, Magritte and his wife packed their bags and left Paris to return to Brussels and that he and Breton did not speak to one another for eight years, creating a lengthy rift between the surrealism of France and that of Belgium.

Buñuel's version seems to be the more reliable one, because only a major face-to-face altercation between the two men would have been enough to lead to such a long separation. It might also explain why, once he was back in Brussels, Magritte spent a whole evening burning all his letters, tracts and other documents relating to his time in Paris. It would not be until 1937 that Breton and Magritte would once again be in contact over surrealist projects.

In was in that year, 1937, that Magritte visited London to paint three pictures for the rich British collector Edward James, to decorate his ballroom. Edouard Mesens recalled later that, when he entered the room where Magritte was painting, he heard him saying out loud to himself 'boring, boring, boring'. It wasn't the subject matter that bored him but the nuisance of having to transfer the idea laboriously onto canvas. He complained about this at other times, too, saying how tedious it was to have to spend hours creating the painting of a perverse idea that had flashed into his mind in seconds. On one occasion he avoided the tedium via a cunning strategy. Commissioned to produce eight huge murals for the Casino in Knokke, he projected colour transparencies of eight of his paintings onto the blank walls

and had interior decorators do the actual painting. Visitors today marvel at what they imagine to be his almost Sistine Chapel-like energy.

Magritte managed to relieve the boredom in London in 1937 by having a brief affair with an attractive young surrealist groupie by the name of Sheila Legge. Known as the 'Phantom of Surrealism', she had gained notoriety by parading in Trafalgar Square with her head covered in roses as part of the launch of the great International Surrealist Exhibition in London in 1936. Magritte's friend Edouard Mesens, who had moved to London to help organize that exhibition, was about to open a gallery there and had been trying to persuade Sheila Legge to work for him as his gallery receptionist. Mesens, a well-known sexual predator, obviously had ulterior motives and Sheila had refused his offer. The charming Magritte was apparently another matter. It must have been the briefest of interludes, however (unless she travelled abroad to be with him), because Magritte was only in London for five weeks in 1937 and a few days again in 1938 for the opening of his solo exhibition at Mesen's London Gallery.

Magritte, perhaps feeling guilty, tempted fate by writing to his close friend, the surrealist poet Paul Colinet, saying, 'I want you to do wherever possible whatever you can to make my absence less distressing to my wife'. Colinet took his duties a little too seriously and began an affair with Georgette. At one point the affair became so intense that Georgette asked Magritte for a divorce. As far as we know, this was the only time that Magritte's marriage ran into difficulties. The truth was that he and Georgette were a devoted couple, deeply in love with one another from childhood to the grave, despite never having any children. His brief dalliance with Sheila Legge and her affair with Paul Colinet were no more than the mid-life crisis that strikes many happy couples. Inevitably it had its moments of drama. When Magritte returned to Belgium from London and found out what had happened, he, rather bizarrely, 'persuaded a policeman to accompany him as he followed the couple to the inevitable confrontation'. Why he felt the need for police protection is not clear, unless he simply wanted to shame the lovers into splitting up. Whatever the reason, it didn't work and the affair dragged on for some time.

We know this because of what happened when World War II broke out in 1939 and, within a few months, Belgium had been invaded by the Nazis. Magritte had made some public statements of a political nature that meant he feared becoming an instant target for the Germans and, five days after their

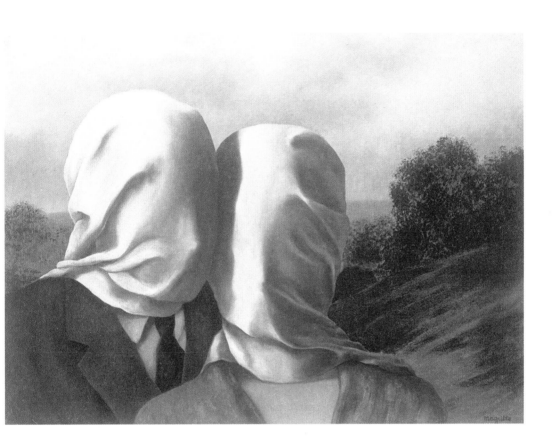

arrival in Belgium, he fled south to Paris. He obviously wanted Georgette to accompany him, but she refused. Colinet was staying put and she would not be separated from him, revealing that, in 1940, three years after their affair began it was still alive and causing friction. As a result, Magritte had to leave without her, something that was difficult to explain to some of his friends. His solution was to lie; he told one of his friends that she could not go with him because she had just had an operation for appendicitis.

René Magritte, *Les Amants (The Lovers)*, 1928.

On reaching Paris and needing funds, he sold a painting to Peggy Guggenheim, who was building up her surrealist collection before departing hurriedly for America. He and his Belgian surrealist friend Louis Scutenaire (1905–1987) then set off for the far south of France, settling in the ancient walled city of Carcassonne to await developments. Magritte found that being away from Georgette was unbearable and after only three months he returned to Belgium and the marital home. He spent the rest of the war quietly in Brussels, occasionally earning a little cash, it is rumoured, by selling his works to the occupying German troops.

In 1943, to pay for the expensive colour plates in a new book about his work, Magritte is said to have painted and sold a number of fakes. According to his friend Marcel Marien (1920–1993), writing in 1983, he cheerfully produced fakes of works by Picasso, Braque, Klee, Ernst, de Chirico, Juan Gris and even Titian, saying that, if they made more money, he would give up painting his own work. Georgette, in a loyal attempt to clear her late husband's name, sued Marien in the courts, but he had postcards written by Magritte to support his claims. It is amusing to contemplate how a modern gallery would set about valuing a Picasso painted by Magritte.

Belgium was occupied by the Nazis from 1940 to 1944 and, as the miserable months dragged by, Magritte reacted to the gloom of the war in a strange way. Instead of depicting the fears, tensions and horrors of the period, he decided to strike out in the opposite direction and paint sunny, happy, escapist pictures. Weirdly, he began painting his usual subjects in the style of Pierre-Auguste Renoir. This lasted from 1943 to 1946 and the paintings he produced during this phase were not at all popular with his devoted followers. Even less popular were the paintings he did in his extraordinary 'vache' period a little later, in 1947. There were twenty-five of these bizarre works and they were deliberately ugly and stupid. They were intended for a show in Paris in 1948 and were meant to be a deliberate insult to his French surrealist colleagues who, in his opinion, had become slapdash, complacent and self-satisfied. His title of vache, meaning cow, was a play on the French word fauves, meaning wild beasts – the fauves were wild and he was tame.

Over the years, one of Magritte's failings was that he would produce paintings to order. If a collector wanted a painting that he had already sold to someone else, he would quickly dash off a second copy of it. Sometimes he would make several versions of the same work to increase his sales.

This blatant commercialism disturbed some of his friends. His protégé, Marcel Marien, in particular, was so irritated by it that he decided to play a joke at Magritte's expense. In 1962 Marien and his friend Leo Dohmen produced a tract, supposedly written by Magritte himself, that they called *La Grande Baisse*, which translates roughly as 'the Great Price-reduction'. In it, Magritte explained that he was giving drastic discounts for anyone buying his new work. It even offered to supply these paintings in whatever size the buyer wanted. The tract was presented so convincingly that everyone believed that it had, indeed, emanated from Magritte. Even André Breton thought so, and praised Magritte for being so irreverent. When Magritte realized what had happened, he was so furious that, despite a close friendship that had lasted for a quarter of a century, he never spoke to Marien again. Of course, the reason he could not appreciate the joke was because behind it there was an element of truth.

Towards the end of his life, Magritte's fame had spread worldwide and in 1965 he was given a major retrospective at the Museum of Modern Art in New York. Although his health was beginning to deteriorate, he attended the exhibition in person, making his one and only trip to the United States. The following year, he and Georgette also visited Italy and Israel, but the end was near and only fifteen months later he died from cancer at his home in Brussels, aged just sixty-nine.

Today, Magritte is perhaps the best known of all the surrealist artists, rivalled only by Dalí. Some critics may dismiss him as a joker and a visual prankster, but he was much more than that. He took our familiar world to pieces and then reassembled it in a perverse way that haunts the memory of anyone who has studied his work. An important point that his critics seem to miss is that he did not just put things together in a strange way. He did so with a skilful selectivity and a consistent vision that created an intense other-world – the unique world of René Magritte. Many people have tried to analyse that world, but Magritte's message to them was: 'One cannot speak about mystery, one must be seized by it.'

ANDRÉ MASSON

FRENCH • Joined the surrealist group in Paris in 1924; expelled in 1929
by André Breton; reconciled with him in 1937; broke off again in 1943
BORN: 4 January 1896 in Balagny-sur-Thérain, Oise, N. France
PARENTS: Father sold wallpaper; mother a foundling of gypsy descent
LIVED: France 1896; Brussels 1904; Paris 1912; Army 1914; Céret in S. France 1919; Paris 1921;
Spain 1934–6; Paris 1937; New Preston, Connecticut 1941; Paris 1945; Aix-en-Provence 1947
PARTNERS: Married ODETTE CABALE in 1920 (divorced 1929); one child
• ROSE MAKLÈS in 1934; two children
DIED: 28 October 1987 in Paris

I ONCE ASKED A FRIEND of mine, who had a large collection of modern
art, why he had hung his André Masson painting in his guest lavatory. He
laughed and said that that was all it was worth. I thought this was harsh, but
it started me wondering why some people did not warm to Masson's work.
He was one of the central figures of the surrealist movement from its very
beginning and, for most of his career, his imagery was in keeping with even
the most severe dictates of André Breton. So why, after half a century, is he
not as highly regarded as the other major surrealist painters?

The answer, it seems to me, is that there is something impatient about
much of his surrealist work, as though he is trying to finish each picture
as quickly as possible, so that he can do something else. There are some
notable exceptions to this rule, when he did produce surrealist compositions
of lasting importance, but there are not enough of these to give his whole
body of work the same significance as the art of other central figures in the
surrealist movement. Masson himself gave a slightly different reason for his
shortcomings, saying that his painting was too surrealist for those who did
not like surrealism and not surrealist enough for those who did.

Masson was born in northern France, where his father ran a school. When
his father started a business selling wallpaper, the family moved to Belgium,
with the result that, from the age of seven, André experienced a Flemish

childhood. His early interest in drawing was encouraged by his mother, who favoured avant-garde authors and who fostered in her son a love of the unconventional. With her backing, he gained entry to the prestigious Art Academy in Brussels at the tender age of eleven, well below the official age level. In 1912, when he was only sixteen, he went to Paris and encountered the cubist movement there.

Masson's precocious start in the world of art was interrupted by the outbreak of World War I. He served as a private in the French Infantry and in 1917 was severely wounded in the chest. When he was recovering in

André Masson at the window of his studio in Le Tholonet near Aix-en-Provence, 1947.
Photo by Denise Bellon.

hospital, an officer, demanding to be saluted, forced his arm upwards and, in the process, re-opened his wound. This was too much for Masson, who promptly shouted abuse at the man and vehemently declared his passionate hatred of warfare. Hearing of this, the military authorities concluded that Masson must be mad and threw him into an army mental asylum. The only advantage gained from this was that it triggered in Masson a lifelong hatred of all forms of authority – a mental state that prepared him for his eager participation in the surrealist movement in a few years' time.

When he was finally discharged at the end of 1918, one of the doctors advised him against urban living and he took this advice seriously, leaving Paris for the French countryside. He ended up in Céret in the far south of France, where he met and married Odette Cabalé. In 1920 they moved back to Paris, where his next-door neighbour happened to be the young Joan Miró. He and Masson became close friends. They were both desperately poor and seeking a way to express their rebellious spirit in their art. They made friends with the macho American author Ernest Hemingway who, on occasion, would convert their studio into a boxing ring and coax them into fighting one another. The vision of Masson and Miró squaring up to one another in boxing gloves is, in itself, a laughably surreal image and Hemingway's coaching was doomed to failure. He said that, although Miró adopted a suitably aggressive boxing posture, he forgot 'that there is an opponent in front of him'. An observer reported that the boxers were in greater danger of being injured by falling through the holes in the dilapidated studio floor, than by punches to the head.

In 1924 Masson held his first solo exhibition. It was visited by André Breton, who bought one of the paintings and then went to see Masson in his studio. He flattered Masson and invited him to join the official surrealist circle. Masson agreed, despite the fact that he was not temperamentally suited to belonging to a group with strict rules. Under the influence of Breton, Masson started making automatic drawings and was soon exhibiting in group shows with the other official surrealists. He became a central figure in the movement for several years until he crossed swords with Breton. The confrontation occurred in February 1929, when Masson, who was well read, very intelligent and articulate, had tired of Breton's dictatorial role in the group. He told Breton that he had had enough and was leaving. As Masson had been one of the very first painters to join the circle, this must have hurt

Breton. His reaction was to announce publicly that he had expelled Masson, thereby giving the impression that it was he who was doing the rejecting, rather than being rejected.

This was not enough. Breton's ego demanded that Masson's crime of disloyalty to the group required further punishment and, in the Second Surrealist Manifesto that he was preparing, he added a savage verbal attack on his old friend. Masson, and seven other enemies of his, were demolished with the following words: 'I am not authorized to let cads, shammers, opportunists, false witnesses and informers run round loose ... it would be tantamount to mystical blindness were we to underestimate the dissolvent nature of these traitors' presence among us, as it would be a most unfortunate illusion to presume that these traitors, who are still rank beginners, can remain unaffected by such a punitive action.' Breton also singled out Masson for a specific, personal attack, accusing him of an inflated idea of his own importance as an artist. According to Breton, during their confrontation, Masson called Pablo Picasso a scoundrel and also attacked Max Ernst 'whom he accuses merely of painting less well than he'. Masson's separation from Breton was not the only one he suffered in 1929, for in that year his marriage to Odette also collapsed, ending in divorce.

The early 1930s saw Masson in a troubled state of mind. He commented that, after forcing himself to be gregarious for the first time in his life, when he joined the surrealist circle, he now found himself once again in a state of solitude, with few friends. He was freed of irksome bonds of attachment, but at the same time felt depressed, with an underlying sense of 'dereliction and despair'. His paintings and drawings during this phase became increasingly violent, as though he was using his art as an outlet for his pent-up emotions.

In 1934 he visited Spain where he met and married Rose Maklès. She would give him two sons and his mood became calmer. In 1936 he participated in the infamous International Surrealist Exhibition in London, showing fourteen of his works there, and his return to the surrealist fold soon followed. At the end of that year he and Breton patched up their differences. This meant a great deal to Masson as he had never been able to come to terms with his separation from the group. There followed a productive phase of painting during which he produced important work that has been referred to as his 'second surrealist period'. This was cut short by the outbreak of World War II, when he joined other surrealists in an exodus to the United States. His

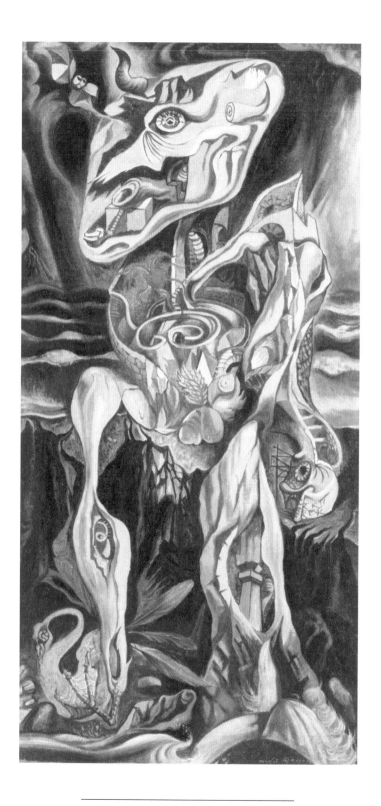

André Masson, *The Labyrinth*, 1938.

arrival there was an unhappy one because the US customs authorities declared the drawings he was carrying with him obscene and confiscated them. After much argument, they returned most of them but destroyed five that they considered too pornographic to be brought into the country.

Once safely in America, Masson and his family had to decide where to live. He settled not in New York like several of the other surrealists, but in Connecticut, where his stimulating neighbours included Alexander Calder, Yves Tanguy and Arshile Gorky. During this period his relations with André Breton, who was not enjoying his enforced stay in America because he refused to speak English, began to deteriorate once again and, in 1943, there was another heated debate after which he left the surrealist group for the second time, never to return. On this occasion it was he who was the scathing one, calling Breton's recent surrealist publication *VVV* both dull and cheap. He insulted Breton's excessive 'demagoguery' and his complacent attitude towards 'dogmas only ruins of which remain'. There was clearly no way back after this rupture and, although he continued to produce a stream of important surrealist paintings, he would never again associate with Breton and his clique.

Masson's point, and it was a significant one, was that a work of art required some sense of order and that Breton's theorizing did not allow for this. What was important, Masson argued, was that the order in a work of art should not be academic order. He summed up his basic disagreement with Breton with the words: 'To indulge in mental chaos is as stupid and narrow as to stick to too much reason.'

In 1945 Masson returned to France and, for the next two decades, exhibited his work there and internationally, with great frequency and success. This continued until, in 1977, his health collapsed and he found himself confined to a wheelchair. Despite this, he continued to paint for another three years, until, at last, he could manage it no longer and had to face the last seven years of his life in a frustratingly non-creative state.

Roberto Matta in his studio, 1959. Photo by Sergio Larrain.

ROBERTO MATTA

CHILEAN · Joined the surrealist group in Paris in 1937; expelled by Breton in 1948

BORN: 11 November 1911 in Santiago, Chile, as Roberto Sebastián
Antonio Matta Echaurren

PARENTS: with Spanish, Basque and French origins; father Chilean,
a landowner and devout Catholic; mother Spanish

LIVED: Santiago 1911; Paris 1933; New York 1939; Paris and Rome 1948;
moved between Europe and South America in the 1950s and 1960s

PARTNERS: Married ANNE ALPERT, née Clark, an American artist, 1937 (separated in
1943); twins born in 1943 · Married PATRICIA KANE (who later married Pierre Matisse), 1945
· AGNES MAGRUDER in 1948 (wife of Arshile Gorky) · ANGELA FARANDA; one child in 1951 ·
MALITTE POPE; two children in 1955 & 1960 · Married GERMANA FERRARI;
one child in 1970

DIED: 23 November 2002 in Civitavecchia, Italy

MATTA WAS A KEY FIGURE in the surrealist movement but was slightly younger than the founders of the group. He was only a schoolboy of thirteen when André Breton produced his First Surrealist Manifesto and it would be another decade before Matta would be able to make contact with the group in Paris. Matta's work is easy to identify but difficult to describe. A typical canvas depicts violent, distressed or orgiastic anthropomorphic figures enmeshed in a chaotically exploding architectural space. They are like frenzied sketches made by aliens to depict the stresses of human urban living.

Size was important to Matta. When I first encountered his early work in Paris in the 1940s, his canvases were all of a traditional size – the kind of pictures you could hang in your house. But then something strange happened. He became convinced that his work would only carry its message if it were done on a vast scale and began to paint pictures that were up to thirty feet long. He was the first of the surrealists to paint on such an epic scale. Matta was working in New York during World War II when he first developed this style, and when the young American abstract expressionist artists there saw

the scale of his paintings they found their impact overwhelming and quickly
imitated him – at least in the proportions of their work.

Matta was born in the Chilean capital, Santiago, in 1911, although his
maternal ancestors were Basques from northern Spain. His Chilean father
was a landowner and his Spanish mother was highly cultured and encouraged
her son's interest in art, literature and languages. Although he enjoyed a
well-funded, upper-class childhood, educated by Jesuits, somewhere inside
him a rebel was forming and he was not pleased when his family insisted that
he must attend university to obtain a degree, not in art but in architecture, a
subject that in their view would provide him with a safe, respectable career.
This may not have been what he himself wanted at the time, but it would
indeed stand him in good stead because it gave his mature paintings a strong
structural quality, as though they were designs for exploding buildings that
had been overrun by frantic humanoid biomorphs.

When he was only twenty-two, Matta decided that he had to be in Paris
and he worked his passage across to Europe as a merchant seaman. Once
there, he survived for a few years working in the offices of the great French
architect, Le Corbusier (1887–1965). During this time, 1935–37, he travelled
to Spain, where he met Salvador Dalí, who introduced him to André Breton.
Breton welcomed him into the surrealist fold as a promising newcomer and
his first surrealist works date from this period. Matta's progress within the
surrealist movement in Paris was soon interrupted by the start of World War
II and, in 1939, he left France for the United States along with other fleeing
surrealists. In New York, he began exhibiting his paintings and was soon in
touch with young American artists, who were fascinated by his compositions.
During this time he made a short visit to Mexico to study the volcanic land-
scapes there and returned with a more brightly coloured palette.

It was in New York that Matta's relationship with André Breton began
to deteriorate. In Paris, Breton had been the undisputed leader and the
younger Matta a comparative latecomer. Breton had supported him as a
valuable new follower, declaring grandly, 'One of our youngest friends,
Matta, is already at the peak of a brilliant pictorial production', but in New
York he was disturbed to find Matta increasingly taking centre stage. The
problem was partly to do with language. Matta spoke English fluently and
Breton did not. Worse still, Matta was university-educated, verbally skilful
and a good communicator. The surrealist refugees who had gathered in

New York fascinated the young American artists, who clamoured for more information about this startling new movement in modern art. The person who, by rights, should have been at the centre of disseminating the surrealist doctrine was obviously the great leader, Breton himself, but he could not get his message across. Instead it was the eager, intelligent, handsome young Matta who began organizing meetings and seminars. The American artists were invited once a week to his studio to learn the principles of surrealism. He also masterminded 'practicals' – evenings at which the Americans were encouraged to carry out surrealist experiments. William Baziotes, Jackson Pollock and Robert Motherwell were regulars at these sessions. Matta's personality suited such occasions, one observer commenting that 'he was high-strung, hyperactive, given to playing cruel jokes'.

Poor Breton found this new development extremely irritating. He could hardly complain about the dissemination of surrealist concepts, but he was finding himself side-lined by the energetic and articulate Matta. He began to regard the young Chilean as an annoying upstart. Worse still, Matta was not above a little sly undermining of the grand old men of the movement, portraying them as stiff, rigid and now slightly old fashioned. An art dealer described Matta's personality as 'chock-full of premature optimism and impatient disappointment ... an *enfant perpetual*, always in a tantrum or a triumph of self-admiration'. The truth was that Matta had started to see himself as the Breton of America – the new leader who would become the focus of the New York art world. His brand of surrealism – the creation of invented visual worlds – appealed especially to the New Yorkers, who found the technically academic work of artists such as Magritte and Dalí unattractive. It was Miró, Masson and Matta that they responded to and whose startling innovations would soon lead them off into the world of abstract expressionism.

In 1942 Matta's private life was becoming complicated. The FBI suspected the Chilean of being a spy – Chile had remained neutral but had strong trading links with Germany. Matta's friend Max Ernst was also suspected and was arrested. During his detention, he was quizzed about Matta, but nothing seems to have come of this. At the time this happened, Matta and Ernst were involved in a strange ménage à trois with Pegeen, the adolescent daughter of Max's wife, Peggy Guggenheim, by an earlier marriage. A difficult teenager, Pegeen was rumoured to have been introduced to the pleasures of sex by both men, some say with her mother's knowledge. During this episode

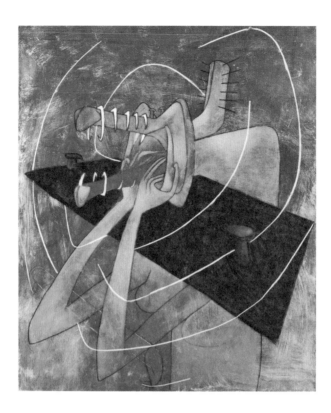

Matta was still the husband of the American artist Anne Alpert. They had been married in Paris in 1937 and had moved to New York together in 1939, but their union came to an abrupt end in 1943, when Anne told him that she was pregnant with twins. For some reason, this made him angry and he threatened to leave her, which he did, when the twin boys were only four months old. He saw little of his sons after this and they both died young, one committing suicide at thirty-three and the other succumbing to cancer at thirty-five. Within a year or so of his precipitous separation from Anne, Matta had remarried, this time to the wealthy American heiress Patricia Kane. This, too, would be a short-lived relationship, ending in 1949 when she left him to marry Pierre Matisse.

Matta's relations with André Breton took a new turn for the worse in 1945. Breton was leaving America for a tour of the West Indies and Matta and his then wife Patricia organized a farewell dinner for him at a restaurant. Breton must have seen this as another example of Matta's attempt to

Roberto Matta, *The Starving Woman*, 1945.

become the new headman of the surrealists. At the dinner, Matta was the host, Breton merely the guest. Arshile Gorky's wife, who was present at the dinner, reported that 'André was in a rage from start to finish'. The final insult came when, at the end of the dinner, Matta and his wife disappeared leaving all the guests to pay for their own meals. Matta saw this as a huge surrealist joke, but as the guest-of-honour Breton was justifiably outraged.

The once tight bond between Breton and his Chilean protégé was finally broken by an event that occurred in 1948. It involved Matta's close friend Arshile Gorky and Gorky's wife, Agnes. She found Matta entertaining and much more amusing than her rather dour Armenian husband. She told a friend that Matta was 'so interesting and funny and very nice. He could talk up his work and wrap those art critics ... around his little finger.' In the late 1940s Gorky had been getting increasingly depressed and was starting to behave violently towards Agnes. In the end, Agnes ran to Matta for comfort. Matta adored her and they had a brief affair. Gorky found out and arranged a secret meeting with Matta in Central Park, where he lost his temper and chased Matta through the park, trying to beat him with his walking stick. After this, Gorky's depression worsened and eventually he hanged himself. Breton, who was now back in Paris trying to rebuild his surrealist empire, blamed Matta entirely for Gorky's death, somewhat unfairly, and promptly expelled him from the surrealist group. It is impossible to avoid the suspicion that Breton must have taken some pleasure in this downgrading of Matta who, in his eyes, had risen from being merely a loyal follower to the level of a serious rival. A few years later, Matta also returned to Europe, but instead of staying in Paris, he settled in Rome. The lure of Paris was, however, too strong for him to resist and he eventually set up home there and at this point also became a French citizen.

In 1959, during an extraordinary surrealist evening, he was finally reinstated into the surrealist group by Breton, who no longer saw him as a threat, but as a true surrealist who simply could not be ignored. The occasion was a celebration of the Marquis de Sade and featured a masked performer who was undressed to reveal his body painted black except for the red crest of de Sade over his heart. Taking hold of a red-hot iron, he proceeded to brand his flesh with the word SADE on top of the red crest. He then invited any member of the audience to do the same and Matta, knowing that Breton was present and wanting to impress him, rushed up, tore open his shirt and

branded his chest in the same way. Breton was staggered by this extraordinary act and two days later issued a formal surrealist communiqué reinstating Matta and declaring that the surrealists would be unworthy if they did not recognize 'that Matta on that date showed himself in a light that utterly re-qualifies him in our eyes'. Safely away from the English-speaking world, where Breton had fared so badly, Matta was allowed back into the fold now that Breton was once again the undisputed leader.

In his later life Matta divided his time between Paris, London and Rome, and continued to produce major works, often on a large scale. His reputation within the art world was spreading and, during the 1960s and 1970s, he was awarded major retrospectives of his work. However, unlike Dalí, Magritte and Miró, his fame in Europe did not spread far beyond that world. He lacked Dalí's showmanship, Magritte's visual humour and Miró's bright colours; by comparison, he was too intense, too serious, too uncompromising. In contrast, by the time of his death at the age of ninety-one, Matta had become so respected in the country of his birth that, on hearing the news, the President of Chile declared three days of national mourning – an honour few artists have ever received.

Unlike many other surrealists, Matta never had a non-surrealist phase. From start to finish, all his paintings and drawings were pure surrealism and for some viewers they may have felt rather inaccessible. For the kind of person who looks at a surrealist painting and asks 'What does it mean?', Matta provided few easy answers. Even when the artist himself tried to explain his compositions, he avoided giving them precise interpretations. He described his landscapes as 'social-scapes, or econo-comics' and as 'attempts to chart our society'. His peers were also unhelpful, Breton describing him as 'a sort of lion with horns on his head fixed in a position to carry a mirror'.

An art critic referred to Matta's 'epic, cataclysmic and utopian vision', and the 'universal, social and public' nature of his work. These phrases do little to illuminate the real value of Matta's work. The truth is that he created for us a fascinating personal world that mysteriously parallels our own. As with all good surrealist work, the best solution is to stand in front of it and let its images wash straight into your unconscious mind, without any attempt to analyse their meaning. Matta himself summed up his life's work succinctly with the words: 'I am interested only in the unknown and I work for my own astonishment.'

E. L. T. MESENS

BELGIAN · Co-founder of the Belgian surrealist group in 1926;
leader of the British Surrealist Group from 1938–51

BORN: 27 November 1903 in Brussels as Edouard Léon Théodore Mesens

PARENTS: Father owned a drugstore in Brussels selling patent medicines

LIVED: Brussels 1903; London 1938; Brussels 1951

PARTNERS: NORINE VAN HECKE 1920s · PEGGY GUGGENHEIM (brief affair) 1938
· Married SYBIL (NEE FENTON) STEPHENSON 1943–66 (when she died)

DIED: 13 May 1971 in Brussels, of 'suicide by absinthe'

E. L. T. Mesens, c. 1958. Photo by Ida Kar.

EDOUARD MESENS WAS TO LONDON what André Breton was to Paris – the leader of the pack, the alpha surrealist. He had been one of the founder members of the Belgian surrealists in 1926 and it is surprising that he chose to leave his close-knit group of friends there and settle in a foreign country. Perhaps he felt overshadowed by his lifelong friend René Magritte and preferred to be the big fish elsewhere. The British art world had a number of artists who were fanatically supportive of the surrealist movement, but they were minor figures compared with Magritte, and Mesens could dominate them with ease.

Mesens arrived in England in 1936 in connection with the important International Surrealist Exhibition of that year, took one look around and promptly re-hung the entire show. Recognizing his impressive surrealist credentials, Roland Penrose decided to set him up with his own gallery – The London Gallery in Cork Street – which Mesens ran from 1938 to 1940, when it had to be closed down during the war, and again from 1946 to 1950, when it was finally shut down due to lack of sales. Throughout that period, Mesens was the nerve centre of the surrealist movement in Britain and, when he lost his gallery, the movement died. Surrealist art continued, of course, and still does, but as an active art movement with official meetings, tracts, declarations, disputes and expulsions, it ceased to exist.

Mesens was born in Brussels in 1903, where his father owned a pharmacy. Of his birth he is quoted as saying: 'I was born ... without god, without master, without king and without rights.' As a boy he was destined for a musical career and was enrolled at the Conservatoire in Brussels, where he became both an accomplished musician and a composer. However, at the age of twenty, he suddenly gave up his musical career and turned his attentions to surrealism and the visual arts. One of the reasons for his change of course may have been that the early surrealists had dismissed music as a 'stupid and meaningless art'. This was no more than contrived posturing stemming from the fact that André Breton was tone-deaf, but it was enough to make an impact on a keen young beginner.

The moment of truth for Mesens was a visit to Magritte's first exhibition in 1920. The two became lifelong friends although, as Mesens admitted many years later, their friendship was punctuated with frequent 'scenes and rows and even threatenings of killing each other'. As the Brussels group of surrealists grew larger over the years, Mesens found himself eased out of

his 'closest friend' relationship with Magritte, but they always had a special feeling for one another due to their very early attachment. Magritte would even let Mesens watch him painting. Because Magritte's creativity all came from a moment before he started painting – when the idea for a piece of visual trickery first sprung into his mind – he found the actual painting of that idea a boring process, and Mesens told a friend that there were occasions when Magritte would suddenly put down his brushes and 'run frantically to the brothel'. Mesens himself was also developing a taste for the erotic and, later in his life, was reputed to have become something of a sexual predator – pursuing either gender with urgent enthusiasm.

Also in 1920 Mesens met Paul-Gustave van Hecke, who had just opened a new art gallery. In the years ahead, van Hecke, became a close friend and taught him how to become an art dealer, something Mesens proved to be remarkably good at. His surrealist activities – publishing tracts, organizing exhibitions and making collages – could not earn him a living, but his art-dealing proved to be financially rewarding. This was not the only benefit he gained from his acquaintance with van Hecke whose attractive wife, a chic fashion designer called Norine, would soon become his lover. When Hecke died he left her with very little and Mesens felt obliged to take care of her financially. She always complained that it wasn't enough, but she was at his side many years later, when he was dying in 1971. Whether this was due to lasting love, however, or the hope of an inheritance is not clear.

Back in the 1920s, as time passed, Mesens began making collages. He never had the technical skill to become a painter, but his collages did show a remarkably poetic imagination and he himself was rather pleased with them. It therefore hurt him badly when he was told that, at some dinner party in his absence, Magritte had casually referred to them as 'rubbish' and a waste of money. After that they refused to speak to one another for at least a year, but in the end their bond of attachment won through. In the Wall Street crash of the 1930s, Magritte's gallery closed down and the owners were about to send 150 of his paintings off for auction at a moment when nobody was buying. Mesens, who managed to persuade his family to lend him the money, came to Magritte's rescue by buying the whole lot.

It was because of his expertise as a gallery owner that Mesens was brought over to London to help organize the 1936 surrealist exhibition there. Two years later, as the director of Roland Penrose's London Gallery, he hired a

secretary for the gallery, Sybil Stephenson, the wife of an abstract artist. Before long, they were lovers, she left her husband and, once the war had started, she and Mesens were married. Mesens feared he might be killed in the war and, by marrying Sybil, he ensured she would inherit his estate. It was in many ways a traditional, loving relationship, that was only ended by Sybil's death from cancer in 1966, yet it did not prevent Mesens from enjoying other sexual activities. He made a clear distinction between lust and love, feeling that occasional lustful pursuits were not in competition with his major, loving relationship. His wife seemed to accept this, even taking part herself, when their young gallery assistant was asked to make love to her as Edouard watched.

Once the London Gallery was up and running in 1938, producing important surrealist exhibitions, publications and catalogues, Mesens started to gather around him all the British surrealists still working in the field and to galvanize them into an active group, with meetings, declarations and expulsions in imitation of Breton's circle in Paris. At a famous meeting in 1940, Mesens insisted that they not only produced surrealist works of art, but that they also obeyed Breton's strict rules of behaviour. This meant that they could not exhibit their paintings alongside non-surrealist work, could not engage in any kind of religious behaviour, could not belong to any non-surrealist society or organization, could not be involved in supernatural studies, and could not accept any public honours. This ruled out several of the artists and Mesens found himself with a greatly reduced entourage. One member of the group had made a Madonna and Child sculpture, one had accepted an OBE, one belonged to a scientific society, and one had become involved in witchcraft. They all had to go. Mesens was a purist.

Because of the danger posed by the bombing, the London Gallery's large stock of paintings and its surrealist library were all housed in a storeroom on the banks of the Thames. As luck would have it, during the first German blitz on the city, the storeroom suffered a direct hit and everything was destroyed. With London being bombed nightly by the Luftwaffe, surrealist activities were inevitably reduced. In 1942 Mesens was given wartime employment at the French Department of the BBC World Service in London and was so preoccupied with this work that there was little happening with his circle of surrealists. It was at this time that the Italo-Russian surrealist Toni del Renzio (1915–2007), who had arrived on the scene in 1940, decided to take

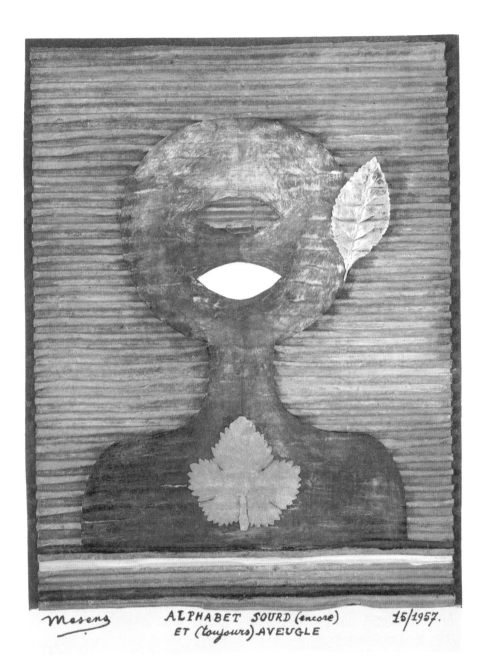

E. L. T. Mesens, *Alphabet Deaf (Still) and (Always) Blind*, 1957. Collage of gouache on cut-and-pasted woven, corrugated, and foil papers, laid on cardboard.

over the running of the group. Mesens fought back and won the day, isolating del Renzio and driving him away. Even at the height of the Blitz, he would not allow anything to interfere with his domination of the surrealist scene in England.

At the end of the war, Mesens was once again able to open the doors of the London Gallery, now at a new address in Brook Street. It was launched with an exhibition of the work of Wifredo Lam in November 1946. This would now become the centre of all surrealist activities in London until it closed in April 1950. The reason for the gallery's closure was that, in the exhausted mood of post-war austerity, with Europe in ruins, buying a surrealist painting was not at the top of anyone's want list. The London Gallery was losing so much money that Roland Penrose decided it had to shut down and Mesens now found himself without employment in London.

On a personal note, as a young surrealist, I was extremely grateful to Edouard Mesens for giving me my first London exhibition in that final year of his gallery. For me, just starting out, it was a heavy blow to find that, within a few weeks of my arrival, the surrealist movement in London was ending. Mesens, always immaculate and helpful, gave no hint of what he must have suspected was on the horizon.

In the years that followed, he busied himself with organizing exhibitions in Belgium and, in 1954, began to devote much more time to making his own collages, an activity that he pursued until his death. In the 1960s he held a number of solo exhibitions of his work in Milan, Venice, London, New York, Knokke and Brussels. Yet it was a sad decade for him because his wife Sybil died of leukaemia in 1966 and his lifelong friends Magritte and van Hecke died in the following year. Mesens himself did not live much longer. He died in a Brussels nursing home in 1971, a rich man because of his collection of surrealist masterpieces, assembled over many years since the earliest days of the movement. His final weeks were painful and he did his best to shorten them by consuming large quantities of alcohol when it was expressly forbidden by his doctors. A friend described his death as suicide by absinthe.

JOAN MIRÓ

SPANISH · Joined the Paris group of surrealists in 1924 but
in old age rejected the label of surrealist artist

BORN: 20 April 1893 in Barcelona

PARENTS: Father a watchmaker

LIVED: Barcelona 1893; Montroig, Tarragona & Barcelona 1910; Paris 1920;

Barcelona 1932; Paris 1936; Varengeville, Normandy 1939; Palma, Majorca 1940;

Barcelona 1942; Palma, Majorca 1956

PARTNER: Married PILAR JUNCOSA in Palma, Majorca, 1929; one child

DIED: 25 December 1983 in Palma, of heart disease

BORN IN BARCELONA IN 1893, the grandson of a blacksmith and the son of a goldsmith who was also a watchmaker, Miró was, by his own admission, a poor pupil at school. He described himself as a silent, taciturn, daydreaming misfit. By the age of eight he was already busy making drawings. His family insisted on a business career for him and he had to start work as a trainee, but was so unhappy in this role that it affected his health and he contracted typhoid. His family relented and, after convalescence, he started as a student at a private art school that encouraged innovation. In 1912, when he was nineteen, he encountered modern art for the first time when he visited an exhibition of cubist art in Barcelona.

In 1915 Miró was called up for military service but continued to paint. During this early phase he produced conventional canvases with a slightly cubist flavour. During the ten years between 1908 and 1918 he produced about sixty landscapes, still lifes and portraits, most of which are best forgotten. Then, in 1920, he moved to Paris, where he visited Pablo Picasso in his studio and explored the art museums and galleries. From this point on, he developed an annual pattern of winters in Paris and summers at the family farm in Montroig, south of Barcelona. It was at the farm in 1921 that he produced his first major work, which he sold to Ernest Hemingway. Called simply The Farm, it included small signs that he would soon abandon representational

traditions and move on to a new phase of imaginative art.

In Paris Miró was meeting artists with similar ideas. His neighbour was André Masson, who became a close friend and introduced him to the Parisian avant-garde. By 1923 Miró was already creating works that involved wild visual distortions and dramatic modifications of the natural world and, by 1924, he had somehow managed to fling off all traditional influences. A key work of that year, *Maternité*, sums up his radical new vision. He now had as little respect for the precise copying of the images of the external world as a child of five. Instead, he soared off into a realm of shapes and colours that were joyfully free of the chains of representation.

At about this time, Miró made a statement in which he formally declared that he wished to shoot down traditional art. He became a visual poet, an inventor of beguiling images that forced the onlooker to abandon any preconceived ideas about what art should be. André Masson was thrilled by his work and in 1928 declared that 'Miró is the most surrealist of us all ... on his own ground he is invincible.' He could see that Miró was working from his unconscious, abandoning all the usual rules of perspective, gravity, modelling and shading and allowing his childlike imagination to run riot on the canvases. His paintings in the second half of the 1920s were among the most extreme in their rejection of the established values of the visual arts. He was creating a whole new visual language.

Miró, for his part, although he participated in surrealist exhibitions, did not care for the theoretical aspects of Breton's concept of the new movement. Nor did he like the idea of having to join a group of intellectuals and submit himself to group rules. He had a deep-seated dislike of all intellectual interpretations of art and, as a result, never signed any manifestos or attended any group meetings. This must have been something of an embarrassment for Breton. Here, by his own judgment, was the most purely surrealist of all the artists and he was refusing to become an official member of his movement. He had no choice but to find some way to punish Miró and to modify the total reverence for his work he had expressed previously. He did this by viewing Miró's visual wildness as juvenile, speaking of his 'partially arrested development at the infantile stage which has left him ill protected against unevenness, overproduction and playfulness'. It was the best he could do, but like many of his petulant outbursts it simply made him look foolish. Miró was off and running, the

Joan Miró with a hornbill at London Zoo, 1964. Photo by Lee Miller.

super-surrealist who would eventually dwarf all the rest and there was nothing Breton could do about it.

By 1929 matters within the surrealist circle had come to a head. There was much grumbling about Breton's authoritarian control of the group and, unable to ignore the level of discontent, he decided to send out a circular letter asking for a statement of allegiance. Miró replied: 'I am convinced that individuals whose personalities are strong ... will never be able to give in to the military-like discipline that communal action necessarily demands.' In an interview in 1931, he was more specific: 'I've been labelled a surrealist, but what I want to do above and beyond anything else is maintain my total, absolute, rigorous independence. I consider surrealism an extremely interesting intellectual phenomenon, a positive thing, but I don't want to subject myself to its severe discipline.'

It was in this same interview that he famously attacked traditional painting, saying:

> I intend to destroy, to destroy everything that exists in painting. I have an utter contempt for painting ... I'm not interested in any school or any artist. Not one. I'm only interested in anonymous art, the kind that springs from the collective unconscious ... When I stand in front of a canvas, I never know what I am going to do – and nobody is more surprised than I at what comes out.

This is a statement of pure surrealism and, whether he liked it or not, it placed him at the very core of the surrealist movement. In the years ahead, as he became better known and more successful, his work slowly evolved to the point where he had invented a whole set of personal images and symbols with which he could populate his brightly coloured canvases. Human and animal figures, sometimes barely recognizable, and moons, suns and stars, all disported themselves in his compositions. It was metamorphic surrealism at its very best. And to be fair to Breton he did recognize this, despite his annoyance at not being able to corral Miró into the confines of his official group. When, in the 1940s, Miró produced his brilliant *Constellations* series, Breton was so moved by them that he wrote: 'the sensation we derive from them [is] of uninterrupted, perfect success ... these superb paintings that appeared quite naturally as floodgates from which love and liberty gushed forth in a single stream.' Miró

had won. He may have rejected Breton's leadership, but Breton could not bring himself to reject Miró's painting.

Throughout the 1920s and 1930s Miró divided his time between France and Spain. From 1920 to 1932 he was mainly in Paris with trips home to Spain. Then, in 1932, he moved back to his father's house in Barcelona and made trips to Paris. In 1936 he was back living in Paris once more. When the war began he decided to return to Spain, even though Franco was in power. He avoided the mainland and settled on the island of Majorca for a couple of years before finally returning to Barcelona. In 1947 he made a nine-month-long visit to the United States, where he encountered the young American artists who would soon be establishing the abstract expressionist school in New York.

In 1956 Miró moved into the house that would remain his home until his death in 1983. Called *So N'Abrines*, it was on a hill above Palma, Majorca. All his life he had dreamt of owning a large studio and now his friend, the Spanish architect Josep Lluís Sert, had designed one for him, right below his house. It was huge, with wonderful light, and Miró was able to move into it all the old works that he had kept in storage in Paris and elsewhere. The first task he gave himself was to study all these earlier paintings and drawings and assess them. Sadly, he decided to destroy large numbers of them. After he had done that, instead of starting to paint vigorously in his wonderful new environment, he froze. The large space that he had wanted so badly seemed to overwhelm him, and he stopped painting altogether. This state of affairs lasted for three years – the only time in his adult life when he was not actively painting.

When, in 1959, he began to paint again, he started on a series of vast canvases that displayed only a few spots and lines, as though he was trying to cleanse himself of every visual obsession and start again. By the late 1960s and the 1970s, his work was much more powerful, more crude and largely lacking in the refined figures that he had perfected in the 1940s and 1950s. It was as though something was telling him that he had become too precise, too organized and that he now needed not to destroy traditional painting but to destroy his own earlier style. He even set fire to some of his paintings and then exhibited the burnt-out stretcher frames. The young rebel had returned in old age to destroy the much-loved work of the middle-aged Miró. Fortunately most of the work from his glory years was beyond his reach, in private and public collections all over the world, and survived.

After he died, two Miró Foundations were established, one in Barcelona and another in Palma. In Palma it is possible to visit his large studio, still arranged exactly as he left it the day he died. His fame has become global. Nearly 200 books have been written about his art. Of the top ten most expensive surrealist paintings sold at auction, six are by Miró. One of his early oils was sold for £23.5 million in 2012. He has come to overshadow all other surrealists, both in popularity and in commercial value.

Miró's personal life was largely uneventful. Unlike many of the other surrealists, he was not interested in drunken parties, sexual adventures or other forms of required surrealist decadency or social life. His wild acts of rebellion were all reserved for his canvases. At other times he was quietly, politely reserved. He was a workaholic. When asked if he enjoyed gallery openings he said, 'I absolutely detest openings and nearly all parties'. When an American interviewer enquired what he did when he didn't feel like painting, he replied, 'But I always feel like painting!' He explained that every day (except Sundays) he painted from 7 a.m. until noon, and then again from 3 p.m. until 8 p.m. After dinner he would listen to music, especially American swing, and turn in early. One of the problems he encountered while living in America was that this routine was disrupted by appointments, meetings and exhibitions, and he was much in demand. Too tired to paint, his main pleasure there was attending baseball matches.

At home, his family life was very ordinary. He had married in 1929 and his cheerful wife Pilar hailed from Palma so, for her, settling there was a matter of coming home. They had one daughter who gave them three grandchildren. Joan and Pilar Miró remained happily married for fifty-four years, until his death from heart failure on Christmas Day in 1983 at the age of ninety.

On a personal note, when Edouard Mesens gave me my first London exhibition in 1950, I was delighted when he wrote to me saying, 'Your neighbouring exhibitor will not be Jean Helion; in Room A there will be a show of Joan Miró.' To share an exhibition with Miró was an honour for me and allowed me to study his work closely. His early blue canvases from the 1920s (like the one that sold for over £23 million in 2012) were marked up at £200, which was way beyond my undergraduate pocket.

Later, in 1958, I carried out an investigation into the remarkable picture-making abilities of a chimpanzee called Congo. His paintings were not random splashes, but visually controlled abstract compositions and Roland

Penrose arranged an exhibition of them at the ICA in London. Roland gave one of Congo's paintings to his old friend 'Don Pablo' and when Miró heard that Picasso owned one, he wanted one too and came to see me in London to acquire one.

In 1964, while Miró was in England staying with Roland Penrose and his wife, the photographer Lee Miller, Roland called me to say that, apart from acquiring a Congo painting, Miró was also fascinated by the possibility of encountering some of the London Zoo animals at close quarters. He asked, in particular, if he could meet 'brightly coloured birds and creatures of the night'. As I was a zoo curator at the time, I was able to make special arrangements for him to go behind the scenes. I fixed up details with the keepers and awaited Miró's arrival. When the car drew up at the zoo gates, the figure that got out was of small stature and immaculately dressed in a quietly elegant suit. He looked more like a Spanish banker or diplomat, rather than the creator of some of the most ground-breaking works of art of

Joan Miró, *Women and Bird in the Night*, 1944. Gouache on canvas.

the century. His manner was courteous and correct. I was used to showing heads of state around the zoo, and this felt no different.

We went to the bird house where, to Miró's joyful if somewhat alarmed surprise, I had a huge hornbill placed on his wrist. I had chosen this bird because the bright colouring around its eye could have been painted by Miró's hand. He gave me a nod that indicated he understood this. Lee Miller took a splendid photograph of him feeding the hornbill and we moved on to the nocturnal house. There I arranged for him to watch in close-up as a chameleon shot out its unbelievably long tongue, which had a sticky knob on the end, to catch a large insect. Miró's response was that of an excited child, his eyes lighting up as the chameleon struck. When we moved to the reptile house and a small snake was brought out for him, there was an almost audible twinkle in his eyes. He was leaning forward to peer closely at the snake's head, when a keeper held up a dead mouse and the reptile struck at it with lightning speed. Miró jumped back as the snake's head flashed past him, then laughed at the sheer beauty and ferocity of the action he had witnessed. Miró has been quoted as saying that, in a painting, a line should 'strike like a knife' and here was a snake doing just that.

I had saved the best for last. I remembered that, in one of the earliest surviving drawings made by Miró, dating from 1908 when he was only fifteen, he had depicted a giant serpent that appeared to be trying to constrict itself. At some risk, bearing in mind Miró's small stature, I had arranged for a huge python to be wrapped around his body, so that he could sense the enormous power of the animal as it settled its heavy bulk around his shoulders. At one point I thought that I had made a mistake and that Miró, who in 1964 was already in his seventies, would collapse under the weight of the (deliberately well-fed) python. There was a brief struggle, and then success. Miró stood smiling triumphantly holding the coils of the monster he had depicted so lovingly over half a century earlier. Lee Miller captured the moment with her camera and to this day it remains my favourite image of the great man.

At the end of the day Miró was tiring and we all walked across to our apartment that was conveniently just outside the zoo gates. There I set out several Congo paintings for him to examine and he chose one of them to take home with him. He was so pleased with it that he decided to do a sketch in exchange. I was able to find a piece of white card and some coloured inks and crayons. Miró was delighted, sat down, and checked each of the crayons

and pens, carefully studying their colours. We had spent a long day together and he was thirsty. My wife brought him a cup of tea and then stood leaning against the mantelpiece watching him as he started to draw. She was wearing tight black toreador trousers that flared below the knee and, to my surprise, the central figure in Miró's sketch, although highly stylized, reflected this.

Once he had finished, he dedicated the sketch to her, with the words: 'Pour Mrs Ramona Morris, Hommage de Miró. 18/IX/64'. One extraordinary detail was the way he wrote the letter M. His own M was, as usual, made up of four slashed lines, but before writing the word Morris he got up, crossed the room and examined the DM monogram with which I sign all my paintings. It takes the form of a spiralling line. He then returned to his sketch and carefully formed a spiral M for the word Morris. Such attention to small visual detail was typical of the man. Perhaps sensing that I was slightly crestfallen that the sketch had not been dedicated to me, Miró went to my bookcases, took out a large monograph on his work, and did a second sketch in it for me. On my sketch he wrote, 'à Desmond Morris en souvenir de cette belle journée' ('to Desmond Morris in memory of this wonderful day'). Two Mirós for one Congo struck me as amazingly generous.

A decade later I visited Miró at So N'Abrines. I had acquired a 1,500-year-old Colima terracotta figurine in New York that had features reminiscent of one of his sculptures and I took it to him as a gift to celebrate his eighty-second birthday. Ever courteous, he sent me a long letter of thanks. I still find the contrast between the neat, polite, quietly charming man and his wild, rebellious paintings rather extraordinary. I suppose that he had been able to pour so much of his most extreme imaginings and outrageous fantasies onto canvas that his need for wildness was all used up in his art, leaving him free to enjoy a congenial, rather orthodox lifestyle. But orthodox or not, there was one physical quality of his that I recall vividly. When Miró saw something that fascinated him, his eyes came alive and fixated it with an intense stare, like a cheetah spotting an antelope. And for most of the time I spent in his company there seemed to be something in his range of vision that warranted this treatment, as though he was constantly receptive to new visual input. The only time his eyes glazed over was when I happened to mention the name of Salvador Dalí. 'Big mistake,' whispered Roland Penrose, and quickly changed the subject.

HENRY MOORE

ENGLISH · Member of British Surrealist Group in 1930s; expelled by Mesens in 1948

BORN: 30 July 1898 in Castleford, West Yorkshire

PARENTS: Father of Irish origin, under-manager of the Wheldale colliery

LIVED: Castleford 1898; with the Army in World War I; Leeds 1919; London 1921;
Hampstead 1929; Perry Green near Much Hadham, Hertfordshire 1940

PARTNER: Married IRINA RADETSKY, an art student at the Royal College of Art,
London, in 1929

DIED: 31 August 1986 at Perry Green near Much Hadham, Hertfordshire

WITH HENRY MOORE, the great mystery is how on earth he became associated with the surrealists, for his personality and his lifestyle were as far as it is possible to get from the spirit of surrealism. When you sat chatting with him, you felt you were in the presence of a down-to-earth, work-toughened Yorkshire farmer, rather than a major avant-garde artist and arguably the greatest sculptor of his generation.

He was never keen to talk about his work and appeared to have no interest in what other modern sculptors were doing. The only time I ever annoyed him was when I suggested that it might be worth making a visit to see the huge, new sculpture-garden of a Scandinavian artist that was making the news in the 1960s. To my surprise, Henry dismissed the man's work as appalling rubbish and a waste of space. This seemed so uncharacteristic of him because, on all other topics, he was the epitome of modest, friendly enthusiasm. I soon learned that there were two Henry Moores – the reserved, easy-going, eager-to-learn companion and the passionately driven sculptor who took no prisoners.

Knowing that I was a zoologist, Henry wanted to spend all our time together discussing animals. He would, for example, want to analyse in great detail the differences in the silhouette and skin texture of the Indian and the African elephant. It was clear to me that he was seeing these giants as pieces of moving sculpture. In particular, he loved the shape of their skulls.

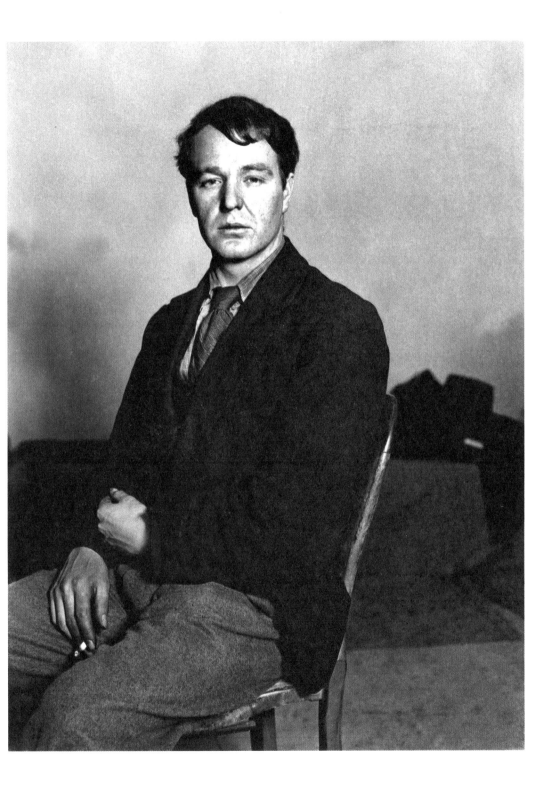

Henry Moore, c. 1930s. Photographer unknown.

It so happened that a mutual friend of ours, the zoologist Julian Huxley, had an African elephant's skull at the bottom of his garden and when Henry, the affably polite visitor, caught sight of it he was immediately transformed into that other Henry – the ruthless sculptor. 'It is magnificent, I must have it,' he gasped. Julian and his wife were taken aback. You don't walk into a friend's house and demand that they hand over one of their prized personal possessions. They told him firmly that could not have it – 'if only because birds are nesting in its eye-sockets'. Henry's response was to say that he would wait until the nestlings had fledged. The Huxleys, trapped by having used an excuse instead of saying simply that they didn't want to part with their splendid skull, had no choice. When the birds left the eye-sockets, they dutifully telephoned Henry with the news. Julian told me that, within hours, a large van had arrived and the skull was gone. Henry was thrilled and used it as the basis for several important sculptures and a number of drawings.

So that was Henry Moore – tough when it mattered and tender when it didn't. And the only thing that really mattered to him, and filled most of his waking hours, was the creation of sculpture. How did this lifelong obsession begin?

Moore was born in a Yorkshire mining town, the sixth of the seven children of a tough coal miner. The family lived in a house that was so small that the children always had to sleep three or four in a bed. But when people referred to his hard childhood, he insisted that it was happy, not hard. Where he lived, everyone had the same sort of lifestyle, so he had no concept of a soft childhood with which to compare his own. It was the norm; it was what you expected of life. But he was lucky because his father, a typical Victorian head-of-the-house whose word was law, respected learning and wanted his children to be well educated. Moore was also encouraged to go out into the local countryside at the weekends, where he became fascinated by the forms of the branches and roots of trees and by piles of rocks he came across in the woodlands. One rock-pile, in particular, looked like a sphinx worn smooth by time and, in later life, he remembered it. He also visited the local church were he saw his first sculpture and was especially impressed by the recumbent figure of a woman, whose face had been simplified without robbing it of its beauty or its serenity, something that could be said of the faces of many of his own stylized, figurative sculptures.

When he was eleven he decided that he wanted to be a sculptor, following a Sunday School lesson in which he was introduced to the work of Michelangelo. His father was against this because he considered sculpting to be manual labour – something he wanted his children to rise above. Henry eventually became a schoolteacher but this career was interrupted by World War I, in which he served and was lucky to survive. After one battle, only 42 of the 400 men in his group remained alive. After the war, Moore was given a grant that enabled him to attend Leeds School of Art and to pursue his sculptural work in earnest. While there, he fell for a young student called Barbara Hepworth and managed to convince her to switch from drawing to sculpting – thereby setting in motion a lifelong rivalry, albeit a friendly one.

Moore eventually moved to London and the Royal College of Art. There he lived in Chelsea, in a room that was only eight feet by nine, but he loved it because he didn't have to share it. In his spare time he haunted the British Museum and the Natural History Museum, but avoided the Tate Gallery because, strangely, he wasn't interested in contemporary art. I once asked him if he enjoyed his art classes, or found them too rigid. He told me that he hated still-life classes and would sneak off if he had the chance. One day, he said, when he was avoiding the boring still-life compositions with their meaningless subject matter, he idly opened some old drawers in the corner of one of the art rooms. Inside he found some dusty animal bones that had long ago been used for drawing lessons. He was fascinated by their shapes and began sketching them. After telling me this, he paused for a moment and then said, in a soft voice, 'I think they have stood me in good stead, don't you?' Of course I agreed, because it was these biomorphic shapes that would become the very basis of all his later work, in which he saw beneath the surface of human and animal forms to get at their structural essence.

It was later, when he was teaching at the Royal College of Art, that he met a young art student, the Russian-Polish Irina Radetsky, who became his wife and lifelong partner. (When René Magritte visited the Moores in London in 1937, Irina made a deep impression on him and he wrote to a friend, describing her as 'a young Russian wife with a SUPERBLY shapely body, like a sturdy wasp'.) After a period in Hampstead in the 1930s, the Moores moved out of London and bought a farmhouse at Much Hadham in Hertfordshire that would remain their home for the rest of their lives. They lived a simple, almost Victorian existence, with Henry going 'down the mine'

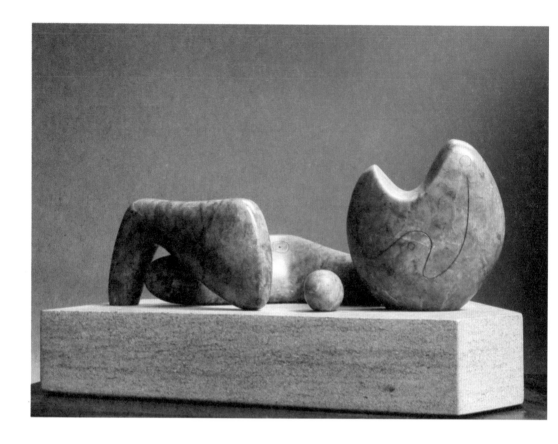

into his sculpture workshop each day, where he would hammer away at a stone surface for hour after hour, just as his father had once hammered at the coal-face. For Moore, the 'dignity of labour' was something that had stuck to him from childhood and he never complained about it. When I was once foolish enough to say to him that it must be very hard work, he gave me the look of someone who was tired of having to answer this question and said, 'No, no, it's just a matter of knowing how to let the mallet hit the chisel'. And that was the end of the discussion.

Henry Moore, *Four-Piece Composition: Reclining Figure*, 1934. Cumberland alabaster.

Family life changed little over the years for Moore. When he and Irina were young they had little money and lived frugally. When, in later life following global successes with his work, he was immensely rich, they still lived frugally and saved their money. Moore had been firmly grounded by his upbringing and was able to enjoy his sculptural experimentations without being corrupted by fame. He was his own man and would have little to do with the establishment in London. Offered a knighthood, he refused saying that he couldn't bear the thought of being greeted in his workshop with 'Good morning Sir Henry'. And he refused all attempts to get him to exhibit at the Royal Academy. It was as if his experiences in the battlefields of World War I had turned him against anything to do with official society.

Here, perhaps, we can see the seeds of his involvement with the surrealists. The surrealist movement had been spawned by a hatred of the pointless slaughter of World War I. When Moore first visited Paris in the early 1930s, a time when the surrealist movement there was at its height, he met André Breton and learned what was going on with sculptors like Jean Arp and Alberto Giacometti. He disliked some aspects of the movement – its tendency towards what he considered pornography and some of its wilder excesses – but he admired the openness of its ideas and the encouragement of unconscious experimentation. The way in which he was starting to play with the human form and metamorphose it in various ways in his sculptures fitted well with the surrealist approach. Above all, he embraced it because 'it was an antidote to absolute pure abstraction'. His lifelong obsession with biological forms meant that he was always the enemy of hard-edge abstraction with its geometric refinements, and the growth of the surrealist movement provided a welcome ally, preventing the abstractionist movement from dominating avant-garde art.

Moore's involvement in the surrealist movement lasted for about eight years, from 1936 to 1944. It became serious in 1936, when a neighbour of his in Hampstead, Roland Penrose, recently returned from Paris, decided to organize a major International Surrealist Exhibition in London that year. Penrose considered Moore's recent work to be fully surrealist in spirit, and four of his pieces were to be included in the exhibition. Moore himself, perhaps because he was the sort of person you knew you could trust, was elected the treasurer of the 'British Organizing Committee'. He attended the notorious evening at the Burlington Galleries, when Salvador Dalí attempted to give

a lecture wearing a diving suit. Moore's comment on the occasion reflected his ambivalent attitude towards the surrealist group. He complained that he had to wait for twenty-five minutes, sitting in front of an empty stage, before Dalí made his entrance. The precision of his timing of his long wait says a lot about the sensibly controlled way he organized his life. He may have been an out-and-out surrealist in the strangely wonderful ways in which he manipulated the human form in his sculptures and created imaginative biomorphic shapes, but in the way he lived his daily life he was far too level-headed for the totally committed surrealists.

Matters came to a head in 1944 when he accepted a commission to make a Madonna and Child for a church in Northampton. There was nothing especially religious about the resulting sculpture. It showed what could be any proud, healthy peasant woman with a sturdy baby boy sitting on her lap. But, by placing it in a church, it became a religious icon and this broke one of the cardinal rules of surrealism and led to Moore's eventual expulsion from the movement. A few years later, in a formal declaration signed by nearly all the British surrealists, Moore was attacked for 'making sacred ornaments'. Surprisingly, his friend Roland Penrose was one of the fourteen signatories. I asked Moore if he had been upset at being expelled. He smiled and said, 'Not a bit. If they didn't want me, that was fine by me.'

He had taken what he wanted from the movement and enjoyed the release it had given him. Some of his best pieces from the 1930s are great examples of surrealist sculpture. Thanks to his involvement with the surrealists he had been freed from conscious control to create excitingly novel forms, still with a basis in biology but with a much more extreme metamorphosis than could be found in his earlier or, for that matter, in his later work. Like Picasso, he was not a complete, out-and-out surrealist but, like the Spaniard, he did pass through a significant surrealist phase.

MERET OPPENHEIM

SWISS/GERMAN • Member of the surrealist group in Paris 1933–37

BORN: 6 October 1913 in Berlin, in the western borough of Charlottenburg

PARENTS: Father a German-Jewish doctor; mother Swiss

LIVED: Berlin 1913; Delemont, Switzerland 1914; Steinen, south Germany 1918; Basel 1929–30; Paris 1932; Basel 1937; Bern 1954

PARTNERS: Man Ray 1933 • Max Ernst 1934–35 • Married Wolfgang la Roche 1949 to 1967, when he died

DIED: 15 November 1985 in Basel, Switzerland

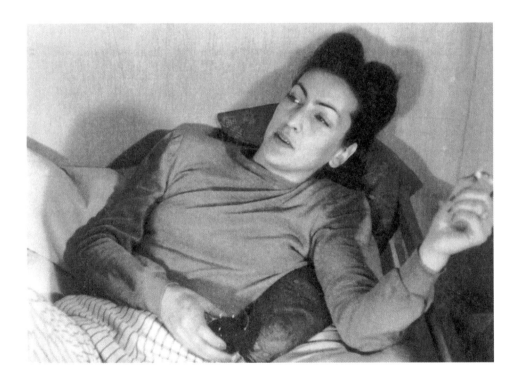

Meret Oppenheim in Basel, autumn 1943. Photographer unknown.

MERET OPPENHEIM IS ONE OF THOSE ARTISTS whose fame rests on a single work. In her case it was the fur-lined cup, saucer and spoon that she exhibited in the International Surrealist Exhibition in London in 1936. She made a number of perversely intriguing surrealist objects, but it was this one that caught the public imagination. The idea of drinking from it was so disturbing that its image became lodged in the imagination and refused to go away.

Oppenheim was born in a wealthy suburb of Berlin just before the outbreak of World War I. Her German father was a Jewish doctor, her mother Swiss. When the war started in 1914, her father was conscripted into the army and her mother retreated to her parents' home in Switzerland, taking the infant Meret with her. She and Meret remained there until the end of the war in 1918, when they moved to a village on the edge of the Black Forest in southern Germany. During her childhood, from the age of seven, Oppenheim showed a passion for drawing and painting. As she was growing up, she encountered the work of the Swiss master Paul Klee that impressed her greatly. Her parents were worried that, because of her obsession with art, she was neglecting her other studies and sent her to Carl Jung for analysis. Jung reassured them that there was nothing to worry about and her parents agreed to let her go to art school.

In 1932, when she was only eighteen, the rebellious, free-spirited Oppenheim moved to Paris with a female friend, to be at the centre of the art world. She recalled that, 'We went immediately, without washing our hands, to the Café du Dôme'. It was there, one day, that she met Alberto Giacometti. Within a year she had infiltrated the male-dominated surrealist circle of artists who gathered around André Breton and was invited to exhibit her work with them. Through Giacometti she also met Jean Arp, and when the two of them visited her studio and saw her work they were so impressed by it that, despite her young age, they invited her to exhibit in the 1933 Surrealist show at the Salon des Surindépendants. Soon she was meeting with André Breton and was joining in the notorious surrealist gatherings in the local cafés. She was celebrated by the surrealists as the 'fairy woman whom all men desire' and she impressed them with her uninhibited behaviour, her surrealist food created from marzipan, and her dangerous habit of taking walks on the ledges of high buildings.

Oppenheim's first moment of notoriety arrived with a photographic session arranged by Man Ray in 1933. He showed her next to a large printing press,

stark naked except for a long smear of printer's ink down the underside of her left forearm and hand. Her dark hair was cut short, like a man's, and her face was expressionless and unsmiling. She appeared to be a victim of some sort of unidentified ritual in which the heavy machinery of the printing press was threatening her in some unspecified way. Her participation in this now famous photo-session seemed to be yet another example of the way in which the surrealists viewed women – as muse, sexual outlet and decorative, secondary figures. There were, indeed, a number of surrealist 'groupies' who did fit this role, but Oppenheim was unhappy about it. She was an early feminist, far ahead of her time, and resented the direction in which the surrealists had been nudging her since her arrival in their circle. Despite her strong feelings, however, it was reported that she did, in the end – even if with some reluctance – find herself in Man Ray's bed.

Many years later, when she was asked what she thought of her surrealist companions, she replied that they were 'a bunch of bastards'. She hated the idea that gender had any impact on the nature of art. Her stated position was that 'art has no gender characteristics'. She wanted to be counted, not as a female surrealist, but simply as a surrealist. Despite her strong feminist stance, there was another male surrealist that she found she could not resist. In 1934 she began a year-long, passionate love affair with the charming, charismatic, birdlike Max Ernst, whom she met at a studio party. Both had German as their first language, which no doubt helped, and the libidinous Max swept her off her feet. He had just concluded a brief affair with the exotic artist Leonor Fini and was now captivated by the free-spirited Oppenheim. However, feeling stifled by him, Meret ended their relationship in 1935. She did this abruptly, when they met one day in a café, blurting out, 'I don't want to see you any more'. Max was hurt and accused her of finding someone else, but she hotly denied this. Much later, she commented: 'Living closely together with Ernst, a fully developed artist, would have been a catastrophe for me. I was only at the beginning of my artistic development.'

Oppenheim's rise to international fame stemmed from a passing remark made by Pablo Picasso. Early in 1936 she was drinking coffee in a Paris café with Picasso and his partner Dora Maar. She happened to be wearing a fur-lined metal bracelet that she had designed herself and Picasso was intrigued by the unusual combination of fur and metal. Jokingly, he commented that one could cover anything with fur. Oppenheim picked up her cup and saucer

and said 'Even this?' The idea stuck in her mind and, when she left the café, she went straight to a Uniprix department store where she bought a cup, saucer and spoon and then carefully lined them with the fur of a Chinese gazelle. This disconcerting work – titled simply *Object* – was exhibited in May 1936 at the first exhibition of surrealist objects at the Charles Ratton

Meret Oppenheim, *Stone Woman*, 1938.

gallery in Paris. It caused a sensation and was described as the 'quintessential surrealist object'. It later crossed the channel to appear in the International Surrealist Exhibition in London in June of that year. It was acquired by the Museum of Modern Art in New York and was destined to become one of the most famous of all surrealist images, along with Salvador Dalí's soft watches and Marcel Duchamp's urinal-fountain.

The publicity surrounding her fur-lined cup had a double impact on Oppenheim herself. Its notoriety made her famous, but it also had the odd effect of inhibiting her further work. Instead of boosting her confidence, it overwhelmed her. She tried to play it down, calling it a 'youthful joke', but to no avail. It had developed a life of its own. The fur-lined cup, with its erotic undertone was here to stay. When asked about it years later, she commented plaintively: 'Ah, this eternal Fur-cup. You make an object, which gets placed on an altar, and everybody only speaks of it and nothing else.'

In 1937, after five years in Paris, Oppenheim was forced to abandon the city for financial reasons and return to Switzerland. The change in her circumstances was caused by Hitler's growing anti-semitism in Germany. This meant that her wealthy Jewish father had to give up his successful medical practice, flee the country and settle in Switzerland in order to escape the Nazis. As a result of this forced change in family circumstances, the regular financial support he provided to Meret had to stop. Her surrealist art had never provided her with a sufficient income to survive and she suddenly found herself having to earn her own living. She tried her hand at making jewellery and at fashion design, but failed with both. It was at that point that she moved back to Basel and took a two-year course in art restoration. With this newly acquired skill she was able to set herself up as a picture restorer, but it must have been a great shock suddenly to find herself torn from the glamorously rebellious cradle of modern art in Paris.

A black cloud descended over her at this point and she sank into a non-creative depression that would last for seventeen years, until 1954. She is on record as saying that she suffered from a 'suffocating sense of inferiority'. Occasionally she would try to create new works of art, but they seldom worked and she destroyed nearly everything that she produced. Then, as suddenly as it had arrived, her depression lifted and she was able to enjoy an active, creative existence for the last thirty years of her life. It was during this depressed period in Switzerland that she decided to take a husband. In

1949 she married Wolfgang la Roche, a man she described as a sensitive busi-
nessman who was 'unconventional inside'. She explained that, 'My marriage
was a healing experience. I felt so crazy at that time, I didn't even know how
to cross the street. My husband gave me support.' They remained married
until his death in 1967.

In 1959, back in the world of modern art again, Oppenheim was involved
in a major scandal when she designed a cannibal feast for the opening cer-
emony of the International Surrealist Exhibition in Paris. Today we would
call this work of hers 'installation art' or 'performance art', but once more
she was ahead of her time. It consisted of a young woman, completely naked,
lying on a dining table laden with food. Some of the food was placed on the
woman's body, as if she herself were part of the feast. The woman remained
still but was clearly alive, and the unspoken suggestion was that you could
cut a slice of her to go with your salad or vegetables. Guests were invited to
eat the food that lay on her body.

The irony of the controversy caused by this exhibit was that Oppenheim,
the arch feminist, was accused, with some justification, of treating the body
of a woman as an object to be devoured. Oppenheim was upset by this inter-
pretation, insisting that her work of art was instead a celebration of fertility
and that the naked woman represented the abundance of Mother Earth.
Perhaps hurt by the critical remarks made about her installation, Oppenheim
never exhibited with the surrealists again. She said that she felt surrealism
had changed after World War II and lost its way. She continued to exhibit as
an independent artist for many years, right up to her death in Basel in 1985.

Looking back at her life in 1984, shortly before she died, she commented:

I despise labels. Above all, I reject the term 'surrealist' because it has
not had the same meaning since the Second World War as it did earlier. I
believe what Breton wrote about poetry and art in his first manifesto in
1924 were some of the most beautiful words ever to have been written
on the subject. By contrast, I feel quite sick when I think of all the things
making reference to surrealism today.

Even as an old woman, she hankered after those magical, early days in Paris
when she was being fêted as a rising young star at the very heart of the
greatest art rebellion of the twentieth century.

WOLFGANG PAALEN

AUSTRIAN/MEXICAN from 1947

Joined the surrealist group in Paris in 1935

BORN: 22 July 1905 in Vienna

PARENTS: Father an Austrian-Jewish merchant/inventor; mother a German actress

LIVED: Baden 1905; Rochusburg in Sagan, Silesia 1913; Rome 1919; Berlin 1922;
Paris 1924; La Ciotat, Cassis 1927; Paris 1928; New York 1939; Mexico 1939;
Paris 1951; Mexico 1953

PARTNERS: HELENE MEIER-GRAEFE 1922 (brief affair) • EVA SULTZER, Swiss heiress
1929 to 1950s • Married ALICE RAHON, French poet 1934; divorced 1947 • Married LUCHITA
HURTADO DEL SOLAR 1947; divorced 1950 • Married ISABEL MARIN 1957–59

DIED: 24 September 1959 in Taxco, Mexico, by suicide

WOLFGANG PAALEN HAS THE DUBIOUS DISTINCTION of being the only surrealist to have been eaten by wild animals. Plagued on and off by depression, he took his own life in a remote location and was not discovered for some days other than, reputedly, by a group of hungry pigs.

Paalen is one of those artists who benefited enormously from his association with Breton's surrealist group in Paris. He was involved with them between the mid-1930s and the outbreak of World War II. During those few years he produced a series of outstanding paintings – spiky, totemic figures in an alien landscape that, once seen, can never be forgotten. Herbert Read said of them: 'The paintings of Wolfgang Paalen are primordial ... The space around is arctic and infinite and the broken membranes float in iridescent ruin through the icy air.' And Georges Hugnet wrote: 'Wolfgang Paalen creates strident figures, with folded wings, encased in cocoons, guardians of a domain – at least marvellous – which he hastens to unravel.' Sadly, after his surrealist period in the late 1930s, he created increasingly abstract work that lost the dreamlike intensity of his earlier paintings.

He was born near Vienna in 1905. His father Gustav was an inventor and merchant and his mother was a German actress. Gustav had been

enormously successful, having invented the commercial version of the vacuum flask, which he called the Thermos. Born Jewish, he had converted to Christianity in 1900, becoming a Protestant and changing his name from Pollak to Paalen. He lived in a castle that he had bought and rebuilt, and enjoyed a high society lifestyle. He also acquired an impressive collection of old masters that included Goya, Titian and Cranach. Young Wolfgang was fortunate in having a father who, because of his own great interest in works of art, encouraged him in his early ambition to become a painter. During World War I he had been educated at home by a private tutor but, when the war ended, the family decided to move to Italy and in 1919 acquired a palatial villa near Rome. It was there, in 1920, that Wolfgang started taking painting lessons from visiting artists and also became an expert on Greek and Roman archaeology.

During the 1920s Wolfgang continued his studies in the fine arts, moving from city to city – Berlin in 1922, Paris in 1924, Munich in 1926, Provence in 1927 and Paris again in 1928. When he was in Berlin in 1922 he met the influential art critic, Julius Meier-Graefe, a friend of his father's, and had a brief affair with his wife Helene. In 1929 he made a disastrous visit home, clashing with his father, who hated the kind of modern art that his son was now producing. Up to this point his father had backed him financially with considerable generosity, but now he told the young artist that if he continued with his appalling modernist work he would cut off all support. Wolfgang refused to alter the course he had taken and was promptly disinherited.

Fortunately for him, in the same year he met Eva Sultzer, the heiress to a vast Swiss industrial fortune and she took over as his sponsor. He now settled in Paris and became deeply enmeshed in the avant-garde scene there. When he was working at printmaking in the famous Atelier 17 studio of Stanley Hayter, he met Roland Penrose and Max Ernst and started to move closer to surrealism. He also met the American Peggy Guggenheim, who would later give him solo exhibitions, first at her London Gallery and then at her New York Gallery.

It was at this point that the Paalen family fortunes began to run into difficulties. One of Wolfgang's brothers had a homosexual affair and then killed himself in a mental hospital. Another brother shot himself in the head – an act witnessed by Wolfgang – and died soon afterwards, also in a mental hospital. His parents separated and his mother suffered from bipolar

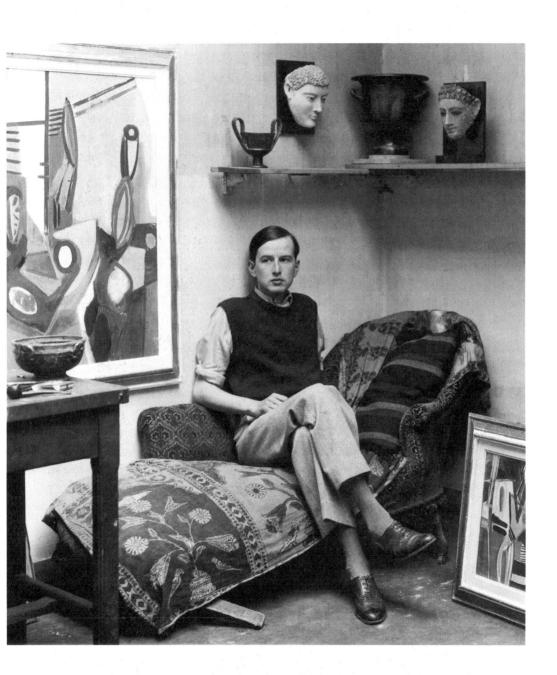

Wolfgang Paalen in Studio Daguerre, Paris, 1933. Photographer unknown.

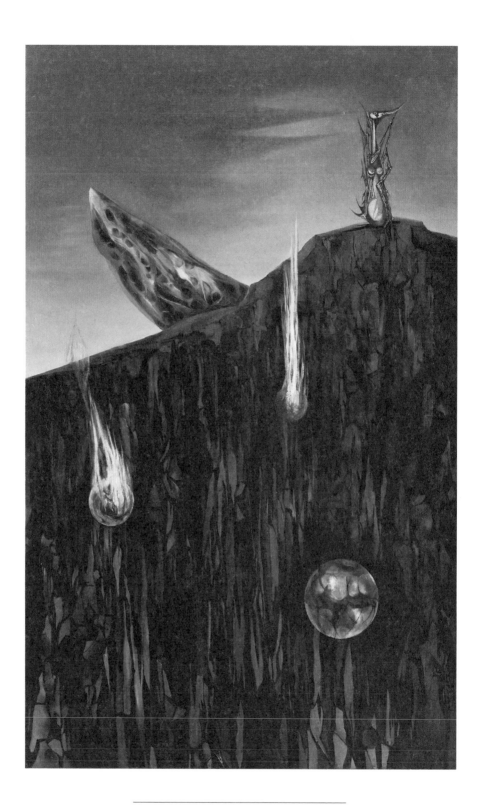

Wolfgang Paalen, *Pays Interdit*, 1936–37.

disorder. To complete the catalogue of disasters, his father lost his fortune. After Wolfgang's pampered, idyllic childhood, these events must have come as a major shock and he was clearly ripe for the surrealist rebellion. The other surrealists had been rebelling against the general rottenness of society. For Paalen, however, it was more personal.

1933 was an important year for him because it was then that he paid a visit to the prehistoric caves at Altamira in northern Spain. The extraordinary cave paintings that he saw there had a powerful impact on him and started him off on what has been called his 'Cycladic period' that ran from 1933 until 1936. In 1934 he married the poet and artist Alice Rahon, who was also a hat designer with her own boutique in Paris. It was then that he started exhibiting with the surrealists, both in London and New York, and began his 'Totemic Period' that would only be terminated by the outbreak of war in 1939.

In 1937 Paalen invented a technique known as *fumage*, in which he held a lighted candle underneath a canvas and allowed it to leave a trail of smoke-patches. These patches would then be embellished with paint to create semi-automatic, totemic figures. Breton praised fumage, calling it 'an enrichment of the methodological treasury of surrealism'. Amusingly, much later, in the 1940s, when Matta was describing fumage to a group of young American artists in New York, one of them, Jackson Pollock, said in a bored voice, 'I can do that without smoke'.

During just three years – 1937, 1938 and 1939 – Paalen created his masterpieces and made his reputation as a major surrealist artist. It was such a short slice out of his life, and yet it was more important than all the rest put together. It was at this point that he started to develop certain affectations, calling himself Count Wolfgang von Paalen and concealing his true family origins. When appearing at the favourite street cafés of the surrealists, he liked to cloak himself in mystery. His English friend, the artist Gordon Onslow-Ford (1912–2003) said of him, 'He ... was always in the thick of conversation, but he appeared to me, in spite of his vitality, to be ethereal as if part of him were winging about elsewhere.'

Then, in May 1939, ahead of all the other surrealists, Paalen decided to leave Europe and he and his wife Alice moved to Mexico, at the invitation of Frida Kahlo (1907–1954). Kahlo had been in Paris early in 1939, had met Paalen and had become friendly with Alice. With war clouds gathering, the

Paalens did not delay in accepting the invitation, arriving in Mexico City in September, after a stop-over in New York to see the World's Fair and a visit to study the totemic art of the Northwest Coast. Paalen's sponsor, Eva Sultzer, went with them. They were greeted at the Mexico City airport by Frida Kahlo and Diego Rivera (1886–1957), and Paalen began what would prove to be a lifelong exile from his European roots.

Part of the appeal of Mexico, in addition to providing an escape from the Nazi menace in Europe, was its wonderful pre-Columbian art. Paalen began to make a collection of ancient figures and studied them in great detail. Sadly, his friendship with Frida and Diego did not last and he broke off relations with them after about seven months. As the war in Europe dragged on, his hopes of a swift return soon vanished and he settled into life in the New World, painting, organizing exhibitions and publishing a journal called *DYN*. The abstract paintings that he created during this period and exhibited in New York would act as an important stimulus to the young American artists who were seeking a way out of surrealist imagery into something with greater visual freedom – the artists who would soon become known as the initiators of a major new art movement, abstract expressionism. A friend of Jackson Pollock's even went so far as to say, 'It was Wolfgang Paalen who started it all'.

When the war in Europe ended, Paalen became a Mexican citizen. About the same time, his marriage to Alice began to disintegrate and in 1947 they were finally divorced. At this point he left Mexico for a spell in California, living in the Bay Area of San Francisco. While there, he met an artist and fashion designer from Venezuela, called Luchita Hurtado. They were married briefly but she divorced him in 1950, describing him as 'the most intriguing spirit possible, but the most impossible man to live with'. A contributing factor, no doubt, were his increasingly frequent periods of depression.

His reaction to the breakdown of his marriage was to return to Paris to reconnect with André Breton and the surrealists, who were trying to re-form themselves as a viable group after the war. After a few years in his old haunts in Europe, Paalen left again for Mexico, having found that the mood in Paris had changed too much to appeal to him. He would now remain in Mexico for the rest of his short life – from 1954 to his death in 1959.

In 1957 he married for a third time, to Diego Rivera's sister-in-law, Isabel Marin, but their marriage would be short-lived because, in 1959, on a hill south of Mexico City, Wolfgang dramatically ended his life. In his isolation

in Mexico his status as an artist had been fading rapidly, overshadowed by the rise of the abstract expressionists clustered in New York. Unable any longer to earn a living from his paintings, and no longer supported financially by his lifelong patron Eva Sultzer, it has been claimed that he turned to criminal activities, becoming a major smuggler of pre-Columbian antiquities. Immensely valuable objects were secretly flown out of Mexico in a light aircraft and into Texas, where they ended up in an art gallery in Dallas. From there, they were sold on to major American collectors such as Nelson Rockefeller. Rumours about Paalen's role in this illegal trade were swirling around and, if they were true, he must have felt that the world was closing in on him. On top of that, he had recently suffered a heart attack and had allegedly taken to excessive alcohol and drug use. Also, like his mother, he suffered from a bipolar personality. His manic-depressive swings had been getting worse, with deep feelings of depression gaining the upper hand. During the night of 24 September he left his hotel carrying a gun and climbed the nearby hill, heading for a favourite spot where he had often gone to contemplate his problems and to meditate. On reaching it, he put the gun to his head and shot himself dead. He had told nobody where he was going, with the result that his body was not found until the wild pigs had made a meal of him.

It was a tragic end to a life that had brought him great praise, not least from André Breton, who wrote of his work:

> In my opinion, among all contemporary artists Wolfgang Paalen is the one who has incarnated most vigorously this way of seeing – of seeing around oneself and within oneself – and who alone has accepted the grave and far-reaching responsibility of translating this vision, even at a personal cost, very often, of great anguish … I believe that no more serious or more continuous effort has ever been made to apprehend the texture of the universe and make it perceptible to us.

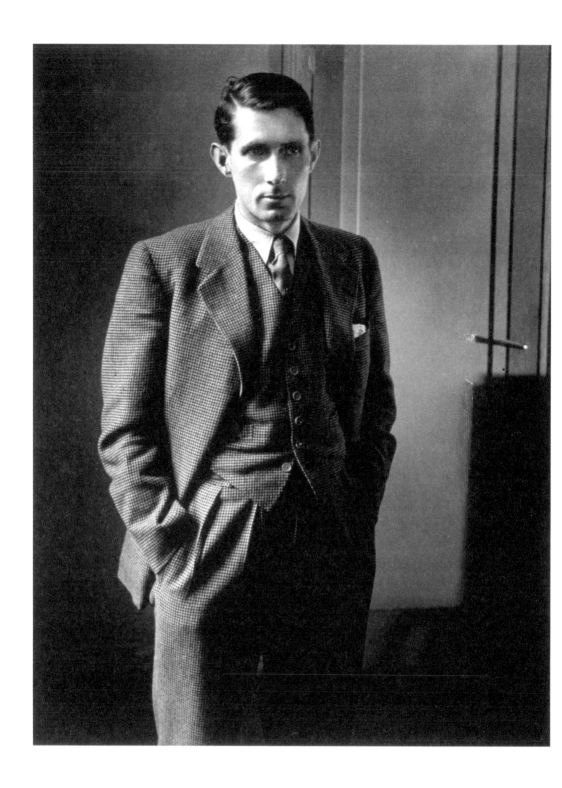

Roland Penrose, 1935. Photo by Rogi André (Rozsa Klein).

ROLAND PENROSE

ENGLISH • Joined surrealist group in Paris in 1928 and the British group in 1936

BORN: 14 October 1900 in St Johns Wood, London, as Roland Algernon Penrose

PARENTS: Strict Quakers; father an Irish portrait painter; mother the daughter
of Baron Peckover, a wealthy banker

LIVED: London 1900; Oxhey Grange, Watford 1908; Italy 1918 with Red Cross;
Cambridge 1919; Paris 1922; London 1936 and East Sussex 1949

PARTNERS: Married VALENTINE BOUÉ 1925–34 (divorced 1939)

• PEGGY GUGGENHEIM, briefly in the 1930s • Married LEE MILLER 1947–77
(when she died); one child • DIANE DERIAZ 1979–84; and many lovers

DIED: 23 April 1984 at Farley Farm, Chiddingly, East Sussex

THE TRAGEDY OF ROLAND PENROSE is that he was a good artist who produced some major surrealist works, but whose paintings were overshadowed by his other high-profile activities. This came about because he happened to be an extremely good organizer, highly motivated and very rich. He bankrolled the surrealist movement to such a degree that it is probably true to say that it would have floundered without him. The humiliating image of the poverty-stricken leader of the surrealists, André Breton, travelling to London, cap in hand, to beg for funds from Roland sums up the importance of this polite, generous, quietly spoken, civilized Englishman.

Penrose was born when Queen Victoria was still on the throne. His mother, who had inherited a fortune from her banking ancestors, married an Irish artist. Roland and his brothers grew up in a strict Quaker household on a large estate. It was this that gave him his good manners and his kindness. It also fuelled his rebellious spirit. It was all too rigidly puritanical, too suffocatingly pious for a small boy with a lively imagination. There were daily morning prayers, evening prayers, bible-readings and prayer-meetings. Roland survived by day-dreaming and enjoying wild, private fantasies.

During World War I Roland lost faith in religion; his parents' repeated prayers for peace fell on deaf ears and the senseless slaughter continued.

Towards the end of the war, he was serving with the Red Cross in the field and saw thousands of starving peasants and roads strewn with rotting corpses. It was a shocking experience for a teenager who had enjoyed such a sheltered upbringing, and left a deep mark on him. Although he knew nothing of it, it was the same shock and disgust that, elsewhere, would lead to the Dadaist outbursts and ultimately the surrealist movement.

Studying him as a child, one would have predicted a future career as a banker or an architect, but somewhere inside the young Roland the need for rebellion was growing stronger. Socially, the first signs of it appeared when he was an undergraduate at Cambridge. There he met a handsome young actor called George Rylands and began an illegal homosexual affair with him. Today it would pass almost unnoticed, but in those days it was risky and could have seen him sent down or even sent to jail. Curiously, an interest in his own sex never resurfaced and for the rest of his life he was a devoted heterosexual. In fact, he became what today would be called a sex addict, and was heard to describe his sharp need for endless sexual expression as a curse that dogged him.

After gaining a First in architecture at Cambridge, Roland upset his father by insisting on moving to Paris to study modern art. Despite his father's dismay, he gave Roland a generous annual allowance and in no time at all the young graduate was enjoying the dubious pleasures of a Parisian brothel, where he was relieved to find that his Cambridge dalliance had not damaged his ability to enjoy the opposite sex. Before long he had met and fallen in love with a wild surrealist poet called Valentine Boué. Their love affair was complicated by the fact that she was anatomically unable to engage in ordinary, penetrative sex. Overcoming this major disadvantage, their passion for one another led to bizarre alternative ways of making love and Roland described one instance where he tied her naked to a pine tree in a forest. They were soon married and started to move into the close circle of the surrealists that gathered around Breton. Max Ernst was their initial contact and he was so kind to Roland, generously showing him complicated techniques with painted surfaces, that Roland was prompted to perform his first act as a surrealist benefactor. Ernst and his wife were so poor that they could not afford to take a holiday, so Roland arranged one for them in Provence at his expense. Later, he repeatedly bought Max's paintings to prevent him from starving. Knowing this must have hurt Max's pride, because

he was overheard saying to Paul Eluard that Roland was a poor artist but that 'it is good to have rich friends'.

In the late 1920s Roland became a full member of the surrealist group in Paris, accepted by Breton and the others. He had found the social niche he needed to finally throw off the shackles of his strict Quaker childhood. In 1930, after receiving his family inheritance, he bought a château in Gascony and lived there with Valentine. They visited India but the relationship was beginning to falter. She was becoming so difficult and demanding that Roland had had enough. He became ill and retired to England to recuperate, but she followed him and begged him to try again with their relationship. He refused, but in his usual kindly way would look after her from a distance for many years.

Recovering from an ulcer, probably brought on by his interminable wranglings with Valentine, he enjoyed a short affair with a married woman in London and then returned to his beloved Paris. There he met a young English surrealist poet called David Gascoyne, who persuaded him that Britain needed its own surrealist identity. Roland warmed to the idea and set up house in Hampstead early in 1936. There he held surrealist meetings and set about organizing a major exhibition to introduce the movement to the British public. This involved roping in all the British surrealists and combining their paintings and sculptures with major works from Paris. The problem he faced was that the official British surrealists were rather a small group, and Roland and Herbert Read had to tour around artists' studios to see who else could, at a stretch, be classified as a surrealist and included in the show. This annoyed some of the purists who felt that, to be involved, one had to be a fully committed member of the surrealist group. In order to put on an impressive show, with strong British representation, Roland and Read ignored these complaints and, in the process, revealed for the first time that there were several categories of surrealist.

Roland's great International Surrealist Exhibition in London in 1936 was a huge success, with over 1,000 visitors every day, and established the movement firmly in the British art world and in the minds of the British public. This heightened awareness did not, however, mean that the surrealists were now widely accepted as serious artists. On the contrary, the majority of people viewed them as a ridiculous lunatic fringe. As far as the surrealists themselves were concerned, this violently negative reaction was appealing

– so much better than simply being ignored. For Roland, with his suffocatingly pious upbringing, this new notoriety was an exhilarating release. His formal relationship with Valentine, however, was nearing its end. In 1939 they were divorced on the grounds of non-consummation and Roland took himself off to Paris where he attended a fancy dress party with Max Ernst. There he encountered Lee Miller, a blonde, blue-eyed American model and photographer who had been the lover of the American surrealist who called himself Man Ray. The couple had split up in 1932, leaving Man Ray feeling suicidal. She then married a rich Egyptian and departed to Cairo, where she enjoyed the high life but missed the Parisian surrealist scene. Still married to the Egyptian, she was now paying a visit to Paris and was soon in bed with Roland. For both of them it was more than a casual affair. Instead it was the start of a forty-year relationship during which time they were always faithful to one another. Their definition of faithfulness was not, however, the usual one. It meant that they were both free to have as many affairs as they liked, but never secretly and always with the knowledge that their love would outlast all their dalliances – which it did. At the end of the 1930s there were surrealist house parties and social gatherings at which partner-swapping was commonplace. Roland and Lee attended these and took part in the fun and games with great abandon, but their deep love for one another never faltered.

In 1939, just before war broke out, Lee finally left her Egyptian husband and headed for England and Roland. They lived together in Hampstead and Roland proudly showed her his recent acquisition – the London Gallery, centre of surrealist activity in England, managed for him by the Belgian surrealist Edouard Mesens. Roland and Lee were happier together at last as a real couple, but the idyll was short-lived. In a matter of months the war began and before long London was being blitzed by German bombers. Roland became an air raid warden and Lee started her career as a war photographer. The London Gallery was closed and its stock of paintings was stashed away in Pimlico. Tragically, a German bomb hit the building and all 83 paintings went up in flames, including 19 by Magritte, 31 by Ernst, 6 by Delvaux, and others by Braque, de Chirico, Giacometti and Man Ray. Most of these belonged to Roland and were not covered by insurance.

Roland moved into camouflage research and wrote a manual on the subject, explaining how animals concealed themselves and how humans could

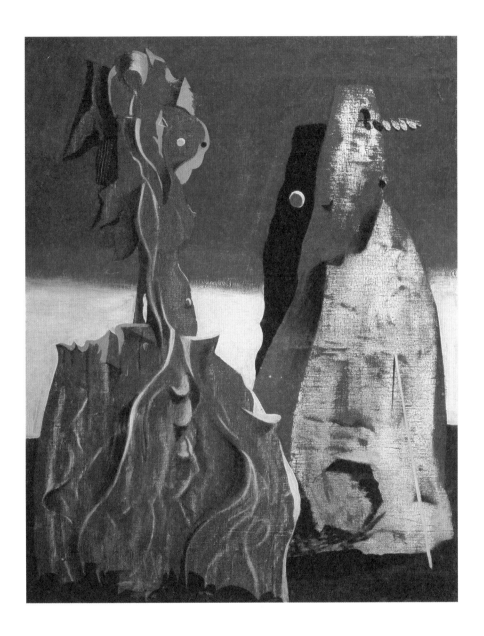

Roland Penrose, *Conversation Between Rock and Flower*, 1928.

learn from their camouflage devices. While he was away undertaking his war work, Lee had an affair with an American photojournalist. This was done with Roland's blessing, and at one point the three of them lived together in Hampstead. As the war was coming to its end, Lee was sent off to the continent in her new role as a war photographer and, during the months ahead, was to capture some of her most important and unforgettable images, including the devastating scenes she encountered at the newly liberated concentration camps. Lee's status as an important visual recorder of the aftermath of World War II made Roland's camouflage work seem rather tame by comparison and this caused a flare-up between them, with Lee departing angrily for more work on the continent. Roland took solace with a young woman who moved into the Hampstead house, but still pined for his beloved Lee. She ignored his pleading messages but eventually they met up in Paris, Lee half-dead from her labours and ready to be carried off to Hampstead, where Roland's new girlfriend quietly and amicably moved out.

Roland now busied himself with re-opening the London Gallery with Mesens, while Lee recovered from her nightmare experiences. Roland was also involved in complicated discussions about opening a Museum of Modern Art in London, to rival the one in New York. One of the people causing trouble with the planning of this project was Roland's great rival, Austin Cooper, who hated the Tate Gallery and wanted to create a centre to challenge its monopoly in London. I once asked Roland why he hated Cooper so much, as they both loved the work of Picasso and had built two very similar collections of modern art. I expected him to say something about being too similar not to be rivals, but instead he launched into a savage attack on Cooper – the only time I ever heard him express acute anger. Cooper, he hissed, was a monster who enjoyed torturing young German prisoners in his role as an official interrogator, and he went on to describe him as the most despicable man he had ever met. Roland's son, Tony, says of Cooper that he was 'the only real enemy Roland ever had and, with an enemy like Cooper, he needed no other'.

Cooper was soon to disappear from the planning meetings – meetings that would eventually lead to the foundation of Roland's new baby, the Institute of Contemporary Arts in London. While this was going on, at home, a surprise was in store for him. Lee had had so many abortions over the years that she had been told she would never be able to have a child. But,

against the odds, she became pregnant at the start of 1947 and gave birth to their son in September of that year. Two years later Lee, Roland and their infant moved out of London to Farley Farm near Chiddingly in Sussex. This would remain their home for the rest of their lives, visited by the good and the great, including both Pablo Picasso and Joan Miró.

In 1950 Roland shut down the London Gallery, which had been losing money at an alarming rate, and poured all his energies into running the ICA. This new institute became the focus of anything novel and outrageous in the world of the fine arts and is still flourishing to this day. Roland himself continued to paint in his studio at Farley Farm and, in London, kept busy organizing massive retrospectives of his close friends Picasso and Miró. His Picasso retrospective at the Tate Gallery was the most successful exhibition ever staged in Britain, attracting over 500,000 visitors. In recognition of this work, Roland was offered a knighthood in 1966 and, to howls of protest from other surrealists, he accepted it, saying of his critics, 'They can call me a Sir-realist'. Over the years he had poured so much of his money into surrealist coffers, repeatedly helping to keep the movement afloat, that even though he had knelt before royalty he could hardly be expelled from a movement that owed him so much.

During the Farley Farm period, Lee said that giving birth had ruined her interest in sex and she encouraged Roland to have affairs. One of these got out of hand when he fell in love with a charismatic trapeze artist called Diane Deriaz. Roland reached the stage where he wanted to marry Diane and live in Paris, while Lee would take her son to America and live with him there. Diane refused, but the tensions were acute and Lee left for a long stay in New York. When she returned, Roland and she once again found their love for one another resurfacing, and the family stayed together at the farm.

In the early 1960s Roland and Lee visited Peggy Guggenheim's art collection in Venice and a curious incident occurred. Peggy had been unkind to Roland in her memoirs saying that he was a bad painter and that, when, in the past, he had made love to her, he had tied her up with ivory bracelets. He asked her to remove the comment about him being a bad painter from any subsequent editions, which she agreed to do, and also to change her statement about the ivory bracelets, saying that he had only used ordinary police handcuffs to restrain her. Curiously, this she refused to do and insisted on retaining her reference to the ivory bracelets. Roland's addiction

to bondage sex seems to have developed at an early stage in his life, caused by the anatomical impossibility of having straightforward sex with his first wife, Valentine. As an erotic ritual it helped to provide an alternative outlet. However, instead of abandoning it when he left Valentine, it appears to have become almost a necessity. Dorothy Moreland, the director of Roland's ICA, once said to me that 'Roland can't do it without handcuffs'. Peggy Guggenheim's memoir confirms this, saying, 'It was extremely uncomfortable to spend the night this way [shackled to a bedpost] but if you spent it with Penrose it was the only way'. Roland's son Antony mentions a pair of solid gold handcuffs made by Cartier that were a gift to Lee, and records that 'she wore both the handcuffs on the same wrist as a chic bracelet by day, always ready to gratify Roland's desire by snapping one on the other wrist'.

Personally, I found him defensive on the subject of sexual rituals. On one occasion when we were walking near the ICA in London, talking about a recent scandal involving a famous pop star who had been raided by the police, he suddenly stopped and said sharply, 'What people do in the privacy of their home is entirely up to them'. His anger at the police intervention in what had been a private ritual suggested that he was becoming slightly concerned about details of his own private life being made public. He had just been awarded a Knighthood and was in a state of conflict between a lifetime of rebellion against the establishment and his recent acceptance by it. It was as though, late in life, the ghosts of his correct upbringing were beginning to haunt him and interfere with his highly developed surrealist convictions.

In 1976 Roland's two closest friends, Max Ernst and Man Ray, both died and in 1977 it was Lee's turn. Roland was inconsolable. Bizarrely, his first wife Valentine had been living at Farley Farm for years and then she too died the following year. Roland was stripped of those he loved. Even his latest girlfriend, a young Israeli called Danniella, had departed. Lonely, he again begged Diane Deriaz to marry him, but again she refused. She did, however, take him out of himself by accompanying him on long holidays to exotic locations, such as Malindi off the African coast and the Seychelles in the Indian Ocean. A few months after returning from the Seychelles he died at Farley Farm in 1984, saying 'I want to go'.

PABLO PICASSO

SPANISH · Associated with the surrealists between 1924 and 1934,
accepting their creative freedom but rejecting their restrictive dogma

BORN: 25 October 1881 in Malaga, as Pablo Diego José Francisco de Paula Juan
Nepomuceno María de los Remedios Cipriano de la Santísima Trinidad Ruiz y Picasso

PARENTS: Father an art professor; mother a minor aristocrat

LIVED: Malaga 1881; A Coruna 1891; Barcelona 1895; Madrid 1897; Barcelona 1898;
Paris 1900; Madrid 1901; Paris 1901; Barcelona 1903; Paris 1904; Avignon 1914;
Paris 1914; South of France 1946

PARTNERS: ROSITA DEL ORO, a circus performer, 1896–99 · ODETTE LENOIR, an
artist's model, 1900 · GERMAINE PICHOT, an artist's model, 1901 · FERNANDE OLIVIER,
an artist's model, 1904–12 · MADELEINE, an artist's model, 1904 (had an abortion)
· EVA GOUEL (Marcelle Humbert) 1912–15 (died) · GABY LESPINASSE, a nightclub singer,
1915–16 · HELENE D'OTTINGEN, a Baroness, 1916 · ELVIRE PALLADINI (You-You), a fashion
model, 1916 · EMILENNE PAQUERETTE, a fashion model, 1916 · IRENE LAGUT, 1916–17 ·
Married OLGA KHOKHLOVA, a ballerina, 1918–35 (died 1955); one child · MARIE-THÉRÈSE
WALTER, teenager, 1927–36 (hanged herself in 1977); one child · DORA MAAR, an artist,
1936–44 · NUSCH ELUARD, a circus performer, 1936 · FRANÇOISE GILOT, an art student, 1943–
53; two children · GENEVIÈVE LAPORTE, a journalist, 1951–53 · Married JACQUELINE ROQUE,
a pottery salesgirl, 1961–73 (shot herself in 1986)

DIED: 8 April 1973 in Mougins, France during a dinner party

PICASSO'S NAME MAY SEEM OUT OF PLACE in a book about the surrealists, but he was involved with surrealism from the very outset, even before André Breton presented his first manifesto in 1924. It was Picasso who had designed the curtain, sets and costumes of the ballet *Parade* in 1917 and had worked with Jean Cocteau on the storyline, and it was in the programme notes for this ballet that the term *surrealisme* was coined. It could be argued therefore that, historically, he was the very first of the surrealists. Guillaume Apollinaire, who was the first to use the term in print, said that he had done so as a way of describing Picasso's art. He envisioned it as a method of transforming the

way in which we look at life. Picasso himself said, 'I think the source of all painting lies in a subjectively organized vision'. And he added later: 'I value a more profound resemblance, realer than real, attaining the surreal. That's how I viewed surrealism.'

From this it is clear that Picasso's early vision of surrealism was broader than the one defined by Breton in 1924. For Picasso, to be sur-real, you had to focus on the essence of something – its subjective, emotional significance – rather than its superficial appearance. The realism of copying nature was to be replaced by the sur-realism of interpreting it. He quoted the Chinese saying, 'I don't imitate nature, I operate like it'. It was Breton's role to borrow this broad concept and narrow it down to something more specific. He and his circle undertook the task of encasing surrealism in a set of rigid rules and regulations that defined it more precisely. It was no longer simply an art term; it was now a movement, a way of life.

Picasso, of course, was not going to take kindly to being handed a set of rules. He was an alpha male and saw himself, with some justification, as being above such matters. What he appreciated, he said, when faced with Breton's rule book was 'surrealist freedom stripped of its dogma'. He had started it and he was going to go on doing it his way. He did not need a bunch of zealous theorists telling him what he could and could not do. He did, however, make statements about his method of working that placed him remarkably close to Breton's 'psychic automatism'. For example, he said that 'an artwork is the product of calculation, but calculation often unknown to the artist himself ... a calculation that predates intelligence.' So there was little difference between Picasso and Breton with regards to the nature of the creative process. Where they differed was in the general conduct of the artist in society. Picasso saw the artist as an individualist, free from any interference. Breton saw the artist as a member of a collective, a strictly run club organized and dominated, of course, by himself.

Picasso was not the only one who was unhappy with Breton's handling of surrealism. Four days before Breton's manifesto appeared, a rival one was published by a group who wanted to retain Apollinaire's broader version of surrealism and who aggressively opposed all 'counterfeit surrealism invented by a few ex-dadas in order to shock the middle classes'. This was fighting talk, but they were up against a formidable opponent in André Breton and it was he, ultimately, who won the day.

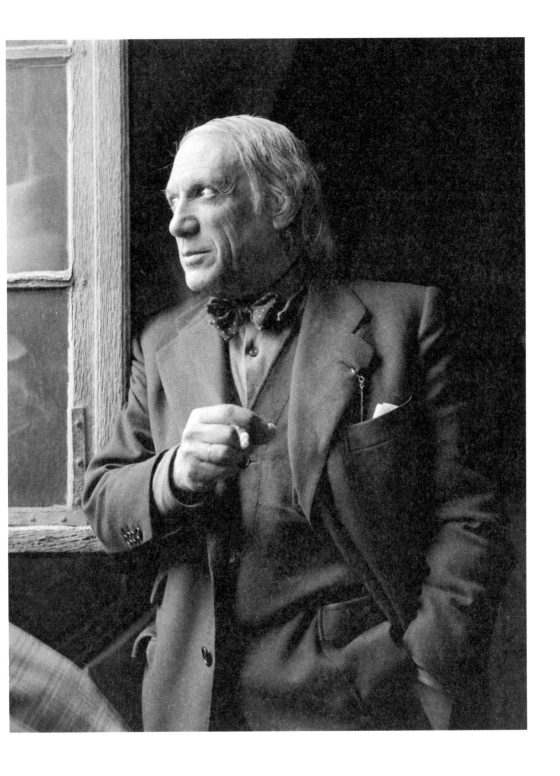

Pablo Picasso in his studio, May 1944. Photo by Herbert List.

For Breton, who had enormous respect for Picasso, the relation of the great Spanish artist to his group posed something of a problem and he did his best to encourage Picasso to join the fold. The result was an uneasy alliance that, in the years following Breton's manifesto of 1924, saw Picasso's work approaching more closely the narrow definition of surrealism, but without any personal involvement in the meetings and discussions of Breton's official group. Some of Breton's written comments about the importance of Picasso were almost grovelling in their praise: 'From his open-air laboratory divinely unusual beings will continue to fly into the gathering night', and 'surrealism if it wants to assign itself a line of moral conduct, need merely follow where Picasso has gone before and will go again', and 'we loudly claim him to be one of us'.

For his part, Picasso was prepared to participate in surrealist exhibitions – he had eleven pieces in the big 1936 International Surrealist Exhibition in London, for example – but always kept his distance and his independence. He loved the idea of unconscious surrealist creativity, but disliked the way in which Breton and his friends were directing the movement. One aspect that annoyed Picasso was that Breton had given surrealism a strong literary flavour. He complained, 'They've completely forgotten the main thing – painting – in favour of lousy poetry ... They didn't understand what I meant by "surrealism" when I coined the term, which Apollinaire then used in print: something more real than reality.' It is amusing that, with Apollinaire dead and unable to fight his corner, Picasso was now, with this statement made in 1933, taking full credit for the invention of the term 'surrealism' and was taking it back to its pre-Breton form. It is little wonder that the relationship between Picasso and Breton was often an uneasy one.

The friendly, if rather distant, alliance between Breton and Picasso lasted until the end of World War II, when it finally collapsed due to political differences. Breton, freshly returned from his wartime exile in New York, met Picasso by accident on the street and refused to shake his hand. That was in 1946 and they never saw one another again. Picasso had some final words to say on their past relationship, commenting, 'If surrealism hadn't been used to designate another movement, I think it would describe my painting.' Picasso clearly saw himself as THE surrealist and felt that Breton had hijacked and distorted his original concept. At the same time, he was grateful for the genuine admiration and support that Breton had given

him in the early days. They may have drifted apart eventually, but they had always shared important beliefs concerning the need to revolutionize the arts. The question remains – how did Picasso become such a revolutionary figure when he had begun as a highly traditional artist?

Picasso was born in Malaga in the south of Spain in 1881. His birth was as dramatic as his art would later be. The newborn appeared to be lifeless and the midwife who had delivered him decided that he was stillborn. The tiny, inert body was placed on a table and left there while she attended to the mother. The baby's uncle, out of curiosity, went to take a look at the little body, lying so still on the table. He happened to be smoking a cigar and, on a whim, puffed a cloud of cigar smoke into the baby's face. To his astonishment, the tiny infant started coughing and spluttering and suddenly came to life, kicking and yelling, miraculously saved from asphyxia. They say that smoking can damage your health, but for Picasso it meant life itself.

As a boy he benefited from the fact that his father was a professor of art and started teaching him how to paint when he was only seven years old. From the very beginning, Picasso was passionate about painting and by the time he was thirteen, his father said that the boy had already surpassed him in technique. By fifteen, he was painting like an old master. Later in life, he was to make a joke about his precocious skills when he said, 'It took me four years to paint like Raphael, but a lifetime to paint like a child'.

At the turn of the century, Picasso moved to Paris where he was so poor that he had to burn his paintings in the stove to keep warm in winter. His art now started to go through a number of distinct phases. First came his blue period (1901–04); followed by his rose period (1904–06); his African period (1907–09); his analytical cubist period (1909–12); his synthetic cubist period (1912–17); his surrealist period (1917–35); and finally his mature period that lasted for the rest of his life.

He was one of the most prolific artists of all time, sometimes producing as many as fourteen oils in a single day, working in a frenzy of activity. Most people, he said, kept a diary using words, but for him his diary was his art. Whatever preoccupied him during the day would end up on his canvases – his meals, his pets, his music, his friends, and above all, his lovers. He was obsessed with painting the human female in all her many moods – reflective, sad, weeping, lustful. It could be said, with only a slight exaggeration, that, throughout his long life, Picasso's twin addictions were his paintings and his

lovers. Sex was very important to him and his virility in the bedroom was echoed by the vigour of his brush when he stood in front of his easel. His biographer John Richardson referred to his paintbrush as his surrogate penis.

He lost his virginity early. The family had moved to Barcelona when he was thirteen and the following year, at the tender age of fourteen, he was already frequenting the notorious red-light district of the city and enjoying the services of the prostitutes in the brothels there. When he was fifteen he acquired his first lover, a flamboyant circus performer called Rosita del Oro. She was successful enough to have her own poster, advertising her equestrian act at the Tivoli Circus, and showing her as an impressive, buxom figure wearing a cloak, ostrich feathers, white tights and fancy boots. It is hard to understand how a fifteen-year-old boy could have attracted such a glamorous girlfriend and suggests that Picasso's personality was already having a remarkable impact on members of the opposite sex. Rosita also had quite a lasting impact on him, because seventy-two years later he was still painting pictures of her performing on her circus horse.

When Picasso arrived in Paris in 1900, aged nineteen, he explored the French brothels for a while until he and his flatmates – two other Spanish artists – acquired a trio of good-time girls to share their beds in their one large room. Picasso's bedmate was called Odette Lenoir. All was going well until one of his two friends fell in love with his own bedmate, an artist's model called Germaine Pichot. It did not work out well and the distraught man ended up trying to shoot Germaine in a crowded restaurant. When he mistakenly thought he had killed her, he turned the gun on himself and shot himself in the head, dying later that night. Not long after, Picasso had a brief affair with Germaine. It was at about this time that he contracted a venereal disease, a condition that brought on his blue period. The doctor who cured him was paid with one of his blue period paintings. In retrospect, this was possibly the highest fee ever paid for a medical treatment.

Back in circulation again, Picasso fell for an artist's model whose husband had gone mad and been incarcerated. He started an intense affair with her that would last from 1904 to 1912. Her name was Fernande Olivier and her arrival in his life triggered his rose period. He had his own studio now and she lived there with him. He was not faithful to her, however, finding the brothels and nightclubs of Paris irresistible. He made one model, Madeleine, pregnant and persuaded her to have an abortion. He dropped another one

because she was having an affair with another Spanish artist at the same time. Angry, he paid a visit to Holland to sample the Dutch prostitutes, reporting that they were so big that 'once you got inside them you could never find your way out'. Throughout all this, Fernande kept house for him and put up with his infidelities.

Knowledge of Picasso's amorous activities is of more than passing interest because they provide the explanation for the subject matter of many of his works of art. It was at about this time that he painted his controversial masterpiece *Les Demoiselles d'Avignon* ('The Young Ladies of Avignon', 1907). The large canvas shows five prostitutes parading for their clients. Four are standing and one is seated with her legs spread wide apart. Picasso's own title for the painting was *The Brothel of Avignon* and he hated the sanitized version that was used later. One particular aspect of this painting has special significance. Three of the figures are shown with normal heads, but two of them have been given hideous mask-like heads of extreme ugliness, no doubt Picasso's way of taking revenge on the girls who gave him VD. In making these unnatural modifications, Picasso was on the threshold of a new way of painting. In the years that followed this would go further and further, as he chopped up natural shapes into smaller details and, in the process, initiated the cubist movement. Once again, his sex life and his creativity were interlinked.

In 1912, Picasso and Fernande split up and she ran away with a futurist. Analytical cubism came to an end at about this time and, when Picasso moved on to a new partner, Eva Gouel, synthetic cubism began. Eva was the mistress of a sculptor and Picasso adored her. He was devastated when, three years later, she fell ill and died. However, even before she had breathed her last he had started up a new affair with a ravishingly beautiful nightclub singer called Gaby Lespinasse. Picasso was now thirty-four and wanted to settle down. He asked Gaby to marry him but she refused. His response to this was to start an affair with the Russian Baroness Helene d'Ottingen, followed by one with the model Elvire Palladini, known as You-You, and another with the fashion model Emilienne Paquerette. Next came a more serious relationship with Irene Lagut, someone else's mistress that Picasso stole. He asked her to marry him, but again he was refused. He locked her in his apartment, but she managed to escape. Even a blackmail attempt by Picasso failed to get her back.

The next time he fell in love he was luckier. It was 1917 and he was in Rome working on the sets for the ballet *Parade*, when he met a young Russian ballet dancer called Olga Khokhlova. This time his proposal of marriage was accepted and they were wed in 1918. This was also the start of his surrealist period of painting. In 1921 Olga gave Picasso his first child, a son called Paulo. As the years passed, however, the marriage did not go well and Olga was always flying into jealous rages. Picasso's response was to start a secret affair, this time with a teenager called Marie-Thérèse Walter. She was thirty years his junior, and Picasso enjoyed a passionate, erotic relationship with her that spawned a highly creative period of painting. In 1935 she gave him

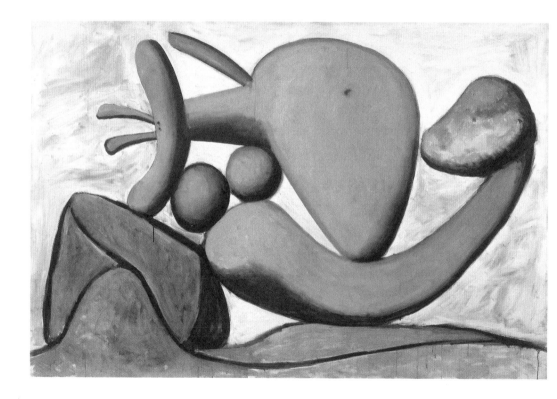

Pablo Picasso, *Femme Lançant une Pierre* (Woman Throwing a Stone), 1931.

his second child, a girl called Maya. This was too much for Olga and she and Picasso would soon separate. They never divorced and remained married until her death in 1955.

Maya's birth caused a hiatus in Picasso's sex life and he filled the gap by seducing a Yugoslavian artist called Dora Maar. They were introduced by the surrealist poet Paul Eluard and Picasso repaid this kindness by going to bed with Eluard's wife Nusch. Nusch was an ex-circus performer that Eluard had found as a starving street-waif and had taken in after he had lost his first wife Gala to Salvador Dalí. Far from being angry with Picasso, Eluard was honoured that the great artist had favoured his young wife in this way. None of this damaged Picasso's relationship with Dora Maar, an affair that would continue for nine years. Dora's problem would be with his earlier bond with Marie-Thérèse, who turned up at Picasso's studio when he was painting his masterpiece *Guernica* in 1937. Seeing Dora there taking photographs, Marie-Thérèse told her to get out. Dora refused and Picasso, still busily painting away on his vast composition, suggested that they fight it out, which they did.

The irony of his mistresses physically attacking one another as he continued to work on his anti-violence painting amused Picasso, and he later told a friend that it was 'one of my choicest memories'. It also gave him the subject matter for one of his greatest smaller paintings – *Weeping Woman* (1937), a portrait of Dora Maar in extremis. 'Dora, for me, was always a weeping woman,' he said. 'And it's important, because women are suffering machines.' He added, 'For years I've painted her in tortured forms, not through sadism, and not with pleasure, either; just obeying a vision that forced itself on me.'

During World War II Picasso installed Marie-Thérèse and Maya in one apartment and Dora in another. Like a sultan doing the rounds, he would visit Marie-Thérèse on Thursdays and Sundays. He also had a third lover, a married woman called Ines, installed nearby. All went well most of the time, but when Dora and Marie-Thérèse met, they fought again, much to Picasso's delight. After such incidents he would tell each of them privately that they were the one he really loved and, in his way, kept his harem happy. His painting thrived on this situation and the work he did during the dark days of the war was immensely powerful.

In 1943 a new phase would begin for the now sixty-two-year-old Picasso. He met and fell in love with a twenty-one-year-old French virgin called

Françoise Gilot. She was an artist and in awe of the great Picasso. He was uncharacteristically restrained and gentle in his seduction and they did not become lovers until the following year. Despite this new love in his life, he found time to deflower a young journalist who came to interview him after the war had ended. Her name was Geneviève Laporte and she had come to write an article for her school magazine. Dora Maar finally snapped. She told Picasso that he was morally worthless and tried to force him to get on his knees and beg for forgiveness. She was taken to a clinic where she was given shock treatment. Later, Picasso bought her a large house to keep the peace. His life with his new love, Françoise, was chaotic. Old loves kept appearing on the scene and Françoise threatened to leave him. Nevertheless, she stayed and they had two children, Claude and Paloma, before she eventually left him and married a handsome young artist, much to Picasso's annoyance.

Now in his seventies, but still sexually insatiable, Picasso began one last major relationship in 1953. He had been making ceramics at a local pottery and the attractive sales-girl there, Jacqueline Roque, caught his eye. She became the last great love of his life, moving in and taking over the household. When Picasso's first wife, Olga, finally died in 1955, he was at last free to marry again and Jacqueline became his second wife in 1961. He became obsessed with her, painting her portrait over four hundred times, and as many as seventy times in a single year. They had no children, but she stayed with him for the rest of his life, becoming an increasingly important figure as he reached old age, protecting him and caring for him until he died in 1973 at the age of ninety. She shot herself dead in 1986.

Few artists can have had a sex life as active and richly varied as Picasso. He was never satisfied, always exploring, throwing himself into adventure after adventure with a primitive vigour, and this same vigour was applied to his art. For many men, this demanding sex life would have been draining, but for him it seemed to be just the opposite. It was almost as though his sexual dramas fired his artistic dramas and one gets the feeling that, had he lived a quiet domestic life, his art would have suffered for it.

When I was working with Roland Penrose at the ICA in London in the 1960s, he would say, 'I am just popping over to see Don Pablo for the weekend', and he would then reappear on Monday with a new Picasso oil, barely dry, and say 'Look what Don Pablo gave me!' He adored Picasso and would not have a word said against him. When I happened to mention that the popular

image of the great artist was that of a rather cavalier womanizer, he flew to Picasso's defence, insisting:

> People don't understand him. What he wanted was to be married and have a family and get on with his painting, with which he was going to change the way that people saw the world. He married Olga, but their marriage was a disaster and he had to seek love elsewhere, often with unsuitable women. You may have noticed that later in his life, when Olga eventually died, he did marry again, straight away, and it has been a great success. You should see how happy he is now, with Jacqueline.

There is an element of truth in this, but it was a wildly flattering comment. Its importance lies in the way in which it shows how Picasso's charismatic personality could create fierce loyalties in those who knew him. And if his treatment of women sometimes makes him look like a monster, he was also capable of great tenderness and kindness. It was this mixture that helped make his paintings so great.

His kindness is illustrated by an anecdote that Roland told me. Late in life, when Picasso was very famous, he had gone back to look at the studio he used to have when he was a struggling young artist in Paris. Outside the studio, he saw an old tramp sleeping on a bench. He recognized the man as someone he had known back in those early days. The man explained that he had fallen on hard times. Picasso went over to a rubbish bin, found a crumpled piece of paper, smoothed it out and did a beautiful sketch on it. Signing it, he handed it to the tramp and said, 'Here, buy yourself a house'.

MAN RAY

AMERICAN • Closely associated with Paris surrealist group but not formally a member

BORN: 27 August 1890 in Philadelphia, Pennsylvania, as Emmanuel Radnitzky

PARENTS: Russian Jewish immigrants; father a tailor

LIVED: Philadelphia 1890; New York 1912; Paris 1921; Los Angeles 1940; Paris 1951

PARTNERS: Married ADON LACROIX (Donna Lecoeur), Belgian poet, 1914–19 (divorced in 1937) • KIKI DE MONTPARNASSE (Alice Prin), artists' model, 1921–29 • LEE MILLER, photographer 1929–32 • Ady (Adrienne) Fidelin, a Filipino dancer, 1936–40 • Married JULIET BROWNER, Romanian-Jewish American, dancer and artists' model 1946–76

DIED: 18 November 1976 in Paris, of a lung infection

ONE OF MAN RAY'S BIOGRAPHERS described him as 'a mystery ... a painter, a maker of objects, photographer, film-maker ... dazzling in the multiplicity of his talents ... he was dedicated to the creative idea rather than any particular style or medium.' He was active throughout the whole period of Dada and surrealism, and beyond, but was hard to pin down because he kept exploring new challenges without any regard to consistency. Perhaps this is why some art critics dislike him – they find it hard to pigeonhole him.

Man Ray was born Emmanuel Radnitzky in Philadelphia in 1890, the eldest son of Russian Jewish immigrants. His father was a tailor and his mother a seamstress. When he was seven the family moved to Brooklyn, New York, where at school he specialized in architecture, engineering and lettering. However, when he was eighteen he turned down an architectural scholarship in favour of becoming an artist. In 1911 his family officially shortened their name from Radnitsky to Ray. The following year Man Ray started studying at the Modern School in New York. In 1913 he visited the famous Armory Show, where he saw the work of Francis Picabia and Marcel Duchamp. He was so overwhelmed by what he saw that he reported, 'I did nothing for six months. It took that time to digest what I had seen.' He left his parents' home and joined an artists' colony in New Jersey for the next two years. Also

Man Ray, Paris, 1931. Photo by Lee Miller.

in 1913 he met the Belgian poet Adon Lacroix, fell in love and married her the following year. They would stay together for the next four years, but in 1919 he was so preoccupied with his work that she became bored and had an affair, after which she and Man Ray separated.

In 1915 he met Marcel Duchamp for the first time and in 1920, when they were co-operating on a motorized artwork called *Rotary Glass Plates*, there was a near disaster. When the machine was activated for a trial run, it flew apart and a large glass blade nearly decapitated Man Ray. Their next experiment was less dangerous, at least for Man Ray. It consisted of the making of a film by Duchamp of Man Ray carefully shaving off the pubic hair of the eccentric dadaist, the Baroness Elsa von Freytag-Loringhoven.

In the summer of 1921, Man Ray went to Paris, where some of his Dadaist photographs were on exhibition. There, he met André Breton, Paul Eluard and other members of the Paris Dada group. He reported being bewildered by their 'playfulness and the abandon of all dignity'. He also met an artists' model and nightclub singer who called herself Kiki de Montparnasse. He was sitting at a table in a Paris café with a friend when there was a loud disturbance. He saw that the management were trying to throw out a girl that they claimed was a prostitute – because she was not wearing a hat. She was objecting noisily, so Ray's companion intervened and offered her a seat at their table. Kiki's vivacity immediately appealed to Ray, as did her anecdote about the painter Maurice Utrillo (1883–1955). Apparently, she had been posing naked for Utrillo for three days and he would not let her see the painting until it was finished. When she finally caught a glimpse of it she discovered that it was a landscape. Later that night, Ray took her to a cinema. Before long he had begun a wild affair with her that would last for six years, during which time she posed for some of his most iconic surrealist photographs.

His first exhibition in Paris was a Dadaist affair, with all his pictures obscured by balloons. On a signal, these were all burst with lighted cigarettes to reveal his work. Later that year he invented a new photographic technique, working directly with photographic paper without the use of a camera. Objects were placed on the undeveloped paper and then a light was turned on to create images on the surface of the paper. He called these prints 'Rayographs' and they were soon being reproduced in mainstream magazines like *Vanity Fair*. Through these contacts he decided to earn some

money as a commercial photographer and began taking portraits of famous figures such as Pablo Picasso, James Joyce and Jean Cocteau. Over the next few years, Man Ray's photographic work and his paintings became better known and his work appeared in several surrealist publications, although he never went so far as to join the official surrealist group.

In 1929 Man Ray was enjoying a drink in his favourite Paris bar, when a beautiful young American fashion model came up to him and announced that she was going to be his photographic student. He refused, saying he did not take on students, but she managed to convince him to let her become his darkroom assistant. Her name was Lee Miller and she and Man Ray would soon become lovers. Together, thanks to a mouse, they invented another unusual photographic technique that they called 'Solarization'. When a mouse brushed against her foot in the darkroom, Miller flicked on the light. Ray flicked it off again and later they found that this brief over-exposure had created an attractive halo outline around the forms on their prints. This became a second 'signature style' for Man Ray.

Three years later, in 1932, Lee Miller returned to New York, where she would open her own photographic studio. Man Ray was distraught at losing her and photographed himself in suicidal poses. He rapidly recovered, however, and was soon having an affair with the Swiss surrealist Meret Oppenheim. His photographs of her naked, her white skin smeared with black printing ink, standing next to the heavy machinery of a huge printing press, would become some of his most famous images.

By 1936 Man Ray realized that, without meaning to do so, he was becoming a full-time commercial photographer. His more serious artwork was being pushed into the corners of his life by his success in the popular field of magazine illustration. He wrote to his sister saying, 'I hate photography and want to do only what is necessary to keep going'. He wanted to get back to his painting, but was finding it hard to do so. Cheering him up, no doubt, was a lively new arrival in his life, an exotic dancer from Guadaloupe called Ady Fidelin. She worked as a model for him and they were soon involved in an affair that would last for four years. During this period he devoted more of his time to painting, with photography now taking a minor role.

This phase was brought to a sudden halt by the Nazi invasion of France in 1940. He and Ady fled south like many others, but they were too slow and were stopped and returned to Paris. As an American, he was then given

Man Ray, *Fair Weather (Le Beau Temps)*, 1939.

permission to leave but, at the last minute, Ady decided that she would have to stay in Paris with her family and Man Ray must sadly depart without her. He took his precious cameras with him, but on the way to New York they were stolen. Back in his home country for the first time in many years, he hid himself away with his sister's family and refused to make any contact with his old friends or galleries. The loss not only of Ady, but also of his Paris studio, his network of friends in France and his cameras, seemed to turn him briefly into a wounded recluse, unable to kick-start his old New York lifestyle. Within a few weeks he had fled the city and travelled to the west coast. There he met Juliet Browner, a Romanian-Jewish American who was a dancer and artists' model, and they soon became a couple, living together in a Hollywood hotel.

As Man Ray's relationship with Juliet grew stronger, they moved into a Los Angeles apartment that had a large studio and he began painting again in earnest. He resisted going back into commercial photography and was able to survive on the savings that he had built up during his years as a photographer in Paris. Towards the end of the war, his spirits had been fully revived and he was able to enjoy a retrospective exhibition of his work in Pasadena. In 1945, when Germany surrendered, he was briefly back in New York for a solo exhibition of his work and was able to celebrate the end of the war with a night out in the company of Marcel Duchamp and André Breton. The following year he and Juliet married in Beverly Hills at a double ceremony with his old friend Max Ernst and Ernst's new love, Dorothea Tanning. Bearing in mind the active love-life of both men in the past, one could be forgiven for imagining that these Hollywood-style nuptials would not lead to lasting relationships. Nothing could be further from the truth. Both marriages lasted for thirty years, from 1946 until the deaths of both Ernst and Ray, a few months apart in 1976.

For Man Ray, Los Angeles eventually became boring and he wrote to his sister in 1948 saying, 'California is a beautiful prison; I like living here, but I cannot forget my previous life, and long for the day when I can return to New York and eventually to Paris.' Before this could happen he was sent a questionnaire by Duchamp in which he was asked for his 'personal creed'. He replied that he tried to paint as much unlike other artists as possible and added, significantly, 'above all, to paint unlike myself'. His aim was to make each series of his paintings as different as possible from the preceding series.

This was a laudable pursuit of innovation, but it also worked against him because the result was that he did not develop any one recognizable style.

In the spring of 1951 Man Ray finally achieved his dream of returning to Paris. He and Juliet were seen off at the docks in New York by Marcel Duchamp, who gave them a farewell present of a plaster cast of female genitals. In Paris they found a studio, where they would live for the rest of Man Ray's life. They enjoyed friendly meetings with Ray's old loves, Kiki de Montparnasse and Lee Miller. In the years that followed, Man Ray saw his work – his paintings, his surrealist objects and his photographs – exhibited repeatedly in retrospective shows and other major exhibitions. In 1968 he was saddened by the death of his lifelong friend Marcel Duchamp. He and Juliet had just had dinner with Duchamp and his wife when he dropped dead from a stroke. Man Ray said that he died 'with a little smile on his lips. His heart had obeyed him and had stopped beating. As formerly his work stopped.' Eight years later Ray himself died and his widow had the rather strange epigraph 'Unconcerned but not indifferent' – apparently a favourite saying of his – inscribed on his tombstone.

YVES TANGUY

FRENCH/AMERICAN • (from 1948)

Member of the surrealist group in Paris from 1925

BORN: 5 January 1900 in Paris as Raymond Georges Yves Tanguy

PARENTS: both of Breton origin; father a navy captain

LIVED: Paris 1900; Merchant Navy 1918; Army 1920; Paris 1922;
New York 1939; Woodbury, Connecticut 1941–55

PARTNERS: Married JEANETTE DUCROCQ 1927, in Paris (divorced 1940)
• PEGGY GUGGENHEIM 1938 (brief affair) • Married KAY SAGE 1940,
in Reno, Nevada (until his death)

DIED: 15 January 1955 in Woodbury, Connecticut, of a stroke after a fall

TANGUY WAS ONE OF THE CENTRAL figures of the surrealist group in Paris, celebrated by André Breton and faithful to the ideals of the movement until his early death at the age of fifty-five. In a strange way, he was the opposite of that other central figure, Joan Miró. Miró was wildly abandoned in front of his easel, but calmly controlled in his private life. Tanguy was calmly controlled in front of his easel, but wildly abandoned in his private life. Tanguy's dream-world landscapes were meticulously disciplined and painted with the careful precision of an old master, proliferating with tiny details, with a serious and often sombre air. When he put down his brushes, however, he became an eccentric, childlike extrovert, often causing havoc at social gatherings and existing as a living embodiment of surrealist rebellion.

Part of Tanguy's problem was his taste for, and susceptibility to, alcohol. When he played chess, it was not chess as we know it. Each piece on the board was a miniature bottle of spirits and when you took a piece, you drank it. His friend Alexander Calder called him 'Three-stage Tanguy'. There was the serious Tanguy when he was stone-cold sober. Then there was the charming Tanguy when he was slightly drunk. And finally, there was the violent Tanguy when he was completely drunk. This third stage could be rather alarming

because, if someone annoyed him, Tanguy would start looking for his knife – a knife that fortunately he never carried. As a substitute he would sometimes grab hold of a table knife and menace a guest with it, until someone like Calder was brave enough to take it away from him. When he was in this advanced condition, he would also become spectacularly abusive towards his long-suffering wife, Kay Sage, who always bravely ignored his insults. Surprisingly, despite the fact that he repeatedly caused social embarrassments, neither his wife, nor his close friends the Calders, seemed too upset by his antics. In his autobiography, Calder summed up his feelings by saying, 'We loved him dearly, three-stage Tanguy!'

Tanguy was born in Paris on the fifth day of the twentieth century, the son of a sea captain. His childhood vacations were taken with his family on the Brittany coast, where he reacted strongly to the dramatic rock formations and pebble-strewn beaches. Nearby was the greatest concentration of prehistoric megaliths in the world – over 3,000 of them at Carnac. These huge standing stones left their mark on the imagination of Tanguy as a small boy. Later, in his mature paintings, his bleak landscapes would be strewn with smooth, rocklike shapes that captured the strangeness of these megaliths.

At school in Paris, one of his classmates was Henri Matisse's son Pierre, and through him the young Tanguy got to know his father's paintings – his first introduction to modern art. Many years later, after Tanguy's death, it was Pierre Matisse who would publish the artist's catalogue raisonné in 1961. When he was fourteen Tanguy was expelled from school for possessing ether. He showed little interest in school lessons and amused himself by inhaling ether and consuming large quantities of alcohol.

At the end of World War I, Tanguy went to sea. Following in the seafaring tradition of his family that stretched back to his great-grandfather, he joined the Merchant Marine and over a period of two years would travel to both Africa and South America in cargo vessels. At the end of this period, when he was faced with being recruited into the French Navy, he simulated having an epileptic fit and feigned madness. As a result he was declared unfit for military service. Then, in 1920, his deception was ignored and he was called up for two years of military duty in the French army. Again, he attempted to avoid service, this time by swallowing spiders and eating his socks, but his efforts were in vain. The one compensation

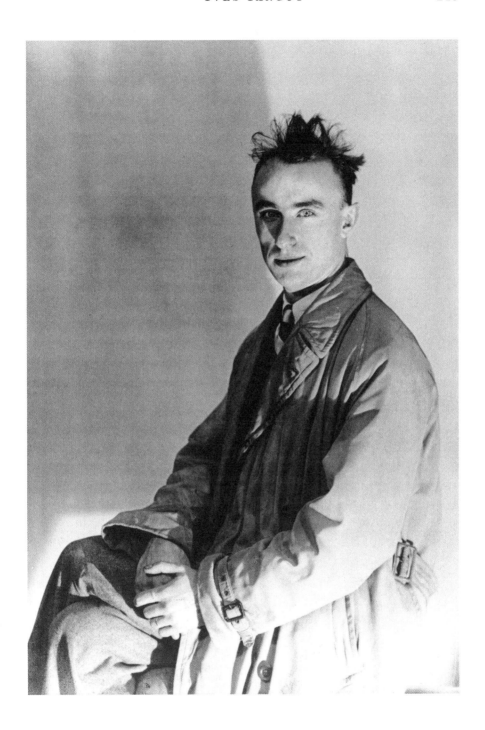

Yves Tanguy, 1936. Photo by Man Ray.

was that, during his time in the army, he was fortunate enough to meet the poet Jacques Prevert, who would later become an important member of the surrealist circle.

After his military service, Tanguy took a number of jobs in Paris to earn a living. At one point he was working as the driver of a streetcar, when he ran into a hay wagon. His reaction was to get down from his cab and walk off. An actor friend of his gave him some paints and canvases and, without any training, he started making amateurish pictures. Then, one day, through the window of a bus, he saw a painting by Giorgio de Chirico on display in a gallery window and its impact was so great that he leapt off the moving bus in order to take a closer look at it. Feeling inspired, he destroyed most of the work he had done so far and started painting with renewed vigour. The results were predictably bad, but he kept going and, in 1925, came into contact with the surrealists, who were in the process of becoming an organized group under the leadership of André Breton.

Breton recognized the potential in the wild young man and took him under his wing. Within a few years, Tanguy had waved goodbye to his indifferent early work and had started to invent a private dreamworld of his own. The first examples, from 1927, depict what appears to be an underwater world of strange marine shapes. These paintings were sufficiently successful to bring him his first solo exhibition. In the same year he married for the first time, to Jeanette Ducrocq, a young woman described as plump and jolly, who loved a drink and a laugh. During the next ten years he worked hard to develop his private world of biomorphs and geomorphs and exhibited with the surrealists in Paris, Brussels, London and New York. Sadly, however, he sold little and was desperately poor.

In 1937 he struck lucky when he was introduced to the rich American collector and art gallery owner, Peggy Guggenheim. She liked his work and offered him a solo exhibition at her gallery in London. Picking up Tanguy and his wife in Paris, she drove them to the Channel ferry and then took them on to London. The show was a success and paintings were sold. Tanguy had some money for the first time and his childlike reaction was to spend it or give it away. His caring side was shown by the fact that each week he was in England, he sent a small sum of money to Victor Brauner in Paris, ostensibly to feed the Manx cat that was a pet of the Tanguys, but in reality to prevent Brauner from starving.

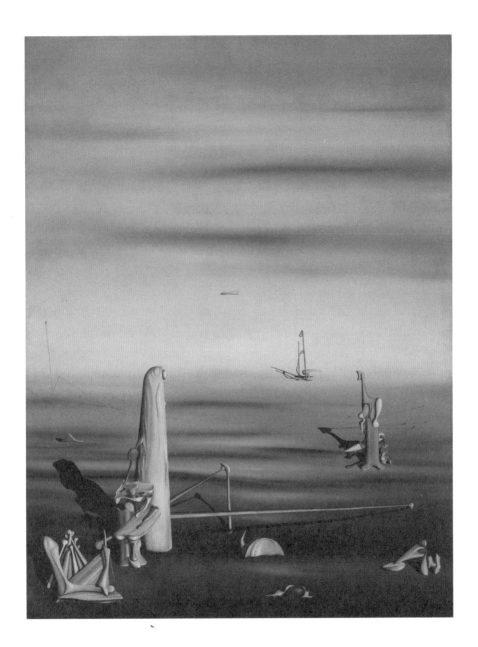

Yves Tanguy, *The Sun in Its Jewel Case*, 1937.

Peggy, who had a bet on with her sister Hazel to see who would be the first to bed a thousand men, decided to add Tanguy to her tally. During the run of his exhibition at her gallery there were many parties, and one evening at Roland Penrose's house in Hampstead she and Tanguy slipped away unnoticed and went to her flat, where she managed to seduce him, despite the fact that he had left his wife behind at the party wondering what had happened to him. Fortunately, Jeanette was too drunk to pursue the matter. She did, however, become suspicious when, some days later, the couple were guests at Peggy's country cottage. There it became all too obvious what was going on, but Jeanette felt she could not complain because they were so much in Peggy's debt. Her solution was to disappear to the local pub and get helplessly drunk.

It should all have ended there, no more than a brief foreign interlude, but Peggy had grown too fond of Tanguy. She described him as being 'as adorable as a child' with a lovely personality and 'beautiful little feet of which he was very proud'. So, after he and Jeanette had returned to Paris, she made plans to go there herself. She arranged a secret meeting with him and whisked him away for another romantic episode, taking him all the way back to her cottage in England. After a few days, Tanguy started to worry about what his wife must be thinking about his sudden, unexplained disappearance and Peggy, with great reluctance, had to drive him back to the ferry to France. Deciding that she could not give him up, she lent her London flat to the playwright Samuel Beckett in exchange for his flat in Paris, knowing that there she could arrange to meet with Tanguy in secret. Tanguy spent the night there with her, but trouble was on the horizon. Peggy was eating in a Paris restaurant when she noticed the Tanguys were also dining there. She went over to their table to say hello, but this was too much for Jeanette, who threw the fish she was eating in Peggy's face. She had put up with the affair in England because of Peggy's sponsorship of her husband's work, but now the woman had followed him to Paris, and that was one step too far. After this, the affair between Tanguy and Guggenheim petered out, although they always remained good friends.

Throughout the 1930s Tanguy had remained the favoured disciple of André Breton, but a new arrival in Paris from Italy in 1939, in the form of a rebellious princess, was about to disturb this relationship. The princess in question was, in fact, a talented American artist by the name of Kay Sage

(1898–1963), who had moved to Rome where she had married a handsome young Italian prince. She had become the Principessa di San Faustino and lived in a palace, but eventually became bored with aristocratic customs and abandoned him to set herself up in a studio in Paris. Once there, she met the surrealists and soon fell in love with the beguilingly childlike Tanguy. Ignoring the feelings of their respective spouses, they began an affair. In 1939, with war clouds gathering, they escaped from Paris to spend an idyllic summer in a rented château with the Bretons and other surrealists. This was a difficult time for Breton. He had a great fondness for Tanguy, who had always looked up to him and had been one of his most faithful followers, staying with him through all the heated disputes and divisions of the surrealist group. Breton had confirmed the strength of his friendship for Tanguy in writing, calling him 'my adorable friend ... the painter of a terrible grace, in the air, below the ground and on the sea', but now, here he was, under the thumb of a rich American. How dare this interloper drive a wedge between him and his faithful friend? He developed an intense hatred towards Kay Sage, but could not express it for fear of offending Tanguy.

For his part, Tanguy was once again basking in the financial glow of a seriously rich American partner. Guggenheim had shown him the rewards of such a relationship and this time, with his marriage to Jeanette already in tatters, he felt much less inhibited. When war finally broke out later that year, he did not hesitate to decamp to the United States and a new, financially safe life with Kay Sage. When he made this decision, he wound up his marriage to Jeanette and left her in his Paris studio. She remained there during the Nazi occupation of the city and began an affair with a young carpenter, who happened to be a great admirer of Tanguy's work. He moved into the studio and, with her guidance, began making fake Tanguy paintings that she could sell.

In 1940, now safely in America, Tanguy and Sage set off on a jaunt to the Wild West, where Tanguy was overwhelmed by the wonderful rock formations that reminded him so much of some of the details in his paintings. They headed for Reno in Nevada, where they both obtained their divorces and then married. Tanguy celebrated by having himself photographed dressed as a cowboy riding a bucking bronco. In 1941 Tanguy and his new wife rented a large house in Woodbury in Connecticut, but kept their apartment in New York, dividing their time between the two. It was a fruitful

period of work and a time for important exhibitions, but then there was an unexpected disruption. André Breton, who was surviving in poverty in New York and was obviously envious of Tanguy's financial good fortune as Kay Sage's husband, could not stand the situation any longer. When the Pierre Matisse Gallery in New York was putting on a show of new work by Tanguy in 1945, Breton confronted Matisse and demanded that he terminate his contract with Tanguy on the grounds that the artist had developed 'bourgeois sympathies'. Max Ernst witnessed this petty-minded assault on his friend and defended Tanguy vigorously.

This was a deliberate attempt on the part of Breton to wreck Tanguy's career. He must have known that Tanguy had been under contract to the Pierre Matisse Gallery since his arrival in New York, and that this was his fourth solo show there. The gallery, as well as his wife, had given him financial stability and Breton could not tolerate the fact that his protégé was now better off than he was. Had his mean-spirited attack worked, he would have destroyed a well-established outlet for Tanguy's work. Fortunately, his reasons were so trifling and the bond of attachment between the old school friends Matisse and Tanguy ran so deep, that he had no chance of succeeding, but Tanguy never forgave him for making the attempt and their twenty-year friendship was over. Kay Sage's reaction to the now tense situation in New York was to abandon the city and buy a large farmhouse in Woodbury. The couple moved there permanently in 1946 and converted two outbuildings into separate studios where both of them enjoyed a highly productive period of painting. Tanguy, free from financial worries, created some of his greatest works there.

This farmhouse would be their home for the rest of their lives and, in 1948, Tanguy put the seal on their way of life by becoming a naturalized American citizen. He and Sage would only return to Europe once, a visit they made in 1953 to see some of their old friends in Paris. While there, he conspicuously avoided meeting Breton, despite an attempt by Max Ernst to bring about a reconciliation. During their stay Tanguy made one last visit to his beloved Brittany, and walked again around his old holiday haunt of Locronan. It seems likely that, while in Brittany, he also strolled along the pebbly beaches that he knew from childhood. My reason for suggesting this is that, back in America the following year, he began work on a huge, climactic canvas that ended up in the Museum of Modern Art in New York.

Called *Multiplication of the Arcs* (1954), it represented, one critic said, 'the summary of the goals and preoccupations of a whole life'. For me, however, it was a magnificent failure. It looks, for all the world, like a vast, pebbly beach, as if his visit to his Brittany homeland had pulled him back into the real world from the brilliantly original and creative surreal world that he had explored so diligently for the past thirty years.

Within a few months of creating this painting, Tanguy fell from a ladder at his home, suffered a stroke and died. His widow Kay Sage, devoted to him to the very end, busied herself working on a catalogue raisonné of his paintings and, once it was completed, shot herself in the heart. Tanguy's ashes had been carefully preserved and they were now mixed with hers and taken by his old school friend, Pierre Matisse, to be buried on the beach in Brittany where he had walked as a child. With this act, Tanguy had completed his extraordinary circular journey.

Dorothea Tanning with *Self-Portrait (Maternity)*, Sedona, Arizona, 1946. Photo by Lee Miller.

DOROTHEA TANNING

AMERICAN · Joined the surrealists in the 1940s, but rejected the title
of surrealist in old age, saying it made her feel like a fossil
BORN: 25 August 1910 in Galesburg, Illinois
PARENTS: Father a Swedish immigrant; mother musical
LIVED: Galesburg 1910; Chicago 1930; New York 1935; Sedona, Arizona 1947;
Paris/Sedona 1949; France 1957; New York 1980
PARTNERS: Married HOMER SHANNON, a writer, 1941 (divorced 1942)
· Married MAX ERNST in Beverly Hills, 1946 (until his death in 1976)
DIED: 31 January 2012 in Manhattan, New York, aged 101

DOROTHEA TANNING BROKE TWO RECORDS. She lived longer than any of the
other surrealists and of all the many sexual partnerships enjoyed by Max
Ernst, hers was by far the longest. She lived for more than a century and was
married to the libidinous Ernst for the last thirty years of his life. In 2010,
celebrating her century and still mentally alert, she said, 'From the neck
up I'm young and strong, but the rest of me is a hundred'. When she finally
died in 2012, she had just published her second collection of poems, writing
having become increasingly important to her in her later life. She never had
children, preferring the company of Pekingese dogs.

Tanning's ancestors were Scandinavian, her devout Lutheran parents
moving from Sweden to the United States at the beginning of the twentieth
century. Dorothea was born in Illinois in 1910, and grew up in what she called
an atmosphere of eerie, bourgeois calm – an atmosphere that would later
come to haunt many of her paintings. By the age of seven she had already
decided that she wanted to be an artist and, strangely, she began making
surrealist images long before she had ever heard of the movement. At the age
of fifteen, for example, she painted a naked woman with leaves for her hair.
Her parents became alarmed by her increasingly rebellious moods but were
prepared to allow her to move to Chicago to attend art school there in 1930.
For some reason, this did not appeal to her and she dropped out of school

after only three weeks and earned a living as an artist's model, an illustra-
tor and a marionettist. As a child she had always lusted after the villains in
movies and while in 1930s Chicago she claimed that she dated a gangster.
This ended badly, however, because when they were drinking together at
a bar one day, he was called away and hauled off to be brutally murdered,
leaving her sitting at the bar wondering where he was.

After five years in Chicago, she left for New York. It was a visit to the
Museum of Modern Art in Manhattan in 1936 that changed her life as an
artist; for it was there that she saw the first major exhibition of surrealism
in America, the *Fantastic Art, Dada and Surrealism* show organized by Alfred
Barr. Displayed on the gallery walls were the kind of paintings she had been
doing for some time, now presented as a serious new art form. What she expe-
rienced at this exhibition gave legitimacy to what she had been wanting to do
since childhood, and provided her with the courage to take it more seriously.
She was so excited by what she had seen of the surrealists at that exhibition
that she decided she had to make their acquaintance. Unfortunately, when
she made enquiries, it turned out that they were all living and working far
away in Paris. She made up her mind that she would have to go there to seek
them out, but this took some time and it was 1939 before she could travel to
the French capital. This was bad timing, because when she finally got there
the war was about to break out and she discovered that they had all fled en
route to New York. Returning home, she was at last able to meet them at
first hand, on her doorstep. Marcel Duchamp became a close friend and,
in 1942, she met Max Ernst at a party. He was still involved in a marriage
of convenience with Peggy Guggenheim, but was attracted to the young
American artist and soon paid a visit to her studio. He was officially there
to study her paintings, but stayed on to play a game of chess with her and
that was the beginning of a love affair that would last until his death in 1976.

Tanning herself had been married briefly to the writer Homer Shannon,
but they were divorced in 1942. The marriage of Ernst and Guggenheim
lasted until 1946 and, as soon as it was over, he and Tanning became man
and wife at a ceremony in Beverly Hills. It was a double wedding, shared with
Man Ray and Juliet Browner. After their marriage, she and Ernst decided to
abandon New York and move into the wilds. They chose the Arizona desert
as their home and built a small, three-roomed house in a remote hamlet
called Sedona. They lived happily there for a decade. In 1957, angered by

Dorothea Tanning, *Birthday*, 1942.

the authorities' refusal to give Max Ernst American citizenship, they left the country for Paris. Again, they wanted to avoid city life and soon moved on to settle in a new home in Provence, remaining there until Ernst's death in 1976. Tanning stayed on in France for a few more years but eventually returned to New York, setting up a studio there in 1980, where she would remain for the rest of her long life.

A remarkable feature of her years with Max Ernst was that her painting style was never influenced by that of her charismatic husband. It could so easily have overwhelmed her, but it never did. From the start she had her own, haunted brand of oneiric surrealism. Painted with academic precision, she created a sinister world of bleak hotel rooms, corridors and landings where young girls interacted in odd ways with monsters, dogs or other strange beings. Hers was the surrealism of academically painted dream scenes, placing her in the same category as Paul Delvaux and René Magritte. Towards the end of her life, her compositions became more fragmented and less precise, eventually becoming almost abstract. In her old age, perhaps tiring of answering endless questions about her late husband, she declared that she did not like being called a surrealist because it made her feel as if the label had been tattooed on her arm 'like a concentration camp victim'. In 2002 she said, 'I guess I'll be called a surrealist forever … but please don't say I'm carrying the surrealist banner. The movement ended in the '50s and my own work had moved on so far by the '60s that being a called a surrealist today makes me feel like a fossil!' Despite this, it has to be said that it is her early surrealist works that are most highly valued today.

FURTHER RESOURCES

KEY EVENTS AND EXHIBITIONS (1925 to 1968)

1924 First Surrealist Manifesto

1925 First surrealist group exhibition at Pierre Loeb's Gallery Pierre, Paris

1929 Second Surrealist Manifesto

1935 Cubism-Surrealism International Exhibition, Den Frie, Copenhagen

1936 International Surrealist Exhibition, New Burlington Galleries, London

1936 Exposition surréaliste d'objects, Galerie Charles Ratton, Paris

1936–7 Fantastic Art, Dada, Surrealism, Museum of Modern Art, New York

1937 Exposition internationale du surréalisme, Nippon Salon, Ginza, Tokyo

1937 Surrealist Objects and Poems, London Gallery, London

1938 Exposition internationale du surréalisme, Galérie Beaux-Arts, Paris

1938 International Surrealist Exhibition, Galerie Robert, Amsterdam

1940 International Surrealist Exhibition, Galeriá de Arte Mexicano, Mexico City

1941 Breton and the surrealists transfer to New York

1942 International Surrealist Exhibition, Whitelaw Reid Mansion, New York & Philadelphia Museum of Art

1945 Surréalisme, Galerie des Editions la Boetie, Brussels

1946 Breton returns to Paris

1947 Exposition internationale du surréalisme, Galerie Maeght, Paris

1948 International Surrealist Exhibition, Topič Salon, Prague

1959 Exposition internationale du surréalisme, Galerie Daniel Cordier, Paris

1959 Mostra Internazionale del Surrealismo, Galleria Schwarz, Milan

1960 International Surrealist Exhibition, D'Arcy Galleries, New York

1964 Le Surréalisme: sources, histoire, affinités, Galerie Charpentier, Paris

1965 Exposition internationale du surréalisme, Galerie L'Oeil, Paris

1966 André Breton dies in Paris

1967	International Surrealist Exhibition, Fundação Armando Álvares Penteado, São Paulo
1967	International Surrealist Exhibition, The Enchanted Domain, Exeter City Gallery and Exe Gallery, Exeter
1968	International Surrealist Exhibition, Národní galerie v Praze, Prague
1969	Surrealist group in Paris is finally disbanded

FURTHER READING ON INDIVIDUAL ARTISTS

Countless books have been written about the work of the major surrealists. The volumes selected here, all of which are in my library, are those that focus more on their personal lives. All quotations in the text have been taken from these publications.

EILEEN AGAR

Agar, Eileen, *A Look at my Life*, Methuen, London, 1988

Byatt, A. S., *Eileen Agar 1899–1991: An Imaginative Playfulness*, exh. cat., Redfern Gallery, London, 2005

Lambirth, Andrew, *Eileen Agar: A Retrospective*, exh. cat., Birch & Conran, London, 1987

Simpson, Ann, *Eileen Agar 1899–1991*, exh. cat., National Galleries of Scotland, Edinburgh, 1999

Taylor, John Russell, 'Peek-aboo with a Woman of Infinite Variety', *The Times*, Arts Section, 15 December 2004, pp. 14–15

JEAN ARP

Jean, Marcel, *Jean Arp: Collected French Writings*, Calder & Boyars, London, 1974

Read, Herbert, *Arp*, Thames & Hudson, London, 1968.

Hancock, Jane et al., *Arp: 1886–1966*, Cambridge University Press, Cambridge, 1986

FRANCIS BACON

Farson, Daniel, *The Gilded Gutter Life of Francis Bacon*, Vintage, London, 1993

Peppiatt, Michael, *Francis Bacon: Anatomy of an Enigma*. Weidenfeld & Nicolson, London, 1996

Sinclair, Andrew, *Francis Bacon: His Life and Violent Times*, Crown, New York, 1993

Sylvester, David, *Looking Back at Francis Bacon*, Thames & Hudson, London, 2000

HANS BELLMER

Taylor, Sue, *Hans Bellmer, The Anatomy of Anxiety*, MIT Press, Cambridge, Massachusetts, 2000

Webb, Peter and Robert Short, *Hans Bellmer*, Quartet Books, London, 1985

VICTOR BRAUNER

Davidson, Susan et al., *Victor Brauner: Surrealist Hieroglyphs*, Menil, Houston, 2002

Semin, Didier, *Victor Brauner*, Filipacchi, Paris, 1990

ANDRÉ BRETON

Gracq, Julien et al., *André Breton*, Éditions du Centre Pompidou, Paris, 1991

Polizzotti, Mark, *Revolution of the Mind: The Life of André Breton*, Bloomsbury, London, 1995

ALEXANDER CALDER

Calder, Alexander, *Calder: An Autobiography with Pictures*, Allen Lane Press, London, 1967

Prather, Marla, *Alexander Calder: 1898–1976*, Yale University Press, New Haven, 1998

Sweeney, James Johnson, *Alexander Calder*, exh. cat., Museum of Modern Art, New York, 1943

Turner, Elizabeth Hutton and Oliver Wick, *Calder Miró*, exh. cat., Fondation Beyeler, Basel and Phillips Collection, Washington DC, 2004

LEONORA CARRINGTON

Aberth, Susan L., *Leonora Carrington: Surrealism, Alchemy and Art*, Lund Humphries, London, 2004

Chadwick, Whitney, *Leonora Carrington*, Ediciones Era, Mexico City, 1994

GIORGIO DE CHIRICO

De Chirico, Giorgio, *The Memoirs of Giorgio De Chirico*, Peter Owen, London, 1971

Faldi, Italo, *Il Primo De Chirico*, Alfieri, Milan, 1949

Far, Isabella, *De Chirico*, Abrams, New York, 1968

Joppolo, Giovanni et al., *De Chirico*, Mondadori, Milan, 1979

Schmied, Wieland, *Giorgio de Chirico: The Endless Journey*, Prestel, Munich, 2002

SALVADOR DALÍ

Cowles, Fleur, *The Case of Salvador Dalí*, Heinemann, London, 1959

Dalí, Salvador, *The Secret Life of Salvador Dalí*, Vision Press, London, 1948

Dalí, Salvador, *The Diary of a Genius*, with an introduction by J. G. Ballard, Creation Books, London, 1994

Etherington-Smith, Meredith, *Dalí: A Biography*, Sinclair-Stevenson, London, 1992

Gibson, Ian et al., *Salvador Dalí: The Early Years*, Thames & Hudson, London, 1994

Gibson, Ian, *The Shameful Life of Salvador Dalí*, Faber and Faber, London, 1997

Giménez-Frontin, J. L., *Teatre-Museu Dalí*, Electa, Madrid, 1995

Parinaud, André, *The Unspeakable Confessions of Salvador Dalí*, Quartet Books, London, 1977

Secrest, Meryle, *Salvador Dalí, The Surrealist Jester*, Weidenfeld & Nicolson, London, 1986

PAUL DELVAUX

Gaffé, René, *Paul Delvaux ou Les Rêves Éveillés*, La Boétie, Brussels, 1945

Langui, Émile, *Paul Delvaux*, Alfieri, Venice, 1949

Rombaut, Marc, *Paul Delvaux*, Ediciones Polígrafa, Barcelona, 1990

Sojcher, Jacques, *Paul Delvaux*, Ars Mundi, Paris, 1991

Spaak, Claude, *Paul Delvaux*, De Sikkel, Antwerp, 1954

MARCEL DUCHAMP

Alexandrian, Sarane, *Marcel Duchamp*, Bonfini Press, Switzerland, 1977

Anderson, Wayne, *Marcel Duchamp: The Failed Messiah*, Éditions Fabriart, Geneva, 2011

Marquis, Alice Goldfarb, *Marcel Duchamp: The Bachelor Stripped Bare*, MFA Publications, Boston, 2002

Mink, Janis, *Marcel Duchamp, 1887–1968: Art as Anti-Art*, Taschen, Cologne, 2006

Tomkins, Calvin, *The World of Marcel Duchamp, 1887–1968*, Time-Life Books, Amsterdam, 1985

MAX ERNST

Camfield, William A., *Max Ernst: Dada and the Dawn of Surrealism*, Prestel, Munich, 1993

Ernst, Max et al., *Max Ernst: Beyond Painting*, Schultz, New York, 1948

Ernst, Max, *Max Ernst*, exh. cat., Tate Gallery and Arts Council, London, 1961

McNab, Robert, *Ghost Ships: A Surrealist Love Triangle*, Yale University Press, New Haven, 2004

Spies, Werner, *Max Ernst: A Retrospective*, exh. cat., Metropolitan Museum of Art, New York and Prestel, Munich, 1991

Spies, Werner, *Max Ernst: Life and Work*, Thames & Hudson, London, 2006

LEONOR FINI

Brion, Marcel, *Leonor Fini et son oeuvre*, Jean-Jacques Pauvert, Paris, 1955

Fini, Leonor, *Leonor Fini: Peintures*, Editions Michele Trinckvel, Paris, 1994

Jelenski, Constantin, *Leonor Fini*, Editions Clairefontaine, Lausanne, 1968

Selsdon, Esther, *Leonor Fini*, Parkstone Press, New York, 1999

Villani, Tiziana, *Parcours dans l'oeuvre de Leonor Fini*, Editions Michele Trinckvel, Paris, 1989

Webb, Peter, *Sphinx: The Life and Art of Leonor Fini*, Vendome Press, New York, 2009

WILHELM FREDDIE

Skov, Birger Raben, *Wilhelm Freddie – A Brief Encounter with his Work*, Knudtzons Bogtrykkeri, Copenhagen, 1993

Thorsen, Jorgen, *Where Has Freddie Been? Freddie 1909–1972*, exh. cat., Acoris (The Surrealist Art Centre), London, 1972

Villasden, Villads et al., *Freddie*, exh. cat., Statens Museum fur Kunst, Copenhagen, 1989

ALBERTO GIACOMETTI

Bonnefoy, Yves, *Alberto Giacometti*, Assouline, New York, 2001

Lord, James, *Giacometti, A Biography*, Faber & Faber, London, 1986

Sylvester, David, *Alberto Giacometti: Sculpture, Paintings, Drawings 1913–65*, exh. cat., Tate Gallery and Arts Council, London, 1965

ARSHILE GORKY

Gale, Matthew, *Arschile Gorky, Enigma and Nostalgia*, exh. cat., Tate Modern, London, 2010

Lader, Melvin P., *Arschile Gorky*, Abbeville Press, New York, 1985

Rand, Harry, *Arschile Gorky: The Implications of Symbols*, Prior, London, 1980

WIFREDO LAM

Fouchet, Max-Pol, *Wifredo Lam*, Ediciones Polígrafa, Barcelona, 1976

Laurin-Lam, Lou, *Wifredo Lam: Catalogue Raisonné of the Painted Work, Vol. 1*, Acatos, Lausanne, 1996

Laurin-Lam, Lou and Eskil Lam, *Wifredo Lam: Catalogue Raisonné of the Painted Work, Vol. 2*, Acatos, Lausanne, 2002

Sims, Lowery Stokes, *Wifredo Lam and the International Avant-Garde*, University of Texas Press, Austin, 2002

CONROY MADDOX

Levy, Silvano (ed.), *Conroy Maddox: Surreal Enigmas*, Keele University Press, 1995

Levy, Silvano, *The Scandalous Eye: The Surrealism of Conroy Maddox*, Liverpool University Press, 2003

RENÉ MAGRITTE

Benesch, Evelyn et al., *René Magritte: The Key to Dreams*, exh. cat., Kunstforum, Vienna and Fondation Beyeler, Basel, 2005

Gablik, Suzi, *Magritte*, Thames & Hudson, London, 1970

Sylvester, David, *René Magritte: Catalogue Raisonné*, 5 volumes, Philip Wilson, London, 1992–97

ANDRÉ MASSON

Ades, Dawn, *André Masson*, exh. cat., Mayor Gallery, London, 1995

Ballard, Jean, *André Masson*, exh. cat., Musée Cantini, Marseilles, 1968

Lambert, Jean-Clarence, *André Masson*, Filipacchi, Paris, 1979

Leiris, M. and G. Limbour, *André Masson and his Universe*, Horizon, London, 1947

Masson, André, *Mythologies*, La Revue Fontaine, Paris, 1946

Poling, Clark V., *André Masson and the Surrealist Self*, Yale University Press, New Haven, 2008

Rubin, William and Carolyn Lanchner, *André Masson*, exh. cat., Museum of Modern Art, New York, 1976

Sylvester, David et al., *André Masson: Line Unleashed*, exh. cat., Hayward Gallery, London, 1987

ROBERTO MATTA

Bozo, Dominique et al., *Matta*, exh. cat., Centre Georges Pompidou, Paris, 1985

Overy, Paul et al., *Matta: The Logic of Hallucination*, exh. cat., Arts Council of Great Britain, London, 1984

Rubin, William, *Matta*, exh. cat., Museum of Modern Art, New York, 1957

E. L. T. MESENS

Melly, George, *Don't Tell Sybil*, Atlas Press, London, 2013

Van den Bossche et al., *E. L. T. Mesens: Dada and Surrealism in Brussels, Paris & London*, exh. cat., Mu.ZEE, Ostend, 2013

JOAN MIRÓ

Lanchner, Caroline, *Joan Miró*, Abrams, New York, 1993

Malet, Rosa Maria et al., *Joan Miró: 1893–1993*, Little, Brown, New York, 1993

Rowell, Margit, *Joan Miró: Selected Writings and Interviews*, Thames & Hudson, London, 1987

HENRY MOORE

Berthoud, Roger, *The Life of Henry Moore*, Giles de la Mare, London, 2003

Wilkinson, Alan, *Henry Moore: Writings and Conversations*, Lund Humphries, London, 2002

MERET OPPENHEIM

Hwelfenstein, Josef, *Meret Oppenheim und der Surrealismus*, Gerd Hatje, Stuttgart, 1993

Pagé, Suzanne et al., *Meret Oppenheim*, exh. cat., Musée d'Art Moderne, Paris, 1984

WOLFGANG PAALEN

Pierre, José, *Wolfgang Paalen*, Filipacchi, Paris, 1980

Winter, Amy, *Wolfgang Paalen*, Praeger, Westport, Connecticut, 2003

ROLAND PENROSE

Penrose, Antony, *The Home of the Surrealists*, Frances Lincoln, London, 2001

Penrose, Antony, *Roland Penrose, The Friendly Surrealist*, Prestel, London, 2001

Penrose, Roland, *Scrap Book 1900–1981*, Thames & Hudson, London, 1981

Slusher, Katherine, *Lee Miller, Roland Penrose: The Green Memories of Desire*, Prestel, London, 2007

PABLO PICASSO

Baldassari, Anne, *The Surrealist Picasso*, Flammarion, Paris, 2005

Baldassari, Anne, *Picasso: Life with Dora Maar*, Flammarion, Paris, 2006

Gilot, Françoise and Carlton Lake, *Life with Picasso*, McGraw-Hill, New York, 1964

Penrose, Roland, *Picasso, His Life and Work*, Gollancz, London, 1958

Richardson, John, *A Life of Picasso, Volume 1, 1881–1906*, Cape, London, 1991

Richardson, John, *A Life of Picasso, Volume 2, 1907–1917*, Cape, London, 1991

Richardson, John, *A Life of Picasso, Volume 3, 1917–1932*, Cape, London, 1991

MAN RAY

Foresta, Merry et al., *Perpetual Motif: The Art of Man Ray*, Abbeville Press, New York, 1988

Mundy, Jennifer (ed.), *Duchamp, Man Ray, Picabia*, exh. cat., Tate Modern London, 2008

Penrose, Roland, *Man Ray*, Thames & Hudson, London, 1975

Ray, Man, *Self Portrait*, Bloomsbury, London, 1988

Schaffner, Ingrid, *The Essential Man Ray*, Abrams, New York, 2003

YVES TANGUY

Ashbery, John, *Yves Tanguy*, exh. cat., Acquavella Galleries, New York, 1974

Soby, James Thrall, *Yves Tanguy*, Museum of Modern Art, New York, 1955

Tanguy, Kay Sage et al., *Yves Tanguy: A Summary of his Works*, Pierre Matisse, New York, 1963

Von Maur, Karen, *Yves Tanguy and Surrealism*, Hatje Cantz, Berlin, 2001

Waldberg, Patrick, *Yves Tanguy*, André de Rache, Brussels, 1977

DOROTHEA TANNING

Plazy, Gilles, *Dorothea Tanning*, Filipacchi, Paris, 1976

Desmond Morris in his studio, 1948. Photographer unknown.

ACKNOWLEDGMENTS

I would like to acknowledge the help I have received with the subject of this book. In particular, I am extremely grateful to Silvano Levy, Andrew Murray, Michel Remy and Jeffrey Sherwin, with whom I have had many valuable discussions over the years. I would also like to thank my wife Ramona for her tireless assistance in researching the elusive details of the lives of many of the surrealists.

Sadly, all the artists that I have known who were active in the surrealist movement between the 1920s and the 1950s are now dead, but I would like to record my debt to them and my sincere thanks for all the stimulating ideas and amusing anecdotes they shared with me in earlier days. Those that I was fortunate enough to know personally included Eileen Agar, Francis Bacon, Alexander Calder, Frédéric Delanglade, Toni del Renzio, Leo Dohmen, Edward Kingan, Conroy Maddox, F. E. McWilliam, Oscar Mellor, Edouard Mesens, Joan Miró, Henry Moore, Sidnay Nolan, Roland Penrose, Simon Watson Taylor, Julian Trevelyan and Scottie Wilson.

ILLUSTRATION CREDITS

Dimensions are given in cm followed
by inches

2　Max Ernst © ADAGP, Paris and
DACS, London 2018

6　Moderna Museet, Stockholm.
Donation 1972 from Erik Brandius
(FM 1972 012 171). © Anna Riwkin/
Moderna Museet-Stockholm

13　© Man Ray Trust/ADAGP, Paris and
DACS, London 2018

14　Collection Roger Thorp

16, 17　Courtesy Desmond Morris

18–19　Max Ernst, *Rendezvous of Friends*,
1922–23. Oil on canvas, 130 x 193 (51⅛
x 76). Museum Ludwig, Cologne.
Photo akg-images. © ADAGP, Paris
and DACS, London 2018

20　Tate, London 2017

24　Eileen Agar, *The Reaper*, 1938.
Gouache and leaf on paper, 21 x 28
(8¼ x 11). Tate, London 2017. ©
Estate of Eileen Agar/Bridgeman
Images

28　Stiftung Arp e.V., Berlin/
Rolandswerth. © DACS 2018

31　Jean (Hans) Arp, *Torso, Navel,
Mustache-Flower*, 1930. Oil on
wood relief, 80 x 100 (31½ x 39⅜).
Metropolitan Museum of Art, New
York. The Muriel Kallis Steinberg
Newman Collection, Gift of Muriel
Kallis Newman, 2006 (2006.32.1).
© DACS 2018

33　© Henri Cartier-Bresson/Magnum
Photos

36　Francis Bacon, *Figure Study II*,
1945–46. Oil on canvas, 145 x 129
(57¼ x 50¾). Kirklees Metropolitan
Council (Huddersfield Art Gallery).
© The Estate of Francis Bacon. All
rights reserved, DACS/Artimage
2018. Photo Prudence Cuming
Associates Ltd

40　Hans Bellmer, *Untitled (Self-portrait
with doll)*, 1934. Photograph. Private
collection, courtesy Ubu Gallery,
New York. © ADAGP, Paris and
DACS, London 2018

43　Hans Bellmer, *Peg-top*, 1937. Oil on
canvas, 64.8 x 64.8 (25⅝ x 25⅝).

Tate, London 2017. © ADAGP, Paris
and DACS, London 2018

46　Photo akg-images/Walter Limot

49　Victor Brauner, *Conspiration*, 1934. Oil
on canvas, 129.8 x 97.2 (51⅛ x 38¼).
Musée National d'Art Moderne,
Centre Georges Pompidou, Paris.
© ADAGP, Paris and DACS,
London 2018

53　© Man Ray Trust/ADAGP, Paris and
DACS, London 2018

58　André Breton, Poem-Object, 1941.
Carved wood bust of man, oil lantern,
framed photograph, toy boxing gloves
and paper mounted on drawing
board, 45.8 x 53.2 x 10.9 (18 x 21 x 4⅜).
Museum of Modern Art, New York.
Kay Sage Tanguy Bequest (197.1963).
Photo 2017 Digital Image, The
Museum of Modern Art, New York/
Scala, Florence. © ADAGP, Paris and
DACS, London 2018

64　Photo akg-images/TT Nyhetsbyrån
AB. © 2018 Calder Foundation, New
York/DACS London

67　Alexander Calder, *White Panel*, 1936.
Plywood, sheet metal, tubing, wire,
string and paint, 214.6 x 119.4 x 129.5
(84½ x 47 x 51). Calder Foundation,
New York/Art Resource, NY. © 2018
Calder Foundation, New York/DACS
London

72　Münchner Stadtmuseum, Munich
(FM-2012/200.226). Sammlung
Fotografie/Archiv Landshoff. Photo
2017 Scala, Florence/bpk, Bildagentur
für Kunst, Kultur und Geschichte,
Berlin

75　Leonora Carrington, *Self-Portrait: 'A
L'Auberge du Cheval d'Aube'*, c. 1937–38.
Oil on canvas, 65 x 81.3 (25⁹⁄₁₆ x 32).
Metropolitan Museum of Art, New
York. The Pierre and Maria-Gaetana
Matisse Collection, 2002 (2002.456.1).
© Estate of Leonora Carrington/
ARS, NY and DACS, London 2018

77　Carl Van Vechten Collection, Library
of Congress, Prints & Photographs
Division, Washington, DC
(LC-USZ62-42530)

80　Giorgio de Chirico, *The Two Masks*,
1916. Oil on canvas, 56 x 47 (22 x 18½).
Private collection, Milan. Photo 2017
Scala, Florence. © DACS 2018

83 Carl Van Vechten Collection, Library of Congress, Prints & Photographs Division, Washington, DC (LC-USZ62-133965)

89 Salvador Dali, *The Enigma of Desire, My Mother, My Mother, My Mother, My Mother*, 1929. Oil on canvas, 110 x 150 (43¼ x 59). Pinakothek der Moderne, Bayerische Staatsgemaeldesammlungen, Munich. © Salvador Dali, Fundació Gala-Salvador Dalí, DACS 2018

95 Photo © Lee Miller Archives, England 2017. All rights reserved. Paul Delvaux © Foundation Paul Delvaux, Sint-Idesbald - SABAM Belgium/DACS 2018

98 Paul Delvaux, *Call of the Night*, 1938. Oil on canvas, 110 x 145 (43¼ x 57⅛). National Gallery of Modern Art, Edinburgh. National Galleries of Scotland. Purchased with assistance from the Heritage Lottery Fund and the National Art Collections Fund, 1995 (GMA 3884). © Foundation Paul Delvaux, Sint-Idesbald - SABAM Belgium/DACS 2018

100 Photo Bettman/Getty Images

105 Marcel Duchamp, *The Bride*, 1912. Oil on canvas, 89.5 x 55.6 (35¼ x 21⅞). Philadelphia Museum of Art. The Louise and Walter Arensberg Collection, 1950 (1950-134-65). © Association Marcel Duchamp/ ADAGP, Paris and DACS, London 2018

111 © Henri Cartier-Bresson/Magnum Photos

114 Max Ernst, *Attirement of the Bride (La Toilette de la mariée)*, 1940. Oil on canvas, 129.6 x 96.3 (51 x 37⅞). The Solomon R. Guggenheim Foundation, Peggy Guggenheim Collection, Venice, 1976 (76.2553.78). © ADAGP, Paris and DACS, London 2018

118 Museum of Fine Arts, Houston, Texas. Museum purchase funded by the Annenberg Foundation, courtesy of Wallis Annenberg, The Manfred Heiting Collection. Bridgeman Images. Dora Maar © ADAGP, Paris and DACS, London 2018

123 Leonor Fini, *The Ends of the Earth*, 1949. Oil on canvas, 35 x 28 (13¾ x 11).

Private collection. © ADAGP, Paris and DACS, London 2018

125 Courtesy Statens Museum for Kunst, (The National Gallery of Denmark), Copenhagen/Wilhelm Freddie Archiv

129 Wilhelm Freddie, *My Two Sisters*, 1938. Oil on canvas, 80 x 81 (31½ x 32). Fine Art Exhibition, Brussels. © DACS 2018

133 © Henri Cartier-Bresson/Magnum Photos

137 Alberto Giacometti, *Woman With Her Throat Cut*, 1932. Bronze, 22 x 87.5 x 53.5 (8⅝ x 34½ x 21⅛). Scottish National Gallery of Modern Art, Edinburgh. © The Estate of Alberto Giacometti (Fondation Annette et Alberto Giacometti, Paris and ADAGP, Paris), licensed in the UK by ACS and DACS, London 2018

139 Photo Gjon Mili/The LIFE Picture Collection/Getty Images

142 Arshile Gorky, *Garden in Sochi*, 1941. Oil on canvas, 112.4 x 158.1 (44¼ x 62¼). Museum of Modern Art, New York. Purchase Fund and gift of Mr. and Mrs. Wolfgang S. Schwabacher (by exchange) (335.1942). Photo 2017 Digital Image, The Museum of Modern Art, New York/Scala, Florence. © ARS, NY and DACS, London 2018

145 Photo Gjon Mili/The LIFE Picture Collection/Getty Images

148 Wilfredo Lam, *Your Own Life*, 1942. Gouache on paper, 105.4 x 86.4 (41½ x 34). Courtesy The Kreeger Art Museum, Washington, DC © ADAGP, Paris and DACS, London 2018

150 By kind permission of the artist's daughter, Lee Saunders

153 Conroy Maddox, *The Poltergeist*, 1941. Oil on canvas, 61 x 51 (24 x 20). Israel Museum, Jerusalem (B98.0516). By kind permission of the artist's daughter, Lee Saunders

156 Photo 2017. BI, ADAGP, Paris/Scala, Florence

163 René Magritte, *Les Amants (The Lovers)*, 1928. Oil on canvas, 54 x 73 (21¼ x 28¾). Australian National Gallery, Canberra (NGA 1990.1583).

© ADAGP, Paris and DACS, London 2018

167 Photo akg-images/Denise Bellon

170 André Masson, *The Labyrinth*, 1938. Oil on canvas, 120 x 61 (47¼ x 24). Musée National d'Art Moderne, Centre Georges Pompidou, Paris. © ADAGP, Paris and DACS, London 2018

172 © Sergio Larraín/Magnum Photos

176 Roberto Matta, *The Starving Woman*, 1945. Oil on canvas, 91.5 x 76.4 (36 x 30⅛). Christie's Images, London/ Scala, Florence. © ADAGP, Paris and DACS, London 2018

179 © National Portrait Gallery, London

183 E. L. T. Mesens, *Alphabet Deaf (Still) and (Always) Blind*, 1957. Collage of gouache on cut-and-pasted woven, corrugated, and foil papers, laid on cardboard, 33.4 x 24.1 (13⅛ x 9½). Art Institute of Chicago. © DACS 2018

187 © Lee Miller Archives, England 2017. All rights reserved

191 Joan Miró, *Women and Bird in the Night*, 1944. Gouache on canvas, 23.5 x 42.5 (9¼ x 16¾). Metropolitan Museum, New York. Jacques and Natasha Gelman Collection, 1998 (1999.363.54). © Successió Miró/ ADAGP, Paris and DACS London 2018

195 Photo Popperfoto/Getty Images

198 Henry Moore, *Four-Piece Composition: Reclining Figure*, 1934. Cumberland alabaster, 17.5 x 45.7 x 20.3 (6⅞ x 18 x 8). Tate, London. Reproduced by permission of The Henry Moore Foundation

201 Archiv Lisa Wenger

204 Meret Oppenheim, *Stone Woman*, 1938. Oil on cardboard, 59 x 49 (23¼ x 19¼). Private collection, Bern. © DACS 2018

209 Succession Wolfgang Paalen et Eva Sulzer

210 Wolfgang Paalen, *Pays interdit*, 1936- 37. Oil and candlesmoke (fumage) on canvas, 97.2 x 59.5 (38¼ x 23⅜). Succession Wolfgang Paalen et Eva Sulzer

214 Centre Georges Pompidou, Musée National d'Art Moderne, Centre de création industrielle, Paris. Don de

Mme Renée Beslon-Degottex en 1982 (AM1982-313). Photo Centre Pompidou, MNAM-CCI, Dist. RMN-Grand Palais/image Centre Pompidou, MNAM-CCI. © Droits reservés

219 Roland Penrose, *Conversation between Rock and Flower*, 1928. Oil on canvas, 89.8 x 71 (35⅜ x 28). © Roland Penrose Estate, England 2017. All rights reserved

225 © Herbert List/Magnum Photos

230 Pablo Picasso, *Femme Lançant une Pierre (Woman Throwing a Stone)*, 1931. Oil on canvas, 130.5 x 195.5 (51⅖ x 77). Musée Picasso Paris (MP133). © Succession Picasso/DACS, London 2018

235 © Lee Miller Archives, England 2017. All rights reserved

238 Man Ray, *Fair Weather (Le Beau Temps)*, 1939. Oil on canvas, 210 x 210 (82⅝ x 82⅝). Philadelphia Museum of Art. 125th Anniversary Acquisition. Gift of Sidney and Caroline Kimmel, 2014 (2014-1-1). © Man Ray Trust/ ADAGP, Paris and DACS, London 2018

243 © Man Ray Trust/ADAGP, Paris and DACS, London 2018

245 Yves Tanguy, *The Sun in Its Jewel Case*, 1937. Oil on canvas, 115.4 x 88.1 (45⁷⁄₁₆ x 34¹¹⁄₁₆). The Solomon R. Guggenheim Foundation, Peggy Guggenheim Collection, Venice, 1976 (76.2553.95). © ARS, NY and DACS, London 2018

250 Photo © Lee Miller Archives, England 2017. All rights reserved. Dorothea Tanning © ADAGP, Paris and DACS, London 2018

253 Dorothea Tanning, *Birthday*, 1942. Oil on canvas, 102.2 x 64.8 (40¼ x 25½). Philadelphia Museum of Art. 125th Anniversary Acquisition. Purchased with funds contributed by C. K. Williams, II, 1999 (1999-50-1). © ADAGP, Paris and DACS, London 2018

262 Courtesy Desmond Morris

INDEX